DRAWING
SHARP FOCUS
STILL LIFES

DRAWING SHARP FOCUS STILL LIFES

BY ROBERT ZAPPALORTI

WATSON-GUPTILL PUBLICATIONS/NEW YORK

Copyright © 1981 by Watson-Guptill Publications

First published 1981 in the United States and Canada by Watson-Guptill Publications,
a division of Billboard Publications, Inc.,
1515 Broadway, New York, N.Y. 10036

Library of Congress Cataloging in Publication Data

Zappalorti, Robert, 1948–
 Drawing sharp focus still lifes.

 Includes index.
 1. Still-life in art. 2. Drawing—Technique.
I. Title.
NC825.S74Z36 1981 743'.835 80–28508
ISBN 0–8230–1435–5

Manufactured in U.S.A.

First Printing, 1981

3 4 5 6 7 8 9/86

To my father
and in memory of my mother

ACKNOWLEDGMENTS

I would like to express my sincerest appreciation and thanks to Howard Munce for generously suggesting that I undertake a book of this caliber; to Marsha Melnick for believing in this book; to Dot Spencer and Betty Vera, my editors, for their patience and skill in putting the correct words in the right places; to Ken Davies for writing the foreword; to Vida, my wife, for her insistence, persistence, and assistance; to Rebecca, my daughter, who kept up my spirits with her bubbly companionship during those long studio hours; to Keith Johnson and Bill Noyes for supplying the information needed for me to produce the photographs correctly; to Jonathan Paier for his many special favors; and finally, to all my friends and fellow instructors at the Paier School of Art who believed in me and this book.

CONTENTS

AN APPRECIATION

It was about 10:30 in the morning one day early in 1968. I was walking past the bulletin board outside the faculty lounge at the Paier School of Art. At that time I taught a third-year composition class, and each week I would post the current assignment on the bulletin board. On this particular morning, several second-year students were reading my latest assignment, and as I passed by, I overheard one of them say, "Now there's a good assignment, not like the ones we're getting." My ears immediately perked up and I made a mental note of the student's face, since I didn't know his name. "Obviously," I said to myself rather smugly, "any student with such discriminating taste deserves investigating."

Subsequently the faculty informed me that he was one of the superstars of the second-year class. He was a serious, excellent student, a real nice guy, and I was told that I should look forward to getting him in my third-year class. His name was Bob Zappalorti. I'm sure Bob doesn't remember the incident, and since I've never mentioned it to him, he will find out about it for the first time when he reads these words.

For the next three years I, along with everyone else at the Paier School, was very much aware of this young man who more than lived up to his advance notices. Upon graduation he was awarded a fifth-year scholarship to continue his studies. I think the high point of his student days was when he won the first prize in the national Benedictine Art Awards with a painting which, I'm very proud to say, was done in my class during his senior year. Ironically, the first time he entered the picture in the competition in 1969, it was flatly rejected—not even included among the fifty or so finalists. Then in 1970 he resubmitted it and this time walked away with the top prize—$1,000!

About that time the school asked him to join our faculty as an assistant instructor—an honor *very* few Paier students have enjoyed. Since then, he has distinguished himself as an excellent and popular member of the faculty. His ten-year teaching experience has produced this extraordinary book on drawing. This work is especially welcome at a time when many amateur artists and even many so-called professionals are using traced photographs as a substitute for drawing skill. Learning to draw takes patience and a lot of hard work. It's not easy, but this book will make it a most enjoyable task. For years I have told my students, "If you can't draw it—don't photograph it." This book will teach you to draw it!

Ken Davies

INTRODUCTION

In my teaching experience, I have often noticed that beginning and even advanced students tend to visualize their finished drawings before they start to draw—and consequently they become frustrated when their expectations exceed their ability. For this reason, I believe it is very important to have basic drawing skills at your command before you attempt your own style. One of the best ways of developing draftsmanship is by learning the techniques of sharp focus drawing, and that is why I have written this book.

What is "sharp focus" drawing? Put very simply, it is rendering with refined, precise line and tone to create a lifelike representation of the subject matter. It differs from other methods of drawing realistically, however, in that it creates an extremely clear, sharp, almost photographically accurate image—hence the term *sharp focus.* In addition, this technique can be used not only to create the illusion of three-dimensional depth, but also to reproduce the surface textures of objects so convincingly as almost to fool the eye. Although I don't consider this the only acceptable way to draw, I do feel that you should learn it before you go on to develop your own style. This

book will teach you to make sharp focus drawings of still lifes in pencil, but the techniques you will learn here can be applied to many artistic styles, to other drawing media such as charcoal and chalk, and to other kinds of subject matter.

This book is intended for both beginners and more advanced artists. If you are a beginning artist, the projects in this book will lead you through the various stages involved in creating a picture, step by step. I have tried to develop these basic concepts and techniques slowly at first, so that you will not become confused or discouraged. What you learn in each project can be applied to subsequent projects, so that you can build and expand upon your knowledge as you become a more competent draftsman. You should proceed at the pace that is most comfortable for you, repeating projects as necessary.

If you are a more experienced artist, you will move through the projects more easily, but you will find them indispensable for reference and review of the fundamentals which every artist must practice constantly—for certain basics simply cannot be stressed enough. You also will find the methods in this book useful for breaking bad

drawing habits and developing better ones; drawing will become fun rather than a frustrating, tedious chore. And you will find that the more you draw, the greater will be your proficiency.

Part I of this book is concerned with constructing three-dimensional objects in line only. You will learn how to visually construct basic forms such as cubes, rectangles, cylinders, and cones; see and draw everyday objects in terms of their basic forms; draw objects in perspective; understand and construct symmetrical ellipses in perspective; use checkpoints and "negative" space to keep objects in proportion; draw still life arrangements of more complex objects; and change the size or angle of objects as necessary in your drawing.

Part II will show you how to render form and a variety of surface textures with tone, starting with a description of various pencils and how to control them to achieve the effects you desire. In Part III you will have an opportunity to peer over my shoulder and observe the objects and techniques I use to create a picture. The step-by-step still life demonstrations show how I approach a variety of drawing problems from the initial setup through the finished drawing. In each of the numerous projects throughout this book, I will demonstrate an exercise intended to help you to understand and master a particular skill or drawing technique. I will specify the materials used, describe my drawing setup, and then illustrate step by step, through text and pictures, exactly how I handle the particular drawing problem. Read through the project first, carefully observing what I do, and then try the exercise yourself.

As you read this book, try to work your way through the projects slowly. Keep in mind that you are learning something new, and be patient. Because sharp focus drawing requires careful study, you will learn to observe your subject more objectively, and consequently you will draw it more accurately. Once you have learned to communicate more effectively in this new way, you will be surprised at how much you can accomplish. Good luck, and don't despair; ultimately, I am sure you will find your new way of communicating very satisfying.

MATERIALS AND EQUIPMENT

To be a competent artist and draw with accuracy, it is essential to be able to select and use the appropriate tools of the trade. There are many drawing mediums—charcoal, different kinds of crayon and chalk, pen and ink—but for sharp focus drawing I prefer pencil. The lines and tones produced by graphite enable me to be as flexible as I wish. I can create a fine-line drawing or a rendering with an endless range of tones and textures.

For the beginning artist, choosing the right pencils, papers, and erasers can be difficult and confusing. The materials I will discuss here are those I have used and have found, through experimentation, to be best suited for disciplined sharp focus drawing. I will be using them for the various drawing projects throughout the book, and I recommend that you use them also, particularly if you are just starting to draw. If at any time you discover other materials that you feel will aid your own drawings, however, by all means experiment with them.

You will need the following basic supplies to complete the projects in this book:

Graphite pencils: 2H, HB, and 2B
Ledger bond drawing pad, 14 x 17 in.
 (36 x 43 cm)
Tracing paper pad, 9 x 12 in. (23 x 30 cm)
Two-ply bristol drawing paper: 16 sheets, 11 x
 14 in. (28 x 36 cm)
Kneaded eraser
Drawing board
Clip-on lamp with 10-in. (25-cm) reflector
 shade and 60-watt bulb
18-in. (46-cm) ruler or straightedge
Single-edge razor blades
Sandpaper block
Masking tape, pushpins, or clips
Workable fixative

Papers. Papers are classified primarily according to two criteria: weight and content. The weight given for a specific paper refers to the weight of one ream, or 500 sheets of a standard size of that paper. For example, a 100-pound paper would weigh 100 pounds per ream. Thus, the heavier the ream, the sturdier the paper.

The content of a paper can be rag, wood pulp, or a combination of the two. Wood-pulp and combination papers are chemically treated, and this causes yellowing and deterioration; 100 percent rag papers are actually shredded and soaked cotton rags held together with a binder, pressed to form sheets, and then dried. This type of paper is more expensive, but it is resistant to yellowing.

For the various projects in this book, I will use three types of paper: ledger bond, tracing paper, and bristol paper.

Ledger Bond. A smooth, glossy, relatively lightweight paper which accepts ink and pencil very well, making it possible to achieve a clean, precise line. This paper can be made of rag, wood pulp, or a combination of both.

Tracing Paper. A semitransparent paper that is often used for preliminary sketches which are then refined and transferred to a good grade of drawing paper. Tracing paper can be purchased in a variety of price ranges. I recommend that you use parchment tracing paper no. 100. This particular kind of tracing paper holds up quite well under extensive erasing.

Bristol Paper. A stiff paper which is available in a variety of weights. Bristol paper also is manufactured using wood pulp, rag, or a combination. I strongly recommend a good-quality, 100 percent rag, two- or three-ply bristol paper for its durability, nonyellowing quality, and moderately textured surface. This is an ideal paper for tonal renderings; it has a slight tooth, which enables you to apply the graphite more easily.

Pencils. Standard "lead" drawing pencils are actually made of graphite, and they are categorized according to the hardness of their lead. The letter *H* indicates a hard lead and the letter *B*, a soft one. Pencils which are marked HB are considered to be in the middle, which means the line that is produced is neither extremely dark nor light. The letter designation is preceded by a number; the harder the pencil, the higher the number preceding the *H*. For example, a 9H pencil has a thin, hard lead which produces a very faint line, whereas a 2H pencil makes a considerably darker, more noticeable mark. The opposite is true of the B pencils; a 6B lead is extremely soft and fat, and it produces a jet-black mark; a 2B pencil makes a mark that is lighter and easier to read.

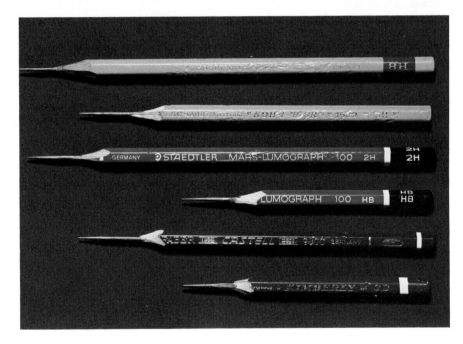

In many of the projects in this book I have used pencils other than the 2H, HB, and 2B recommended on page 14. These additional pencils are optional, and you need not purchase them; you should be able to do all the projects with your three basic hard, medium, and soft pencils. You will find that although each one makes a characteristic mark (depending on the hardness or softness of its lead), you can produce a whole range of tones by applying more or less pressure on the graphite as you draw.

Erasers. Inexperienced artists depend upon the eraser far too much; they constantly erase mistakes, not giving themselves the chance to create a rough foundation for a drawing. By the time a drawing is completed, the surface of the paper has been ruined by so much abrasion. The purpose of an eraser is to correct mistakes, but it's not necessary to erase every mistake at the beginning. Develop a well-constructed drawing first; then eliminate any mistakes.

There are many types of erasers: Pink Pearl; Artgum, a type which is sometimes called a soap eraser; vinyl, which erases extremely well and does minimal damage to the surface of the paper; and finally the kneaded eraser, my favorite. The kneaded eraser, which is sometimes called a kneaded rubber, is soft and pliable like putty; it can be kneaded with the fingers to obtain a clean erasing surface and can be used over and over. Another important characteristic of this eraser is that it can be formed into a smaller eraser to clean tiny, detailed areas for which other erasers would be too large. The other erasers are solid in form and produce many small particles which can smudge a drawing very easily. Experiment with various erasers and then choose the one you prefer.

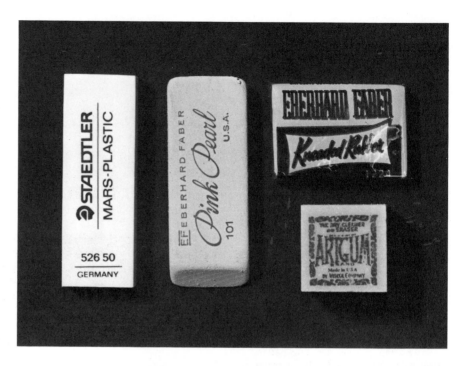

Drawing Board. You will need a drawing board as a support to which you can attach your paper. It does not have to be elaborate. A piece of plywood, Masonite, or even a stiff piece of cardboard will suffice, as long as it is large enough to accommodate your drawing paper. I suggest a board size of about 24 x 20 in. (61 x 51 cm).

Fixative. Fixative is a spray which binds the graphite to the paper so that it will not smudge. Both workable and final spray fixatives can be purchased in aerosol cans. The workable fixative is more practical because after a drawing has been sprayed, graphite can still be applied over it, whereas a final spray is just what the name implies and cannot be worked over.

Before applying fixative to a drawing, always spray a piece of scrap paper first to make sure the spray is fine and that blobs don't spatter and ruin your drawing. Before using this or any new material, read the directions; and most important of all, always spray fixative in a well-ventilated area and try to avoid inhaling the fumes, which may be harmful.

Lamp. The only light you will need for doing the projects in this book is a clip-on lamp with a 10-in. (25-cm) reflector shade and a 60-watt bulb. I have found, through experience, that the 60-watt bulb enables me to see objects easily.

Ruler or Straightedge. For creating accurate sharp focus drawings, a ruler or straightedge is essential. In addition to helping you refine straight lines in your drawing, it is a necessary tool for the procedures used in creating symmetry.

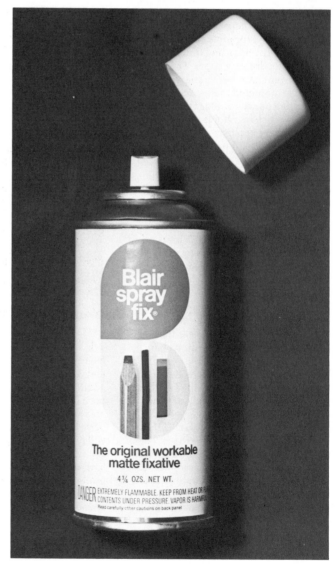

Tape, Pushpins, and Clips. You will need pushpins, clips, or tape to secure your paper to your drawing board or drawing desk to prevent its moving while you are drawing. Masking tape is useful, not only for attaching drawing paper to your board, but also for securing tracing paper in order to create symmetrical shapes or ellipses (these procedures are discussed at length in Chapter 4).

Single-Edge Razor Blades and Sandpaper Block. For sharpening pencils, you will need some single-edge razor blades and a sandpaper block, which can be purchased at an art supply store. A sandpaper block is a small rectangle of wood with sheets of sandpaper attached to it. By rubbing the graphite of your pencil against it, you can form a fine point. When a sheet of sandpaper becomes unusable, you just tear it off and expose a clean piece.

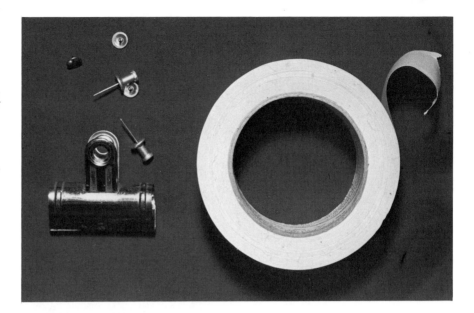

Why not use a pencil sharpener? The reason is that in disciplined sharp focus drawing, it is essential to apply thin, light pencil lines in a precise, accurate manner. With a razor blade and sandpaper block, you can create an elongated point on your pencil; this will prevent your applying too much pressure, which would indent the paper, leave traces of mistakes, and cause the lead to snap.

Here is how to do it. Grasp the pencil with the thumb and forefinger of one hand (your left, if you are right-handed), and hold the razor blade between the thumb and forefinger of the other. Resting the sharp edge of the razor on the pencil about ½ in. (1.3 cm) from the end, begin whittling away the wood, pushing the razor with the thumb of the hand holding the pencil, as shown in the photograph. Continue this procedure until the graphite is exposed. Be sure to use only single-edge razor blades!

Next, to create a needle-fine point, hold the sanding block in one hand (your left, if you are right-handed) and with the other, gently rub the exposed graphite against the sandpaper, as shown. As you rub, constantly roll or rotate the pencil so that a nicely tapered, elongated point will form.

When you sharpen a pencil, be patient, take your time, and do not press the lead too hard against the sandpaper block; if you apply too much pressure, your lead may break. Soft pencils tend to snap more easily than hard ones.

REFINED
LINE DRAWING

BASIC VISUAL CONSTRUCTION

Looking at objects in a still life and constructing them on paper freehand, without the use of mechanical aids such as compasses, rulers, or templates, is what I term visual construction. You learn to coordinate your hand and eyes and to draw what you see. In still life drawing, it is important to be able to look at an object, recognize its basic shape—such as a triangle for an ice cream cone—and then draw its basic three-dimensional form (a cone, a cylinder, or whatever). When you can do this, you have a better understanding of an object's construction. In the four projects in this chapter, I will demonstrate the proper way to construct the basic forms of a cube, cylinder, sphere, and cone by first reducing each object to its simplest shape and then adding other lines to create three-dimensional form.

PROJECT 1

CUBE OR RECTANGLE

A cube is a six-sided rectangular object whose adjacent sides, or planes, are at 90-degree (right) angles to one another. For this project I have chosen to use a tall jewelry box, which I've sprayed with white paint in order to show the planes easily. You will notice that this same box appears throughout the book; I use it frequently because its basic shape can be found in so many other objects. When you are ready to try this exercise, you may use a child's block, jewelry box, paint-tube box, cigar box, or any other cubical or rectancular object you wish. For this project I suggest you use inexpensive bond paper, which erases easily, and an HB (medium) pencil. I have set the box slightly below eye level so that I can see three of its six planes; this helps me to study and understand just how it is constructed. The three illustrations which follow do not represent a sequence of steps for drawing a cube. They are simply informative illustrations that will clarify how a cube should be drawn if it is to have the correct appearance.

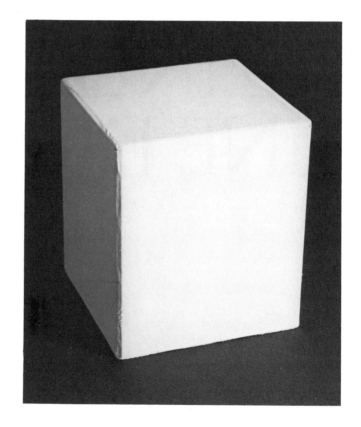

The first drawing of a cube demonstrates one of the most common errors made by beginning artists. The front face, or plane, of the cube is shown as a square, and the top and base of the square are perfectly horizontal relative to the viewer. This is correct only if the artist is positioned directly in front of one face of the cube, which would make that plane exactly parallel to the picture plane. In sharp focus drawing, when a cube is not positioned with one side parallel to the picture plane, it would be drawn as shown in the next illustration.

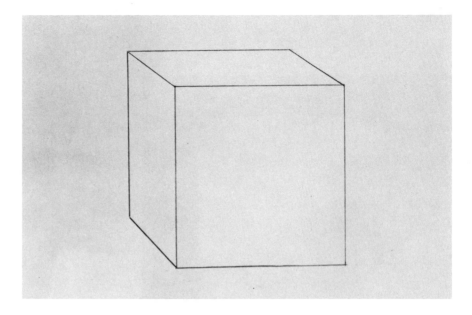

The next illustration shows how to construct a cube. To draw a cube correctly, I first place it on a table about two or three feet away from where I am seated, just below eye level. In the center of a sheet of ledger bond paper, I draw a vertical line with an HB pencil; this line represents the left edge of the plane closest to me. Next I visualize the angle of the cube, which is illustrated by the dark lines in the drawing. The cube is tilted away from the picture plane, which is represented by the heavy horizontal baseline. Holding the pencil horizontally between my thumb and forefinger, at arm's length, I line up the tip with the lower front corner of the edge I have already drawn. By tilting the right end of the pencil slightly upward or downward until it aligns with the bottom edge of the plane, I can determine the angle of the cube easily. Keeping in mind the angle I have just visualized, I draw the bottom edge with a line which slants upward at approximately the same angle. Next I visualize the left side of the cube, starting at its base, tipping my pencil up until it coincides with the angle of the cube; then I draw it. Now I draw a vertical line upward from the end of each of the angled lines, ending these verticals slightly higher than the main vertical; then I intersect the vertical lines with four lines which are parallel to the angled lines at the base of each of the planes, thereby creating a top plane for the cube.

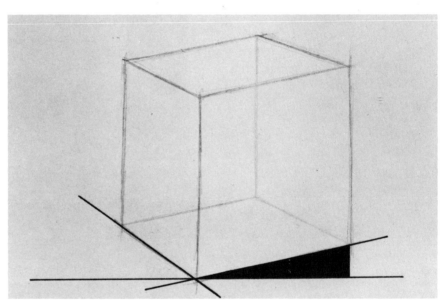

The third illustration shows how a completed cube looks. Its various angles, which show how the planes move back into space, give it a three-dimensional appearance. Now try doing this project yourself, repeating it if you wish. When you are satisfied with the way you have visually constructed a cube, go on to the next project.

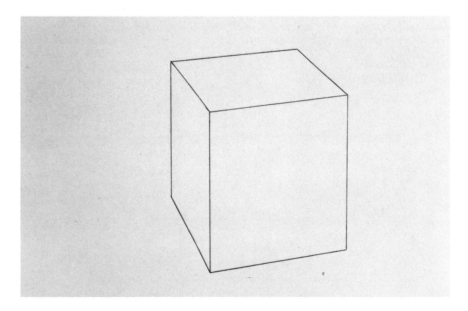

CYLINDER

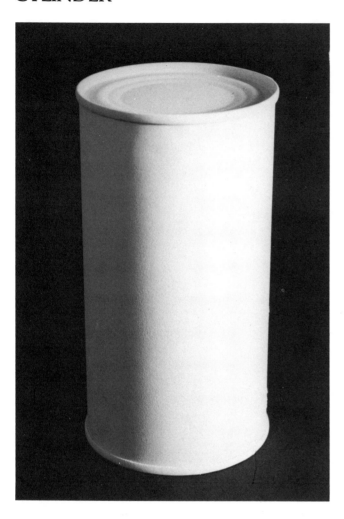

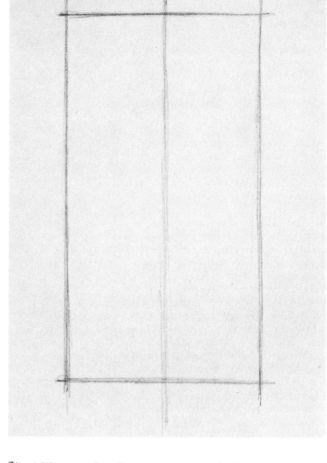

A cylinder can be any size and have any proportions, ranging from tall and thin to short and stout. For this project I am using a juice can which has been painted white. You may use any cylindrical object you wish—a soda can, a paper tube, or even rolled-up construction paper. To draw the cylinder, I place it on a table slightly below eye level so that I can see its top; this enables me to see its overall shape better.

Step 1. The procedure for constructing a cylinder on paper is actually rather simple: it is really nothing more than drawing a rectangle and adding curved lines at the top and bottom to suggest roundness. Therefore, I begin by drawing a rectangle on a sheet of ledger bond paper with an HB pencil. The proportions of my rectangle, which is taller than it is wide, follow as closely as possible the proportions of the cylinder I am drawing. Then I draw a vertical guideline through the center of the rectangle; later, this will help me to position the curved lines correctly. I locate the center by eye, without mechanical aids, checking to make sure that the proportions of the rectangle are the same on each side of the guideline.

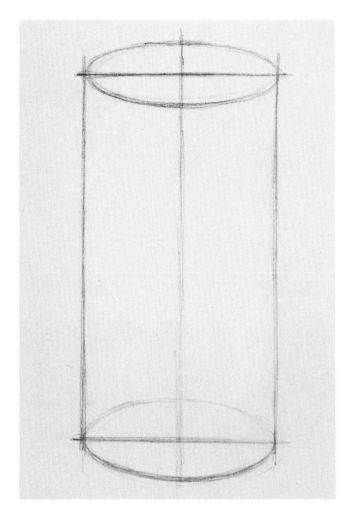

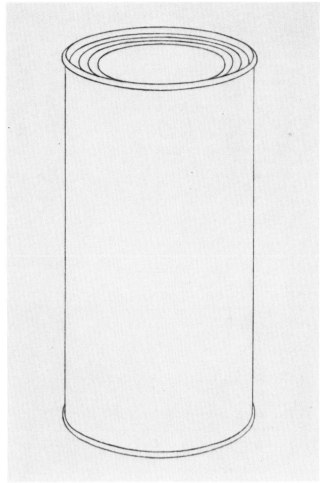

Step 2. Next I draw the curved top and bottom edges of the cylinder with ellipses. Ellipses will be discussed at length in Chapter 4, but for this exercise it is necessary only to develop the basic skills for constructing them by eye, causing the cylinder to appear three-dimensional by drawing its precise contours. Because I am looking downward at the cylinder, the bottom ellipse appears slightly rounder than the top ellipse, even though they are actually the same; by drawing the ellipses the way they appear, I create the illusion of looking downward. The center of each ellipse is the point where the horizontal line of the rectangle intersects the center vertical guideline. These guidelines help me to construct an ellipse whose angle is correct relative to the direction of the object. By continually comparing both halves of the ellipse as I draw, I make sure the curves of my ellipse are the same.

Step 3. With a kneaded eraser I eliminate the center vertical guideline and the original horizontal lines that I drew in Step 1. I also erase all the extra lines outside the basic cylinder, refining the elliptical curves and straight sides. I add the ellipses at top and bottom which define the rim of the can and the rings encircling the top, and my drawing is finished.

CONE

A cone is a three-dimensional form that
tapers to a point from a circular base. You
can use rolled construction paper or even
an ice cream cone as a model. (If you use
rolled construction paper, a cone is quite
simple to construct. On a 14 x 17 in. [36 x
43 cm] sheet of ledger bond, use a com-
pass to draw a circle with a 12-in. [30-cm]
diameter. Next, cut the circle in half with a
single-edge razor blade and a ruler or
straightedge; roll this half-circle into a
cone and secure the edges with tape.)
Again, I am setting up my rolled cone
slightly below eye level so that its base
will appear as an ellipse.

Step 1. Using my HB pencil on ledger
bond paper, I draw a triangle with sides
that are slightly longer than its base. Then
I draw a light vertical guideline through its
center. This vertical center line, known as
the longitudinal or long axis, divides the
triangle in half. The horizontal baseline of
the triangle has been divided exactly in
half by the vertical. These lines will help
me construct a symmetrical ellipse in the
next step.

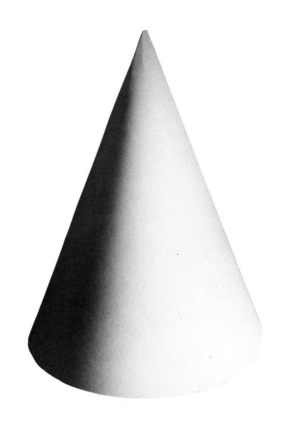

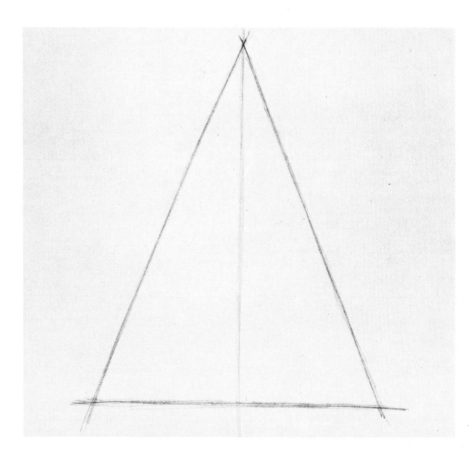

Step 2. Next I draw an ellipse at the base of the triangle. As I draw the first curved line below the horizontal guideline, I make sure that the curve is the same on each side of the center vertical.

Step 3. Now I eliminate the center dividing line and the original base of the triangle with a kneaded eraser. Then I straighten the lines of its sides and use the eraser to clean the curved lines of the ellipse.

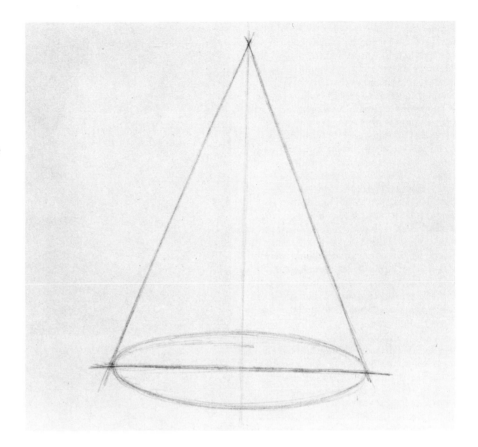

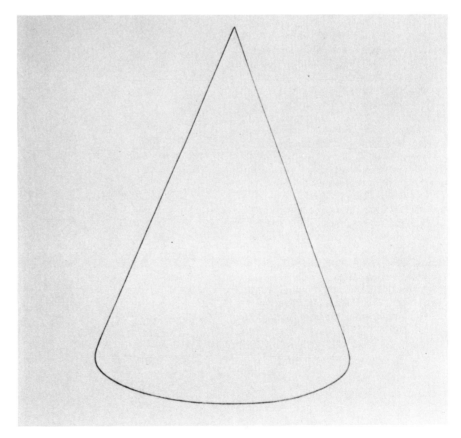

STILL LIFE CONSTRUCTION

Now that you have a better understanding of how to use the method of visual construction to draw three basic forms—a cube, a cylinder, and a cone—you should be ready to draw a simple still life. Arranging objects for a still life will help you develop your ability to see shape and form. As you do this project, don't be concerned with details; just try to construct the basic forms of the objects on your paper.

First I assemble a still life using the cube, cylinder, and cone from the first three projects, plus a sphere. For the sphere, I use a small rubber ball which has been sprayed with white paint. When setting up the still life, I make sure the four objects work as a unit, overlapping them so that when I draw them, I won't have four separate objects sitting on the page. Remember, the purpose of this exercise is to teach you to look carefully and to try to draw what you see.

Step 1. First I do a rough sketch of the entire still life, establishing the basic shapes of the objects one at a time. I begin with the cube because it is totally visible, and the proper height and width of each of the other objects can be determined easily in relation to it. I want to draw the cube as close to life size as possible; doing this will help me to compare the other objects and their relative sizes visually.

Using an HB pencil on ledger bond, I begin construction of the cube by drawing the corner closest to me, as I did in Project 1. Then, using my pencil as a visual guide, I determine and then draw the angle of the baseline of each of the two side planes that are visible.

Lightly I rough in the sides I *cannot* see, drawing "through" the cube as if it were transparent. This will help me place the other objects correctly in relation to the cube. Next I draw the vertical lines that define the sides, making sure they are parallel to the first edge I drew. I construct the top plane by drawing lines parallel to the baselines; now I have created the three visible planes. For the cylinder to the right of the box, I draw a rectangle, and for the cone to the left, a triangle. Finally I add a circle to the top of the box, completing my rough sketch. At this stage I don't worry about the messiness of the lines; I will refine them later.

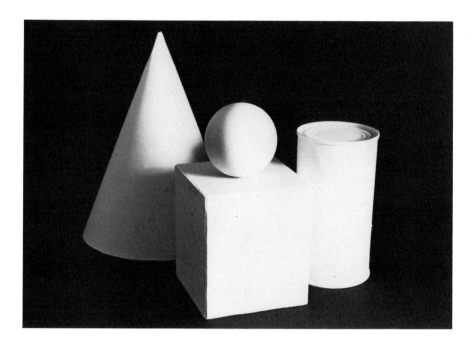

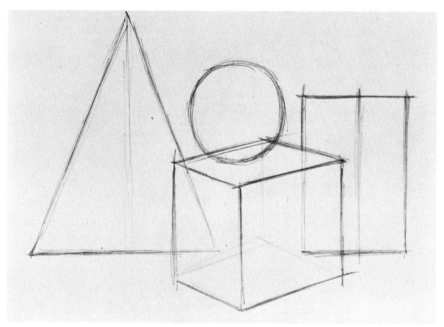

Step 2. For now I forget about the cube, which needs no further work at this time, and go on to define the forms of the cylinder and the cone. Following the same procedures I used in Projects 2 and 3, I add ellipses to each shape so that the rectangle becomes a cylinder and the triangle, a cone. The still life is beginning to look three-dimensional. Even though the circle remains as I originally drew it, it appears to take on the roundness of a sphere because it is seen in relation to the other forms.

Step 3. Now I erase the remaining construction lines with a kneaded eraser. I clean the forms by straightening lines and smoothing the curved lines with my HB pencil. The texture of the line has a great effect on the overall appearance of the finished drawing, and so a smooth consistency is a must. Neatness always plays an important part in precise, accurate drawing. When the drawing is finished, I spray it with fixative to prevent the graphite from smudging and protect the white areas of the paper.

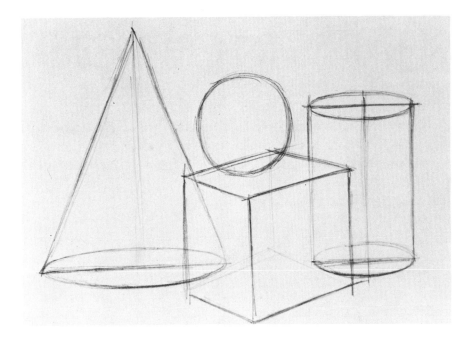

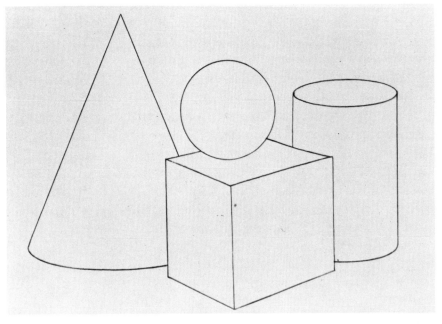

SEEING BASIC SHAPES IN OBJECTS

When I correct my students' drawings, they often comment that I make the corrections look easy. The secret of making "easy" corrections is breaking the objects down into their simplest shapes—seeing them as basic circles, squares, rectangles, and triangles. When you look at the toys in the photograph on page 29, try to ignore surface details and pick out the basic shapes of which they are made. The blocks are cubes, the slate is a rectangle, and the doll is a combination of spheres, cubes, cylinders, cones, and rectangles. By visualizing these shapes before starting to construct your drawing, you will find that it is a lot easier to draw the objects in your setup. Once you have made this preliminary breakdown of the objects, you can begin to draw the smaller shapes within them and then start developing three-dimensional forms, adding curves, details, and other subtleties to create a more realistic drawing.

This chapter contains two projects which will help you learn to draw, with practice, a simple still life. The objects in the first project are children's toys, which are shown in a photograph of the still life as I arranged it; this is followed by a step-by-step demonstration of how I develop my finished drawing. The second project consists of a still life of household or kitchen objects. Again, a photograph of the items shows you my setup, and then I draw the objects in sequence so that you can see how I work, from the first and largest basic shapes to the final, most detailed elements.

I chose the objects for both of these projects because they not only contain simple, easy-to-draw basic shapes, but also make interesting subjects. In addition, they are objects which I found in my home. They illustrate how several simple items, when grouped together, form the basis for a still life drawing that can be charming as well as easy and fun to produce.

When starting the projects in this chapter, begin slowly and progress at your own speed. You may even find you want to repeat the projects or rearrange the setups. Repetition will improve your ability to render a realistic drawing as well as build your confidence, which will pay off when you try more complex drawings later on. Start with simple objects and draw them until you fully comprehend how to construct them in terms of their basic shapes. Nothing is more rewarding than being confronted with a drawing problem and solving it by constructing basic shapes.

CHILDREN'S TOYS

Toys, while having great simplicity of form, can offer a fascinating variety of shapes to draw, and that is why I have selected a group of them for this still life. You do not have to use children's toys for your own still life; these were handy for me, but if you don't have any, choose any other simple objects which you have around your house.

I will begin drawing this particular setup by visualizing the basic shapes in each of the objects and then setting them down roughly on my paper before proceeding to develop their subtleties. At this point I don't want you to rely on any mechanical aids such as a ruler, T-square, protractor, or carpenter's level for drawing basic shapes. In the beginning it is more important to train your eye to see basic shapes, not only in the still life objects but also in all objects around you, and to practice recording what you see.

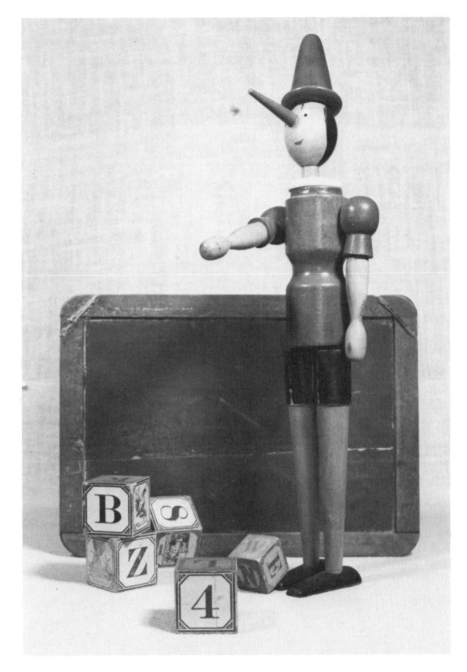

Step 1. I start by making a rough sketch with an HB pencil on ledger bond paper, putting down what I see as loosely and freely as possible. I'm not concerned at this point about any mistakes I may make, so I don't use my eraser. I am just concerned with breaking down the toys into basic shapes. The slate is translated into a large rectangle; the blocks become cubes; the doll, as I work from its feet up, becomes a diamond, two large rectangles, two small circles connected to two small rectangles representing the arms, two smaller rectangles for the shoulders and neck, an oval for the head, and so on.

Step 2. Now I start to rework my rough sketch by breaking down the objects into even smaller basic shapes. I still keep the drawing loose, but I establish more circles, cubes, rectangles, and triangles within the larger basic shapes. I indicate the inner border of the slate, delineate the doll's feet more specifically, and draw more specific sections in the body to give the doll a more realistic appearance—and also to give me a more substantial block-in from which to create a three-dimensional appearance.

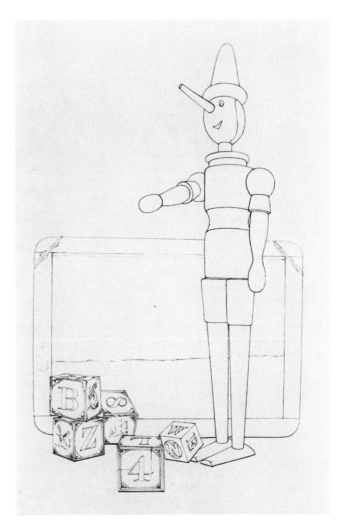

Step 3. Now I start to refine the objects. I round off the corners of the slate; designate the letters and numbers on the sides of the blocks, giving them a more solid, three-dimensional appearance; refine the doll's feet, giving them more shape; soften and round the lines of the legs and trunk; and make the shapes of the arms more conical. I make the neck more cylindrical and draw in the features of the face; the nose has become more conical, adding more dimension, and I have rounded and softened the hat. The drawing is beginning to look more like the actual setup.

Step 4. To complete the drawing, I erase the earlier sketch lines, continuing to refine all the objects. I draw the cracks in the slate and decorate the blocks in more detail. At last I draw the final shapes of the doll's trunk, arms, legs, and feet.

KITCHEN OBJECTS

I have chosen to draw kitchen objects for this project. For your setup, you can find many objects of various shapes and forms in this part of your home. You may want to use pots, pans, blenders, utensils, and even fruit or vegetables. I will be drawing an old coffeepot, a round pail, a ladle, and what every artist paints or draws at one time or another—an egg. Make sure the objects you choose are not too complicated, since you are dealing with basic shape construction. It is important to start out drawing simple objects, and only when you feel that you have mastered the skill of drawing them should you choose more difficult subjects. Begin this project by visualizing the basic shapes in each object and then roughing them in. By drawing everything freehand, you can learn to coordinate your eyes and hands, and therefore draw what you see.

Step 1. I start by making a rough sketch, using an HB pencil on ledger bond paper. I block in the drawing as loosely as possible. My main concern is getting the large basic shapes down on paper. At this point I'm not worried about how perfectly they are drawn, so I don't depend on an eraser. The pail in the background is broken down into a rectangle with a slanted side; the coffeepot, either in part or whole, is a series of triangles; the ladle is composed of a half circle for the scoop and a long, horizontal rectangle with a triangle at the end for the handle; and finally, the egg is a circle to which I add an elliptical end on the left. The rough sketch enables me to concentrate on basic shapes without worrying about exactness yet.

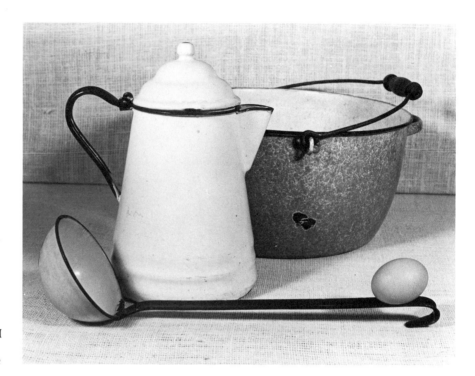

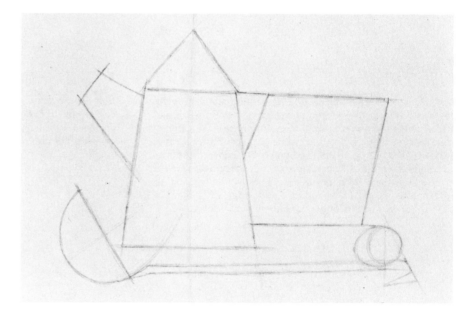

Step 2. Reworking my rough sketch, I begin adding more shapes to create the illusion of roundness, but I still keep the drawing sketchy. I have added the separations in the top of the coffeepot to make it easier to identify; and with the addition of a handle, the background shape is now recognizable as a pail.

Step 3. I now start to refine the objects, making the lines neater and erasing the preliminary guidelines which ran through the pail, coffeepot, and the scoop of the ladle. I create a more accurate illusion of roundness by defining the curves more precisely.

Step 4. To complete the drawing, I erase all earlier sketch lines and continue to refine the objects. I complete various parts of the coffeepot and pail in greater detail and thicken and round the handle of the ladle. After I indicate the contours of the chipped enamel on the front surface of the pail with the fine lines, my basic shape construction of kitchen objects is complete.

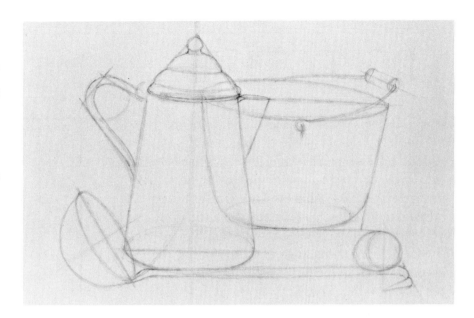

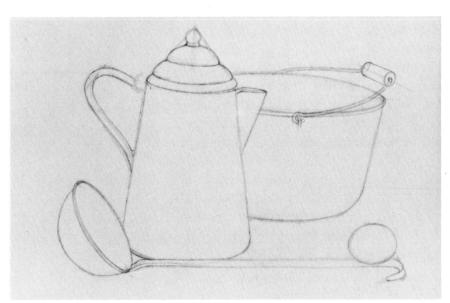

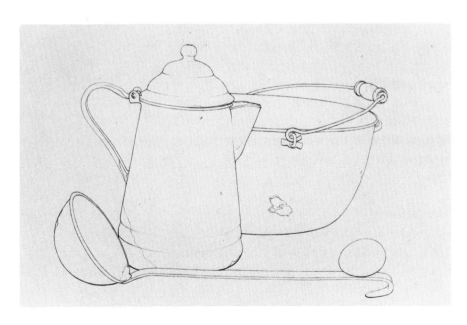

PERSPECTIVE

Perspective is a complex subject, and there are many books available which explain it in detail. For still life drawing, however, it is usually necessary to know only a few basic rules; these pertain to linear perspective, which is the representation of parallel lines in such a way that they appear to converge; since objects appear to get smaller as they recede into the distance, the converging lines create the illusion of three-dimensional depth in a drawing. The diagrams at right show the difference between geometrically parallel lines and parallel lines seen in perspective, which vanish to a point above, below, or on the horizon line.

In this chapter I will define the terms you will need to know in order to understand linear perspective; explain the rules and principles which will help you to excute a convincing three-dimensional drawing; and discuss three types of perspective—one-point, two-point, and three-point—used in creating three-dimensional effects. The last portion of this chapter consists of two demonstrations: how to locate the vanishing points in a basic still life and how to construct an inclined plane in perspective.

DEFINITIONS

Every profession or field of endeavor, be it art, music, cooking, or whatever, has special terminology affiliated with it. The study of perspective also has its own technical terms, and it would be difficult to understand the principles of perspective without first understanding those terms. Throughout my discussion of perspective, I will use only a few of the most common terms: *horizon line, vanishing point, baseline, point of sight, and station point.*

Horizon line (H.L.)—The eye level of the artist, and therefore of the viewer as well. This line changes as you raise or lower your viewpoint, which also enables you to see more or less of the horizontal planes that lie between you and the horizon.

PARALLEL LINES

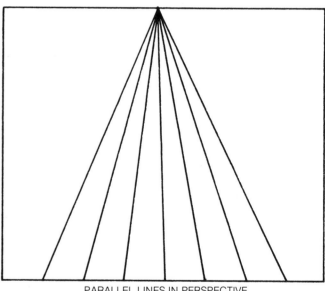

PARALLEL LINES IN PERSPECTIVE

Vanishing point (V.P.)—A point on the horizon line or other axis at which parallel lines appear to meet.

Baseline (B.L.)—A horizontal line, parallel to the horizon line, which represents the base of the picture plane.

Point of sight (P.S.)—The point on the horizon line which is directly opposite or in front of the viewer.

Station point (S.P.)—The fixed position, or vantage point, of the artist or viewer in relation to the subject.

RULES OF PERSPECTIVE

Of the many rules of perspective, I will explain only the few that I feel are necessary for still life drawing. These rules will help you to successfully create a three-dimensional effect on a flat surface.

1. In perspective drawing, all straight lines seen in perspective remain straight; no bowing or curving takes place, as often happens in photography when a wide-angle lens is used.

2. Vertical lines in perspective remain vertical in relation to the picture plane, except when buildings or still life objects are viewed from above or below. When this is the case, vertical lines appear to slant, converging near the top or bottom; however, they remain straight.

3. Parallel lines of a plane which inclines or declines have vanishing points above or below the horizon line.

4. The farther away an object is from the baseline of the picture plane, the closer to the horizon it appears, and its top surface becomes less visible.

5. Horizontal lines of an object that are drawn to the same point on the horizon are parallel to one another.

If at any time in the creation of a drawing you become confused about the perspective, refer to these five rules. They will give you a better understanding of how to create the illusion of three dimensions.

VISUAL PRINCIPLES OF PERSPECTIVE

The illusion of depth in a drawing can also be created by the relative sizes of the objects, their placement (overlapping), and the value of the lines and tones with which they are drawn. These visual principles, which are as important as linear perspective in making a finished still life drawing

look three-dimensional, are probably a little easier to comprehend.

The most common example of relative size is a series of telephone poles which, although they are exactly the same size, appear to get smaller the farther away they are from the viewer. To create a realistic drawing of a series of identical objects in perspective, you would need to keep in mind their *apparent* sizes and positions relative to one another. Of course, the context in which an object is seen also has a bearing on the illusion of depth. At first glance, the circles in the illustration below might simply appear to be of different sizes, particularly when seen against a background of plain white paper. If the circles were put into a still life, however, their sizes might be seen as an indication of their relative distance, thereby creating the impression of depth.

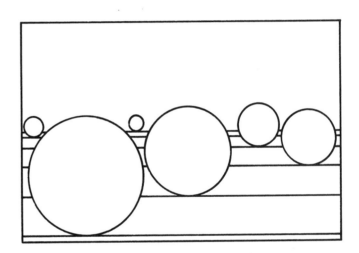

The placement of objects is yet another means of creating depth in a picture. By overlapping or covering part of one object with another, an artist can imply that the partially covered object is behind the other one, as shown in the next illustration (page 36).

Finally, the value of the lines with which an object is drawn can indicate its distance from the viewer. The eye "reads" a dark line more quickly than a faint, light one, and therefore an object that is dark in value appears to come forward visually, as shown in the third illustration. To make one object stand out from another, simply draw it with a darker line.

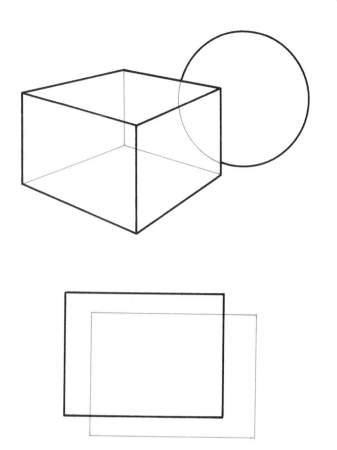

One-Point Perspective. The best-known example of one-point perspective is a pair of railroad tracks receding toward the horizon. One-point perspective occurs when all parallel horizontal lines vanish to a single point—the point of sight, located on the horizon. Note that in the illustration at right the undersides of the boxes above the horizon line are visible, but when boxes are below the horizon line, their top planes are visible. The front planes remain parallel to the picture plane regardless of whether they are above or below eye level. One-point perspective is useful when constructing rooms because no matter where you are standing, the ceilings, walls, and floors always recede to one vanishing point.

Two-Point Perspective. In two-point perspective there are two sets of parallel lines and two vanishing points. When you are constructing objects in a still life drawing, a knowledge of two-point perspective becomes essential. This is because not every object is placed with its front plane parallel to the picture plane, a necessary condition for one-point perspective. When a box is placed at an angle to the picture plane, its parallel sides must be drawn so that they appear parallel when seen in perspective, as in the illustration on page 38.

Three-Point Perspective. When you look up at a tall building from the ground, or look down at one from the air you notice that the vertical lines of the sides appear to slant inward. These lines vanish at a third point either above or below the horizon line, as shown in the illustrations on page 39. When the horizontal lines vanish toward two points on the horizon and the verticals recede to a third point, the object is shown in three-point perspective. Project 15 on page 59 is an exercise in drawing objects in three-point perspective: the objects are placed in such a way that the artist views the still life from above, thus utilizing the third point in perspective. For the purpose of drawing a still life, it isn't really necessary to plot the actual vanishing points; usually it is sufficient to know that the vertical lines slant inward.

Tone as well as line can create a three-dimensional quality in a drawing. Depending on the overall value of the drawing, either the lights or the darks will pull forward. In a rendering that is light overall, the darks would be noticed first, whereas in a dark rendering the lights would be noticed.

These are only a few of the visual principles which, in addition to a knowledge of perspective, will be helpful in creating the illusion of depth in your drawings.

THREE TYPES OF PERSPECTIVE

A knowledge of three basic types of perspective, utilizing from one to three vanishing points, will enable you to create depth in a variety of drawing situations. The important thing to keep in mind, no matter how many vanishing points you are using, is that a fixed position, or station point, on the part of the artist is mandatory. If you create a drawing from more than one station point, the perspective will confusing to the viewer, and you will not be able to achieve a realistic interpretation of your subject.

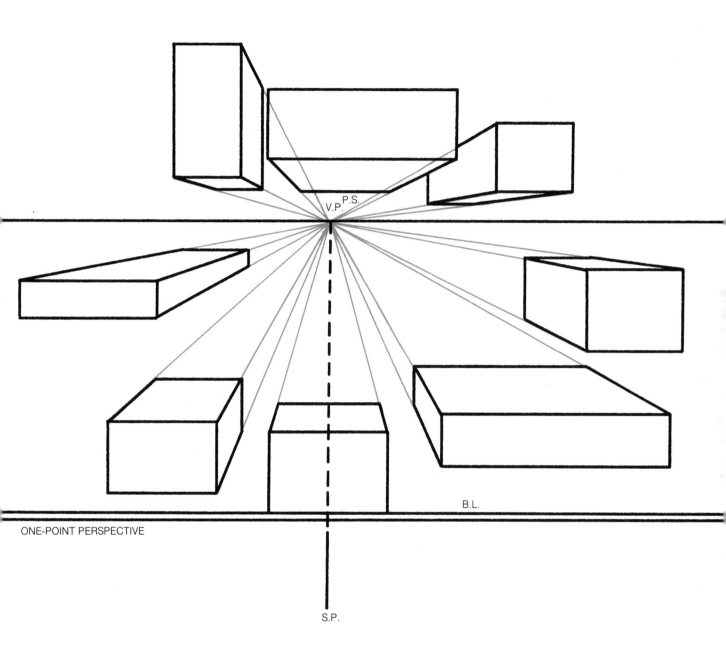

P.S.

V.P.

B.L.

ONE-POINT PERSPECTIVE

S.P.

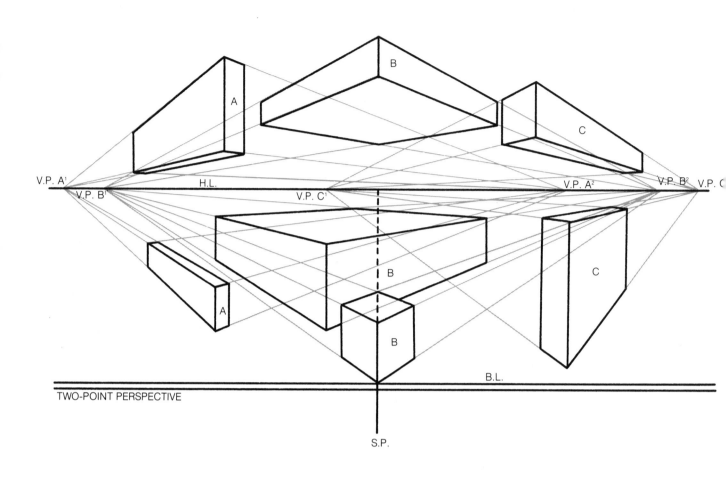

V.P. A¹ H.L. V.P. C¹ V.P. A² V.P. B² V.P. C

V.P. B¹

TWO-POINT PERSPECTIVE

B.L.

S.P.

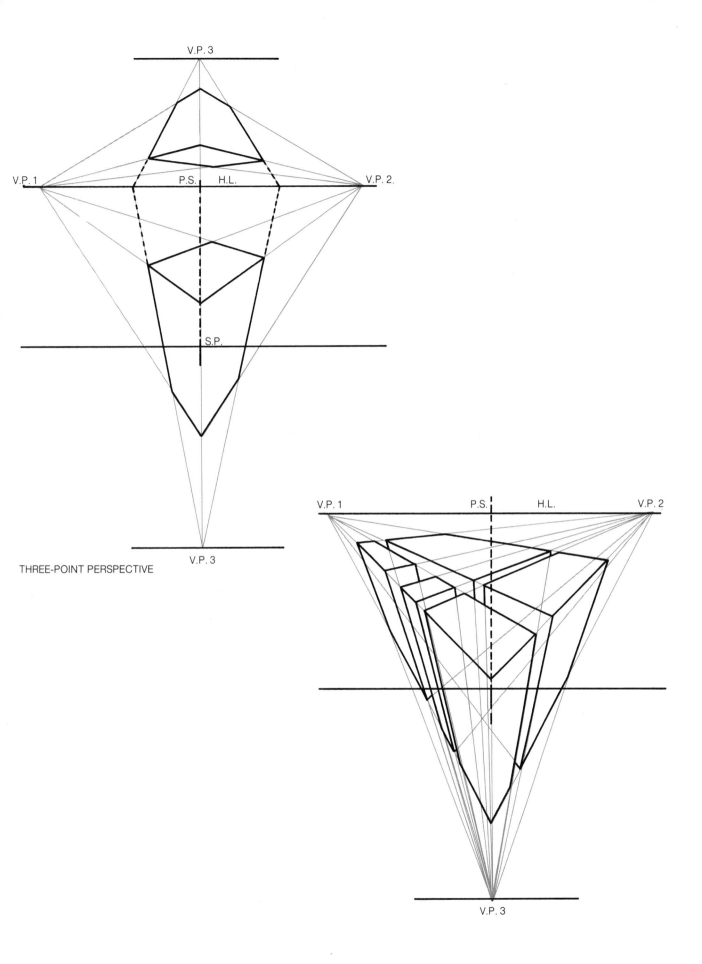

THREE-POINT PERSPECTIVE

39

UTILIZING PERSPECTIVE IN YOUR DRAWINGS

The preceding discussion of perspective has barely touched upon the many ways in which this method of seeing can be applied to creating the illusion of three-dimensional objects in space. If the subject of perspective intrigues you, I strongly suggest that you do some further reading on the subject. The fine points are beyond the scope of this book, but there are many excellent books devoted solely to the topic, and you may want to obtain one for your library. For your own still life drawing, the important thing is simply to be aware of the ways in which objects seem to change in appearance when viewed from different angles. Learn to observe carefully and to draw what you see—not what you *think* you see.

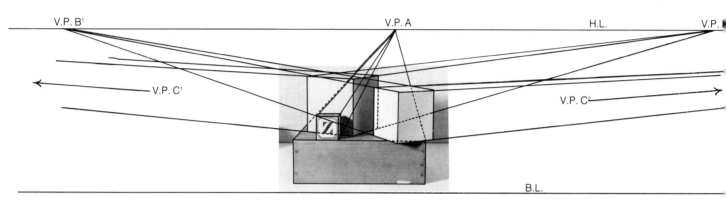

LOCATING VANISHING POINTS

This project is a simple exercise in finding the vanishing points of objects in a still life of basic objects. It is intended to develop your understanding of perspective so that you can apply it to your own still life drawing—for artists use their *knowledge* of perspective rather than actually plotting vanishing points when they draw. On a photograph of four geometric objects, I have used a fine felt-tip pen and a ruler to extend the horizontal parallel lines to vanishing points located on the horizon line. Both the box on which the cubes rest and the child's block are parallel to the baseline and recede to the same vanishing point, thus illustrating one-point perspective (A). The remaining cubes, which are not parallel to the baseline, vanish to separate points on the horizon line,

creating two-point perspective (B). The lines which do not meet at a vanishing point in the diagram would do so if the horizon line were extended. Whenever the angle of a plane is almost parallel to the baseline, an extremely gradual convergence is created as the object recedes (C).

To become better acquainted with the application of perspective, do as I have done in this exercise: use a photograph—or perhaps a magazine clipping showing rectangular objects—and locate the vanishing points. Remember, the parallel lines of each plane should vanish to either one or two points located on the horizon.

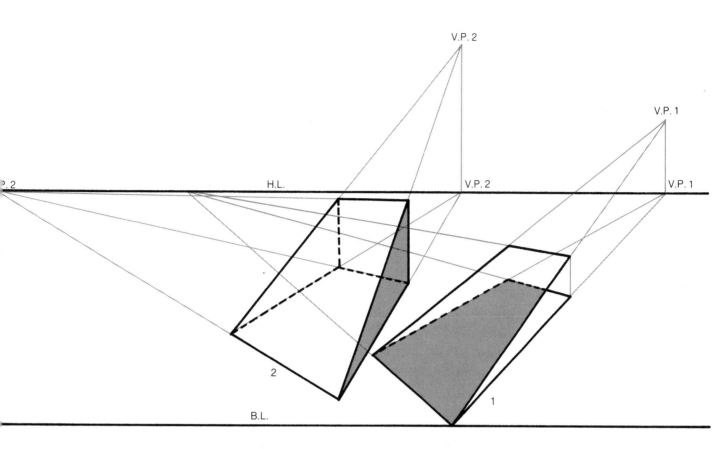

PROJECT 8

INCLINED PLANES IN PERSPECTIVE

Not every object in a still life has surfaces which are either horizontal or vertical. Sometimes you'll need to be able to draw objects which are tilted at an angle or are wedge-shaped, such as a book of matches. This project is designed to familiarize you with the construction of an inclined plane—a surface which is tilted so that it is no longer parallel to the ground plane and therefore, because it is tilted upward, has a vanishing point above the horizon line (a plane which declines, or tilts downward, has a vanishing point below the horizon line). To construct an inclined plane, you must apply this rule of perspective (no. 3 on page 35).

To create an incline, you must first draw the base of either a cube or a rectangle on the ground plane, as shown in the shaded area of incline no. 1, with its parallel sides vanishing to two separate points on the horizon line. Directly above the vanishing point, draw a vertical line on which the third vanishing point will be placed. The parallel lines of the inclined plane are drawn upward to this point from the rectangular base on the ground plane. Incline no. 2 has a vertical line attached to its side plane, which has been shaded to create a more solid triangular shape. Practice drawing a variety of inclines at various degrees of steepness, widths, and lengths. Constructing a book of matches or another wedge-shaped object can be an excellent challenge.

ELLIPSES

An ellipse is a circle seen in perspective, and its shape depends on where it is relative to the artist's eye level. As you will remember from the discussion of perspective in Chapter 3, eye level, which is also known as the horizon line, is the viewer's direct line of sight when looking straight ahead. Any object above this line is above eye level, and anything below it is below eye level. The diagram at right shows what happens to a circle that is parallel to the ground plane: the closer it is to eye level, whether above or below it, the flatter it appears; the farther away from eye level it is, the rounder it becomes. A horizontal circular shape viewed exactly at eye level flattens out so completely that it appears simply as a horizontal line. Whenever you draw an elliptical object—which is really a circular one seen in perspective—the first thing you must ascertain is its position in relation to your eye level. This will help you to judge its shape and proportions correctly.

An ellipse is not an oval, nor should it take on the shape of a football or a hot dog. A circle's contour is consistently curved and never has points or flat areas, even when seen in perspective. Only when a circle is exactly at eye level does it appear flat—and then it is represented by a straight line.

An ellipse is always symmetrical. When it is divided in half by its long axis, a line that runs through its longest dimension, each half is exactly the same. An ellipse is also symmetrical when divided in half along its short axis, which is the shortest distance, or depth.

Symmetrical ellipses are difficult to draw freehand. When I first started drawing them, I had to struggle to get them right, and I found instructional information hard to comprehend. Now, after many years of practice, I can sit down and correct my students' drawings—and hear them comment on how easy I made it look.

The only really "easy" way to draw a perfect ellipse is to trace an elliptical template, but this method does not help you develop the skill to draw ellipses freehand or to construct them in

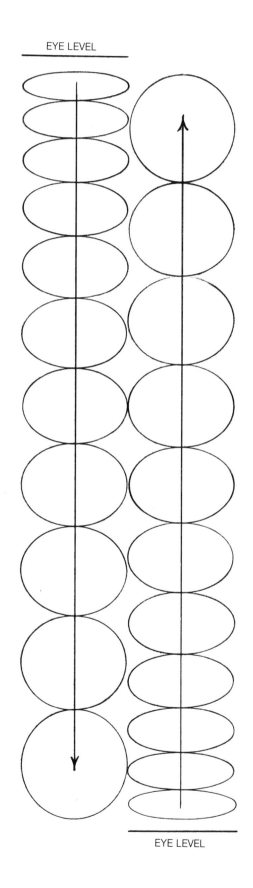

EYE LEVEL

EYE LEVEL

any size or from any angle of perspective. The techniques presented in the next seven projects, however, will help you to learn to construct ellipses in a variety of drawing situations. By practicing these methods, you should eventually feel confident enough to try drawing complex symmetrical objects made up of many different sizes of ellipses.

Before going on to the projects, I will explain how to construct an ellipse—for once you understand the basic construction of ellipses, it is a fairly simple matter to construct symmetrical objects which contain ellipses, using the methods which will be demonstrated in the projects. First I am going to illustrate the framework on which an ellipse is built. Next I will show cylinders at various angles which utilize this foundation or preliminary framework. At the same time I will show how to avoid some of the mistakes most commonly made by students, both beginners and advanced.

The diagram above, right, shows the framework around which I will construct a cylindrical object. The long vertical line (A) is the center line and establishes the direction in which the cylinder will be positioned. The horizontal line (B), which is perpendicular to it, is the long axis of the ellipse to be constructed; it determines the width of the ellipse. An ellipse also has a short axis (C), which is a segment of the center line and determines the depth of the ellipse; this axis is always perpendicular to axis B. The center point, where the long and short axes intersect, divides each of them exactly in half.

Now I construct a cylinder over my basic framework (see diagram at right), drawing the sides by connecting the ends of axis B to the parallel line directly below it. Next I construct the top ellipse with smoothly curving lines which connect the ends of axes B and C. I do the same thing for the bottom ellipse, drawing "through" the cylinder with a dotted line and creating a slightly rounder ellipse because of its distance from eye level. Notice that the ends of axis C determine the deepest portion of the ellipse and therefore the fullest curve. The ends of the long axis determine the smallest curves of the ellipse. The rounder the ellipse, the rounder the ends; the shallower its depth, the sharper the ends. Re-

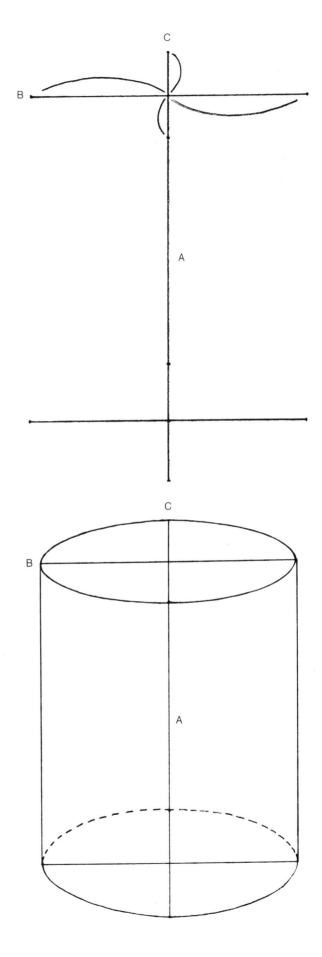

member that these ends are not points, however, nor are they oval; the narrowest curves of the ellipse flow smoothly into the fuller ones at axis C.

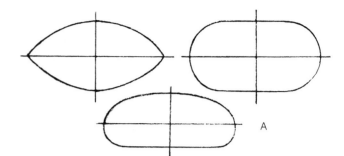

A

The diagrams at right show some of the most common mistakes made by students when they try to construct ellipses. Frequently an ellipse is drawn as if it were shaped like a football, a loaf of bread, or a hot dog (A). The football-shaped ellipses at the top and bottom of cylinder B are pointed at the ends. Notice also that the bottom ellipse is shallower than the top one, which should not be the case if the artist is looking down at the cylinder, as implied here. Because the bottom ellipse of such a cylinder is farther away from eye level, it should be rounder than the top one, not flatter. Cylinder C resembles a piece of bologna sliced off at an angle. The reason is that the long axes of the ellipses are not drawn perpendicular to the center line. The ellipse on the left is obviously out of alignment, but if you look carefully at the one on the right, you'll see that it too is slightly askew.

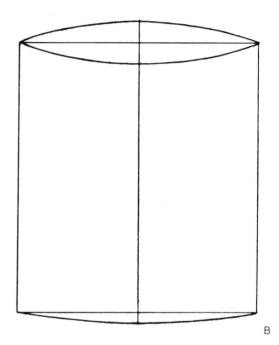

B

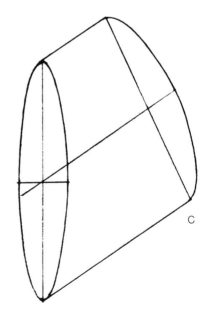

C

The final diagrams show how the ellipses and cylinders in the preceding example would look if they were drawn correctly. If you compare these two illustrations carefully, you will begin to understand the importance of the center line and axis lines in constructing an accurate elliptical shape. The ellipsis, A, has been drawn with a smooth, continuous curved line so that it no longer resembles a football; notice that the halves on either side of the intersecting axes are exactly the same, or symmetrical. Cylinder B now has a deeper ellipse at the bottom than at the top, creating the illusion that you are looking downward, and the ends of its ellipses are correctly rounded. Cylinder C has been constructed with the long axes of the ellipses perpendicular to its center line; this causes the ellipses to tilt correctly according to the angle of the object.

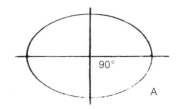

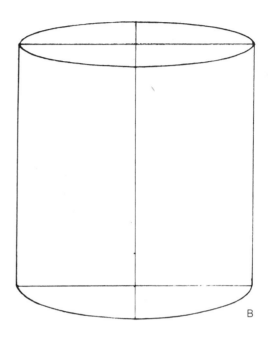

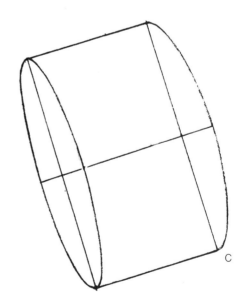

CUPS AND SAUCERS

The dishes, mugs, cups, and saucers I have selected for this project are simple in form but pose the problem of drawing ellipses of various sizes and at different angles in a basic still life. If you wish, you may substitute other objects such as glasses, cans, and paper tubes. Set them up in such a way that they tilt at different angles. Throughout this project you will use your pencil to determine these angles.

Step 1. Using an HB pencil on ledger bond paper, I begin roughing in my drawing, starting with the plate resting flat on the table. I establish its direction by holding my pencil in a vertical position until the plate is divided in half and then rough in this center line. Next I divide the bottom of the plate horizontally to establish the width or long axis of the ellipse. Using these guidelines, I now sketch my ellipse, approximating its size as I see it. I establish its depth in relation to the width by holding my pencil vertically at arm's length with its point at the rear curve of the ellipse and sliding my thumb up or down the pencil until it is lined up with the front curve. Retaining this measurement for the depth, I turn my pencil horizontally until its tip is lined up with one end of the plate. Now I move my depth measurement horizontally across the width until I have determined how many depths there are in the width. If my drawing has the same proportions, I have sketched the plate correctly. I construct all the ellipses in the plate, using a new long axis for the rim, which is at a different height relative to eye level. The vertical center line remains the same. I go on to rough in the rest of the ellipses, establishing a long axis for each one and retaining balance and symmetry. Remember that each ellipse in the cup should become slightly rounder as it drops farther from eye level. I draw the cylindrical mug on the left by holding my pencil horizontally and tilting it until it divides the cup in half lengthwise; I also notice where this center line touches the cup that is resting on the plate. Once the front ellipse of the mug is roughed in, I add its sides, which follow the direction of the center line but converge slightly and create the illusion of depth. I determine the back ellipse by sketching in what I can see of the bottom of the mug inside the first ellipse. Using the same procedures as before, I construct the other objects in the grouping.

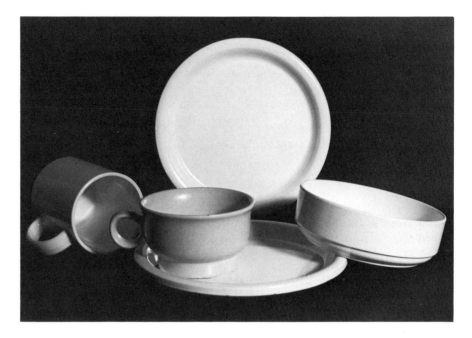

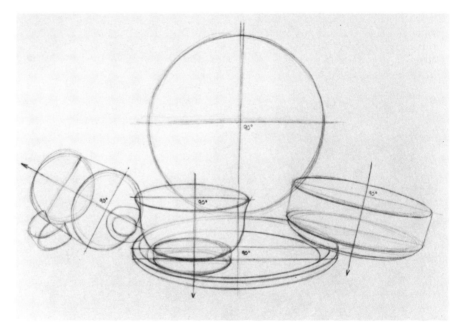

Step 2. Having completed my rough block-in drawing—the most important segment of this project—I now begin to refine it. With a kneaded eraser I begin erasing my first construction until only a slight indication of it remains on the paper. Changing to a 2B pencil, I start to reconstruct the still life, making a cleaner, more accurate drawing. To refine the ellipses and the shapes of the objects, I draw the center lines with a ruler. This step helps create exactness and makes the still life easier to read.

Step 3. Now I eliminate center lines and axis lines with the kneaded eraser. I add refinements, such as ellipses to indicate thicknesses, and draw the handles in detail to create more interest. I give the drawing more character by leaving some of the ellipses—such as the front curve of the cup and the inner ellipse or the plate that's propped up on edge—unfinished. Being selective about which lines to emphasize expresses more of my own feelings about the subject I am drawing. Finally, I erase any smudging which may have occurred during the drawing and spray workable fixative on the finished still life.

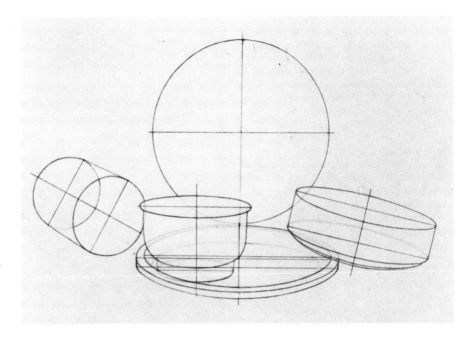

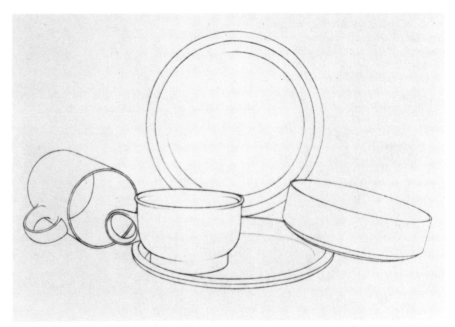

CREATING SYMMETRY WITH TRACING PAPER

A symmetrical object can be divided exactly into two halves of equal proportions. Each side, with the exception of surface additions such as handles, spouts, and so on, is an exact duplicate of the other. When you are drawing an extremely difficult subject that is symmetrical, you can eliminate a great deal of frustration by using the tracing paper method to construct it. The method is this: once you have roughed in the object as accurately as you can, you decide which side is drawn more correctly and, taking care to retain the center line, erase the other half. By tracing the remaining side, flipping over the tracing, and transferring it to your drawing, you can duplicate it precisely. Many people are reluctant to use this method, saying that it is too mechanical or that it is deceptive; however, I feel it is very helpful in achieving accurate drawings. Keep in mind that with this method you must still construct an accurate drawing first; use the tracing paper only if a problem arises in making both halves symmetrical. If your drawing has been done haphazardly and the object is drawn incorrectly in the first place, you are likely to magnify your mistakes with the tracing paper method. But don't overestimate yourself—if it helps, use the tracing paper.

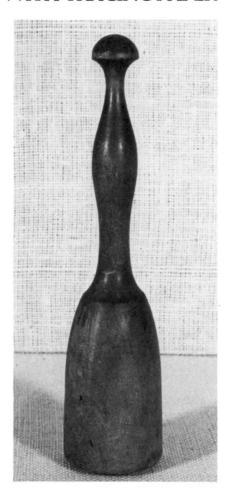

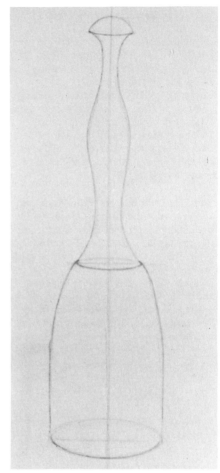

Step 1. Using ledger bond paper and an HB pencil, I sketch a center line and then begin roughing in the shape of the wooden mallet. By constantly working on both sides of the center line, I am able to maintain a certain amount of symmetry in my drawing, even at this stage. Axis lines help me to rough in symmetrical ellipses, which become rounder toward the bottom of the object as it moves farther away from eye level.

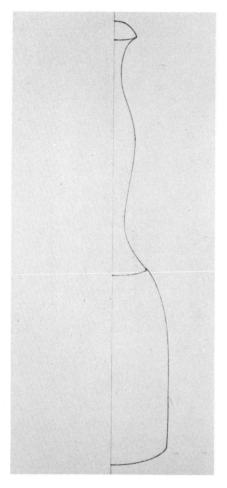

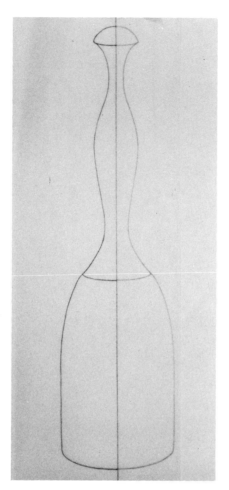

Step 2. Before I decide which half of my drawing to erase, I refine the object as much as I can, sharpening its contours and erasing all guidelines but the center line. The process of refining the shape of the object actually helps me determine which side should remain, and I decide that the right side conforms more closely to the actual object. I erase the left half, leaving traces of the center line, and then construct a new center line over its "ghost," using a ruler for greater accuracy.

Step 3. I attach a piece of tracing paper to the right side of my drawing with masking tape, making sure it is large enough to cover the object. Using a ruler and a sharp, soft-leaded 2B pencil, I begin by tracing the center line carefully. Then I put aside the ruler and trace the rest of the object. I remove the tape, flip the tracing over, and realign the two center lines, making sure that both halves of the object line up. I secure the tracing paper once again with tape to prevent its slipping, change to a sharp 2H pencil, and go over the center line and the lines of my tracing. The soft graphite of my original tracing now acts as a carbon sheet and leaves a faint impression on my drawing paper as I retrace it.

Step 4. I remove the tracing paper and, using an HB pencil, refine the lines I have just transferred to the left side of my drawing. I erase the center line, clean any smudges from my paper, and the drawing is finished. As usual, I protect it from smudging further by spraying it with workable fixative. By using the tracing paper method, I have ensured that the object I have just drawn is as symmetrical as I can make it.

SYMMETRICAL CANDLESTICKS

This project is intended to give you practice in using the tracing paper method to construct more complex symmetrical objects. I have composed a setup of several kinds of candlesticks which vary in complexity and proportion, but each of them requires careful attention to proportions on either side of its center line in order to draw its exact curves symmetrically. The tracing paper method will enable you to draw a similar setup of symmetrical objects with greater accuracy and less apprehension. If you don't have candlesticks, other symmetrical objects will suffice as long as they pose a challenge. If you are not yet comfortable with the tracing paper method, you may want to start by drawing a group of simple objects such as drinking glasses and then progress to more difficult ones like these candlesticks. After completing the tracing, you may find your drawing is no more accurate than if you had drawn it freehand; if so, it will prove you have a keen eye.

Step 1. To begin, I establish the direction of each candlestick by holding my pencil in a vertical position and then horizontally, transferring these directional center lines to my paper with an HB pencil. This also gives me an idea of the angles of the receding candlestick. Next I block in the objects, breaking them down into a series of basic shapes. I start with the candlesticks closest to me and work toward the back of the still life. Since I am drawing symmetrical objects, whatever is drawn on the left side must also be drawn on the right. Whenever my pencil point becomes slightly rounded, I renew the point on my sanding block.

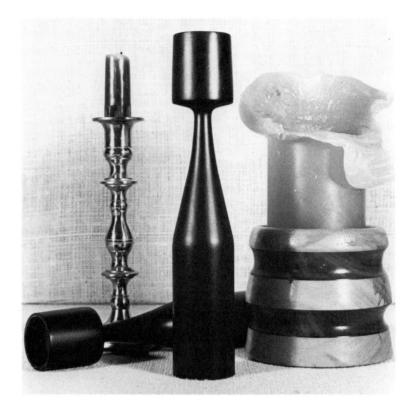

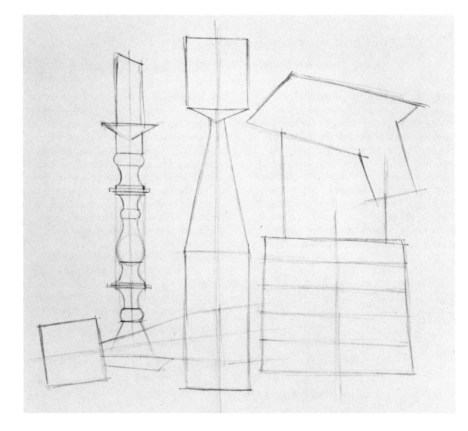

Step 2. Wherever a horizontal line has been drawn in the initial sketch, I construct an ellipse to give the illusion of roundness. This also puts the candlesticks in proper perspective. Remember, eye level is the artist's direct line of sight when looking straight ahead; ellipses become slightly rounder the farther they are above or below eye level. This is particularly noticeable in the large candlestick on the right.

Step 3. I begin to refine my sketch now, using an HB pencil and a ruler to draw the center lines. As I go over the contours of the candlesticks, making them more exact, I erase my original guidelines. The refinement of each object makes it easier to determine which half describes it better, and the next thing I do is erase the half that I no longer need. I tape pieces of tracing paper over each object; then I trace each one with a 2B pencil, as shown in Project 10, beginning with the center line (this will be my guideline in the next step). At this stage I complete the melted wax of the large candle on the right by drawing irregular lines to capture the character of its contours.

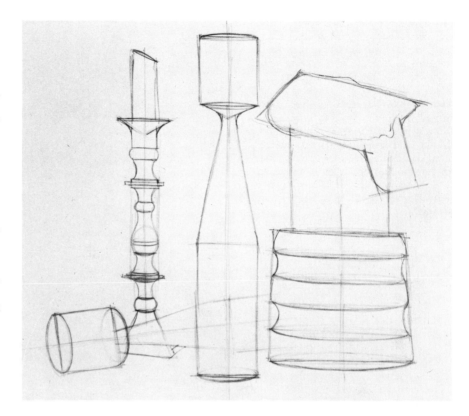

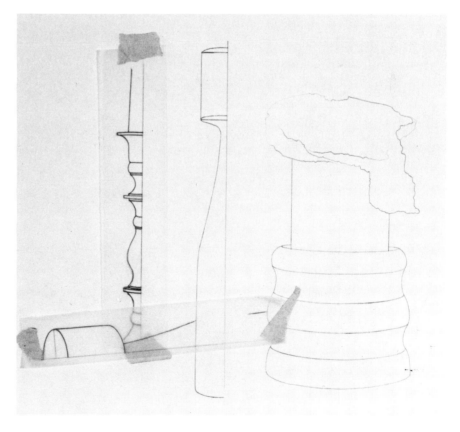

Step 4. After all the tracings are made, I flip them over, line up each one with its center line and tape it in place, and transfer it with a sharp 2H pencil. The hard pencil, which retains a sharp point longer, enables me to transfer the graphite from the softer lead without using too much pressure, and therefore I don't run the risk of leaving indentations on the paper.

Step 5. When I have completed transferring all the halves, I begin to refine my drawing with an HB pencil. I make sure the halves of each candlestick connect, the straight lines are straight, and the ellipses are smooth, flowing curves. Now the center lines can be erased and the completed drawing sprayed with fixative to prevent smudging.

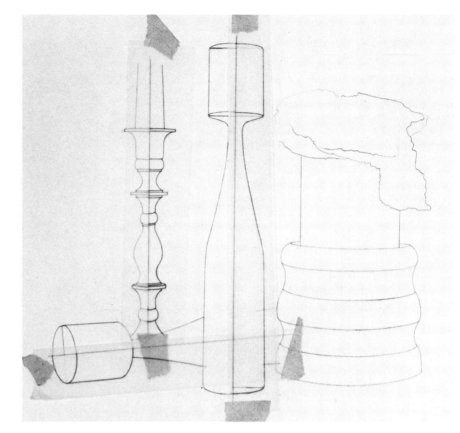

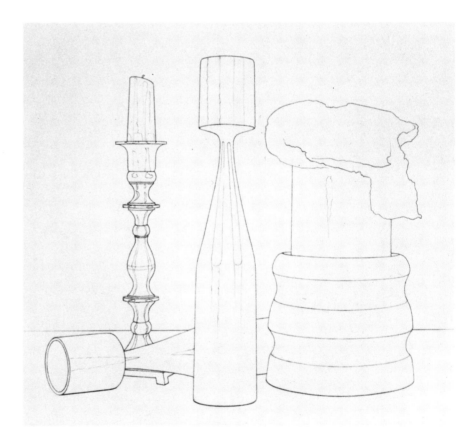

CONSTRUCTING AN ELLIPSE: THE DOT METHOD

At this point some students are able to conquer their problems in drawing ellipses, while others continue to struggle—drawing hot dogs, footballs, and loaves of bread for ellipses in their still life drawings. Objects that contain smaller ellipses usually can be drawn with a reasonable degree of accuracy if a student devotes enough time and practice to this aspect of still life drawing. Larger ellipses also can be drawn correctly if care is taken with them, but for some reason mistakes tend to become magnified in a large ellipse.

The dot method is a technique for plotting the curves of an ellipse exactly, and it's particularly helpful for constructing a large ellipse. Like the tracing paper method, the dot method is a me-

chanical aid, and some people may feel that using it in still life drawing is "cheating." However, for extremely precise sharp focus drawing, which is better: a beautifully rendered drawing with poor ellipses, or a beautifully rendered drawing with perfect ellipses?

In this project I am going to demonstrate how to use the dot method by simply constructing one large ellipse on a sheet of ledger bond paper. If you are using this method to construct an ellipse in an actual still life drawing, where you want to minimize erasures, you may prefer to construct your ellipse on tracing paper first and then transfer it to your drawing.

Step 1. I begin by establishing the width and depth of the ellipse, and then I block in the long and short axis lines freehand, using an HB pencil. I don't use a ruler because after I rough in my ellipse, the axis lines may no longer be in the exact center; it may be necessary to move them to accommodate the ellipse. (After all, it's easier to change straight lines than to construct a whole new ellipse.) Now I rough in the ellipse, keeping it as symmetrical as I can.

Step 2. I erase the sketched axis lines and ellipse just enough to leave light traces of them on my paper; then I use a ruler to create a more precise long axis line. Next I want to find the exact center so that I can put in the short axis. If the long axis is measurable and the exact center can be located easily on the ruler, this is the best way to find the center. If the ruler's markings do not coincide with the exact measurements of my axis line, as in this case, I use an alternate method: along the straight edge of a piece of scrap paper, I mark a dot at each end of the long axis, fold the paper so that the dots coincide, and then mark a dot in the crease. When I unfold the scrap paper and place it alongside the long axis I have drawn, I can mark the exact center. I construct the short axis in a similar manner but use one half of the short axis to determine the length of the other half. I align the edge of a piece of scrap paper more or less with the "ghost" of the short axis, making sure it is perpendicular to the long axis, and mark one dot on it at the front, or lower, curve of the ellipse and another at the center of the long axis. Then I line up the scrap paper so that one dot is at the center and the other is at the back, or upper, curve of the ellipse and mark this spot on my drawing with a dot. I connect the ends of the short axis with a straight line, using a ruler for accuracy, and now both the long and short axes are established. Each one is divided exactly in half.

To construct my ellipse, I first align the straight edge of a fresh piece of scrap paper with the long axis. I mark a dot at the left end (A) and another at the center (C). Keeping point C aligned with the center, I swing the other end up until the edge of the paper touches the top of the short axis and mark a third dot (B). My scrap paper should now have dots A, B, and C. The long axis line on my drawing will be known as line A, the short axis will be line B, and the center point, C. Starting with dot B at the exact center and dot A touching the short axis (line B), I slide dot B just a little away from the center along the long axis (line A) and swing dot A over to touch the short axis again. I mark a dot on my drawing next to dot C and move my scrap-paper guide a little farther from the center, still making sure that dots A and B are touching the axis lines before I mark the next dot on my paper. I continue in this way until I have indicated the curve of the entire ellipse with dots, placing the dots closer together at the shaper curves to guarantee that these curves will be nicely rounded. I connect all the dots with a smoothly curving line. Although I have plotted the entire ellipse here to demonstrate the dot technique, all you need to do is construct half the ellipse and then continue with the tracing paper method to establish the other half.

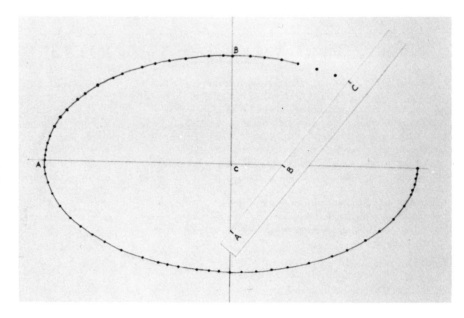

Step 3. I erase the ellipse I have just constructed, including the axis lines, but leave barely visible traces of the dots on my paper. Then I connect them with a smooth, curving line—I don't want to have any abrupt angles from dot to dot—and refine the ellipse until it is as perfect as I can make it. The dot method works well for constructing ellipses of any size or shape, as long as enough dots are used to create a smooth, accurate curve without any abrupt angles. Since this method involves a lot of erasing, I usually construct my ellipse on tracing paper and then transfer it to my drawing in a manner similar to the tracing paper method. This eliminates the risk of leaving indentations in the surface of the paper by inadvertently applying too much pressure.

RECORDS, REEL, AND ROLL OF TAPE

The setup for this project consists of three records, a roll of masking tape, a reel from a tape recorder, and a box. Although these objects are not complex, this exercise in drawing ellipses may be one of the most difficult because the objects are so flat. This makes it harder to determine their direction and therefore the placement of the center line. However, imagining that a disklike object is the top or bottom of a cylinder makes constructing it much easier. In this project I will use both the dot method and the tracing paper method; this will enable me not only to practice both techniques, but also to decide which is easier to use for each particular ellipse.

Step 1. Using an HB pencil and ledger bond paper, I start the construction by blocking in the box on which much of the setup rests. The direction of each object is determined by its relationship to the box—whether it is leaning against it, sitting on top or in front of it, beside it, and so forth. To draw the elliptical shapes, I begin by establishing the direction of each object—visualizing it as the top or bottom of a cylinder—and roughing in a center line. Next I draw a short axis perpendicular to each center line, and finally I rough in the elliptical shape. The arrows in my sketch indicate the direction of each object.

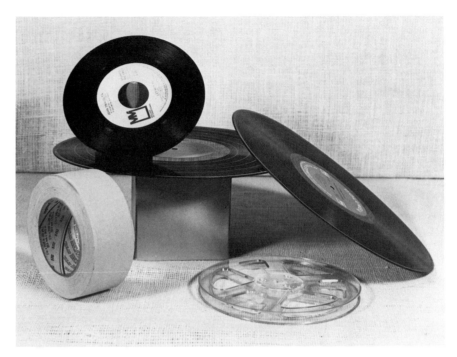

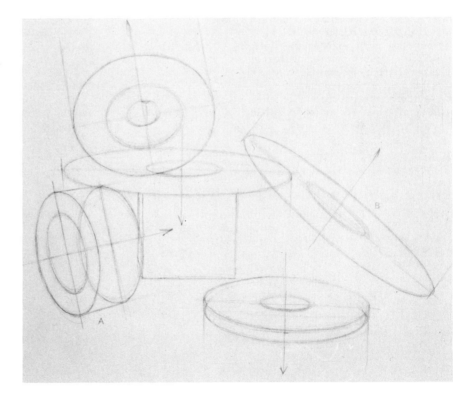

Step 2. Now I put in the center lines and the long and short axes more precisely with a ruler. I determine their exact centers by marking their lengths with dots on a piece of scrap paper and then folding it in half, as in Project 12. I make the short axes symmetrical by using the length of one half to determine the measure of the other half, again using dots on scrap paper as an aid. On a fresh piece of scrap paper I mark the distance between one end of the long axis (A) and the center (C) with a hard, sharp HB pencil. Then I rotate the scrap of paper until its edge aligns with the top of the short axis and mark this point (B) between A and C. Now, aligning dot A with line B and dot B with line A, I plot the curve of the ellipse, using dot C as my guide for marking the dots. Notice that the record lying flat on the box, the record propped against it on the right, and the tape reel each have one center line but different long axis lines for each separate ellipse. I have constructed the tilted record on the right entirely with the dot method, while only half the roll of masking tape on the left has been calculated in this way; this half has been traced and the tracing turned over, ready for transferring to the other half. Both methods are very exact.

Step 3. In this last step I erase and then connect all the dots, transfer my tracing, and then erase all the center and axis lines. I clean all smudges from the white areas of my paper and spray the drawing with workable fixative to prevent further smudging. The painstaking effort required for this project has been very tedious—but the end result is rewarding.

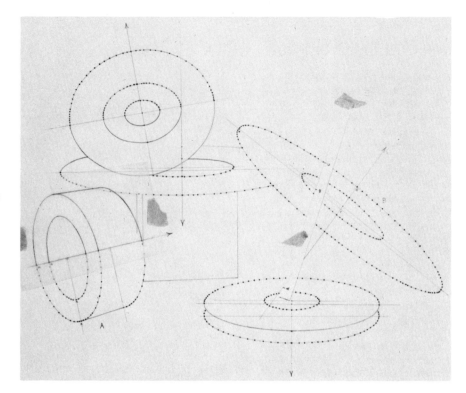

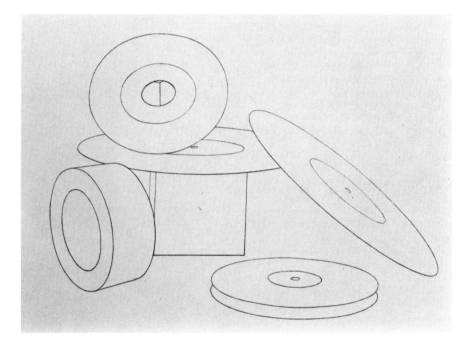

AERIAL VIEW OF BOTTLES

In this project I will be working with the third point in perspective, toward which vertical lines taper and ellipses become rounder. The ellipses drawn in the projects up to this point have been very shallow. This project will give you practice in emphasizing the illusion of depth. Foreshortening, which creates the illusion that you are looking downward, and the overlapping of ellipses become important factors in creating this illusion. For this setup I have chosen several bottles and a jug, which I place upright on the floor about two feet away from where I will be sitting. The largest bottle is positioned directly in front of me, and the others are placed on either side.

Step 1. Holding my ledger bond pad in my lap, I construct a vertical center line for the bottle in front of me. For the small ellipse at the top, I rough in an axis line perpendicular to the center with an HB pencil. After roughing in the top ellipse and its thicknesses, I begin to add the neck of the bottle, working on both sides of the center line. For the shoulders of the bottle, I use another axis line to achieve the correct arch, which I connect to the sides of the bottle. The sides taper inward slightly toward the bottom to create the illusion of looking down at the bottle. Where the sides of the bottle meet the bottom ellipse, I add another axis line to enable me to construct the base more easily. I study the negative space around the front of the bottom ellipse in order to position the base correctly in my drawing.

Each bottle, whether it is to the left or the right of the center, will lean in slightly, depending on its distance from the center. To determine the angle of each one, I hold my pencil parallel to the floor and tilt it slightly to the left or right until the bottle is divided exactly in half. Once I have established the center line, I must use an axis line for each ellipse I construct. Remember, center lines and axis lines are always at right angles to each other.

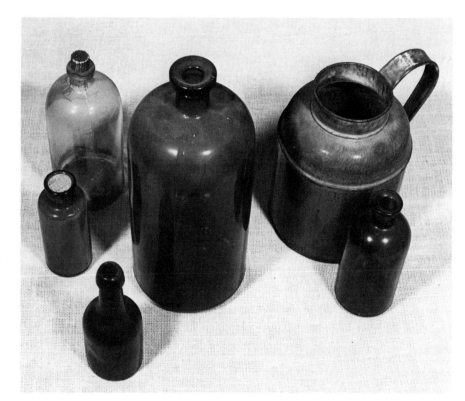

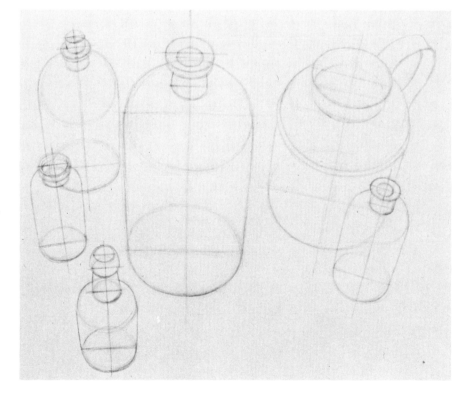

Step 2. Now I refine the center lines, using a ruler to make them more precise. After determining which half of each bottle is more accurate, I erase the unwanted half. I tape a piece of tracing paper over the half to be transferred and trace the center line and then the bottle with a sharp 2B pencil. When I've completed the tracing, I turn it over and place it over the blank half, lining up the center lines where the two halves connect. I secure the tracing with tape and begin transferring it with a hard 2H pencil. I follow this procedure for all six bottles in order to achieve exact symmetry.

Step 3. I remove the tracings from the bottles and begin to refine the lines, making sure the halves connect smoothly and the ellipses are true. With irregular lines I add texture to the cork and delineate the reflections on the bottles to convey a better sense of what they are. My drawing is now complete. After cleaning the white areas of my paper with a kneaded eraser, I spray workable fixative on the drawing to prevent smudging.

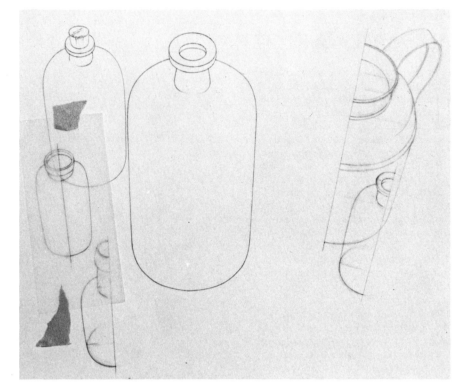

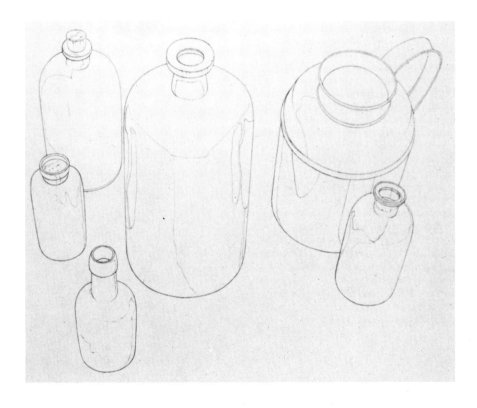

COMBINING THE TRACING PAPER AND DOT METHODS

This project combines all of the methods from this chapter in the construction of an accurate line drawing. My still life is composed of one object from each project. You may substitute simpler objects as long as they contain the same problems of construction. When dealing with the smaller and thinner ellipses, I am going to use tracing paper rather than the dot method. If you devote enough practice to drawing symmetrical objects, you can draw ellipses freehand without using either dots or tracing paper; but when size becomes a factor, I suggest you use one or more of these drawing aids until you are very sure of your drawing abilities. I use the dot method very little now, but I sometimes refer to the tracing paper method.

Step 1. Starting with the large container, I block in the objects, using an HB pencil on ledger bond paper. My reason for starting with this container is that it is the main object in the setup, and all of the other objects are juxtaposed with it. I draw a center line to establish the direction of the container and horizontal axis lines where ellipses will be added. Next I add the other objects, using center and axis lines and keeping my construction in its simplest form.

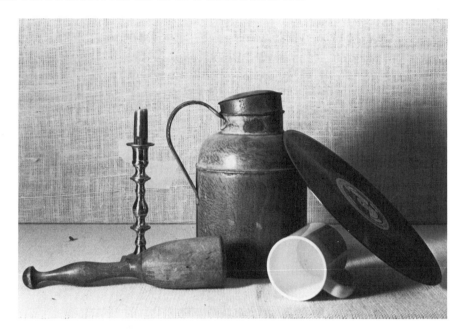

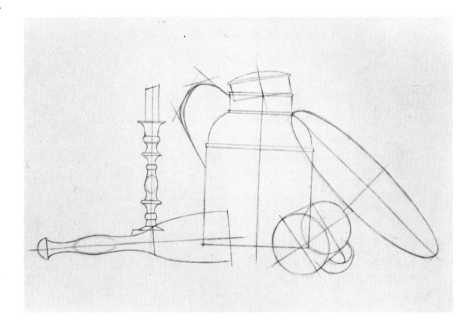

Step 2. To my simple preliminary sketch of the objects I begin adding ellipses wherever a horizontal or long axis line crosses the object's center. As I construct these ellipses, I increase their size through the short axis; this roundness creates the illusion that I am looking downward.

Step 3. Having positioned each object correctly and created a sound foundation on which to build, I erase my rough drawing and redraw the construction lines, using a ruler and an HB pencil. To make sure each half of an object is exactly the same, I place two dots on a piece of scrap paper, one at the center of the object and the other at the outside contour of one side; moving the paper so that one dot remains in the center and the other is on the opposite side of the object, I make sure the proportions are symmetrical. I add the curves, constantly working on both sides of the center line. For now, the cup and record are indicated only with construction lines; later I will use dots to establish perfect ellipses for them.

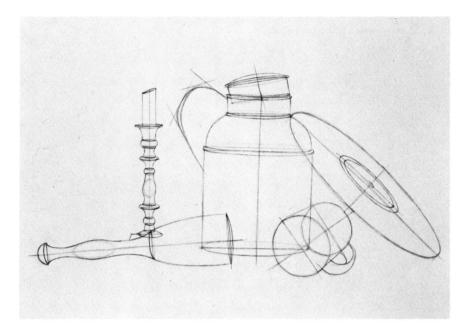

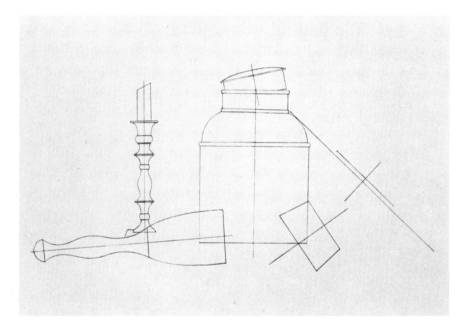

Step 4. Now that I have drawn all the structural lines, I begin adding ellipses to the candlestick freehand, increasing their roundness the farther down they are from the top. The lid of the container and the mallet in the foreground also contain narrow ellipses, and so drawing them freehand is easier than using dots. You will notice that the ellipses have been drawn all the way through the objects so that I will be able to make them symmetrical by comparing their curves. I construct the ellipses of the container, cup, and record with the dot method, marking off points A, B, and C on a separate strip of fairly stiff paper (bristol is good for this) and establishing half of each object with dots. The dots must be made with a very sharp, hard pencil—preferably a 3H—to leave a faint but accurate pattern.

Step 5. After I connect the dots, the objects are recognizably elliptical. I erase half of the candlestick and mallet, leaving the half which better represents the shape of each object. After erasing the right side of the container, I trace the more accurate half (including the center line) with a 2B pencil; then I flip the tracing paper over and transfer it to the right side with a sharp 3H pencil.

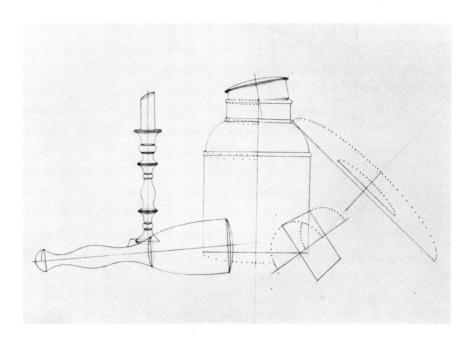

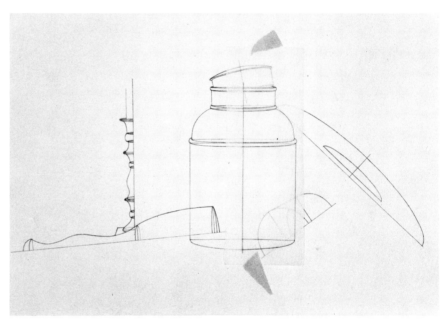

Step 6. In the same manner I complete each of the other objects, renewing the sharp point of my 3H pencil frequently on a sandpaper block so that the tracings will transfer precisely. Each object appears to be perfectly symmetrical. Had I made even the slightest mistake in using the dot and tracing paper methods, or if the long axis of an object were not perpendicular to its center or direction line, such a mistake would have been magnified and would be very noticeable at this stage. In such a case it would be necessary to erase my mistake and start the procedure over again from Step 3.

Step 7. I finish my drawing by erasing all the construction lines, refining the contours of the objects, and drawing ellipses which indicate the thickness of the record, the cup, and the rim of the candlestick. I add handles to the container and cup, and I indicate surface textures and reflections. After I've cleaned the white areas of the paper with my kneaded eraser, I spray workable fixative over the finished drawing.

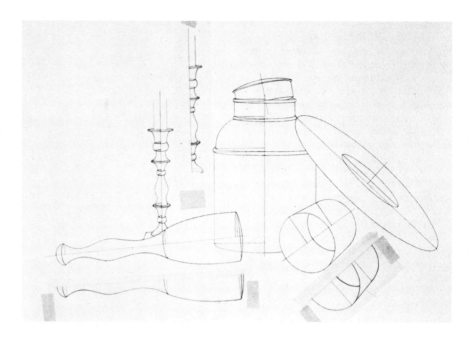

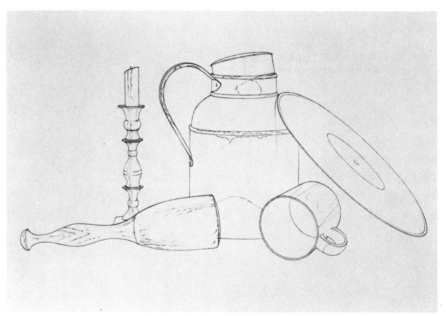

PROPORTION

By now it should be easier for you to draw objects that are recognizable, but grouping them together in such a way that they have accurate proportions in relation to one another is another bridge to cross. In this chapter I will introduce two new methods of drawing which will help you to position objects correctly without guessing. The first method employs checkpoints to determine size and spatial relationships, and the second, negative space (the areas between, around, and adjacent to the edges of objects). These methods, together with your new understanding of perspective can help you to achieve extremely accurate drawings.

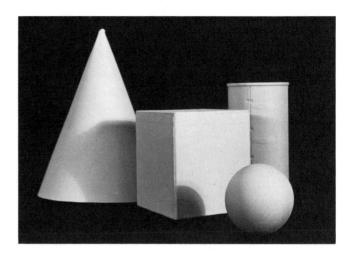

CHECKPOINTS

The term *checkpoints* refers to the use of vertical and horizontal guidelines to determine where objects are in relation to one another. Checkpoint lines should be used as you draw, so that you can keep in mind where each object is in relation to the first one drawn; apply them lightly so that they can be erased easily after the picture has been completed. After the first object in a still life has been drawn, it is simple to find its checkpoints, beginning with the horizontal ones. First look at the actual subject; then, holding your pencil horizontally between thumb and forefinger (at arm's length, of course), plot a line which hits the object to its right or left.

For a vertical checkpoint, hold the pencil vertically—again, at arm's length so that your viewpoint relative to the objects is always the same—and then plot a vertical line, which will determine where an object in front of or behind the first one will be placed.

The basic still life shown in the photograph above will be used to demonstrate the use of vertical and horizontal checkpoints in a simple manner, relating each object to the others in the setup. You may use this photograph to practice using checkpoints, or set up a grouping of your own; either way, it is essential to become familiar with using checkpoints if you are to achieve accuracy in your drawings.

The first drawing shows how you can use horizontal lines as checkpoints. A horizontal line is drawn at the top and bottom of each object in order to determine its height in relation to the first object drawn, for a more accurate representation.

The second drawing shows how vertical lines are used to establish the width of the objects in relation to the sphere. When these vertical lines are used with horizontal ones, they help you to sketch the objects correctly in place.

NEGATIVE SPACE

Another way of determining the correct proportions and placement of objects is by referring to the negative space, the area outside the perimeters of the objects. By studying the shape, size, and location of the areas around and between objects before you begin to draw, you will be able to visualize the objects themselves much better. The negative space in the setup shown at top right tells a lot about the size, proportions, and placement of the objects within it.

In the second picture the negative space is shown in black so that it can be seen more easily. Notice how it defines the shapes of the objects as well as their relationship to one another.

The third illustration is a finished drawing of the setup. After I studied the negative space, I roughed in the shapes and placement of the objects in line. Then I refined the lines to describe each object completely, differentiating one shape from another and showing the spatial relationships between them. Yet if I were to black out the negative space in this picture, it would correspond very closely to the negative space shown in the previous example.

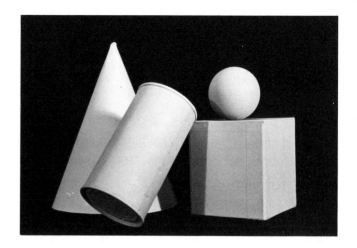

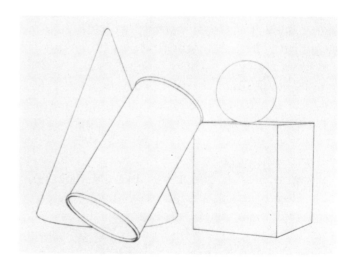

USING CHECKPOINTS AND NEGATIVE SPACE

In this project I am going to redraw the setup from Project 4—but this time, by using checkpoints and negative space to guide me, I'll draw it much more accurately than before. Compare the photograph of the setup with the finished drawing below it. What errors in proportion and placement do you find? How does the negative space differ? How much of the cube's side planes can be seen, and where is the bottom edge of the cylinder in relation to the cube? Your new knowledge of checkpoints and negative space should enable you to spot several errors immediately; it should also start to show positive results in your own drawing.

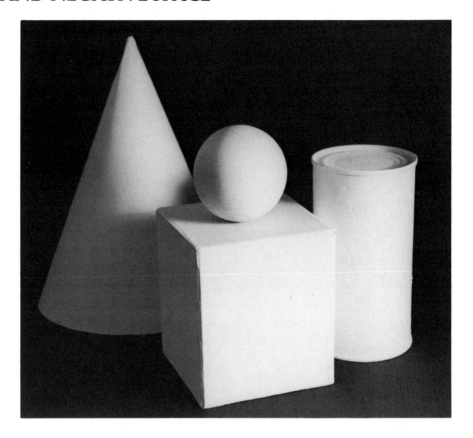

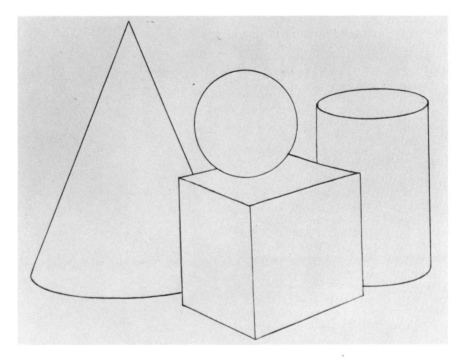

Step 1. I begin by roughing in the basic shapes, as I did in Project 4, using a sharp HB pencil on ledger bond. First I establish the main vertical of the cube; then, holding my pencil horizontally, I tilt it until it coincides with the baseline of one side plane; I also try to visualize the shape of the negative space created by this angle, which helps me record the angle on my paper more accurately. I continue this procedure until the entire cube has been roughed in.

Now I align my pencil with the left side of the cylinder to determine where it meets the top of the cube, and I transfer this vertical line to my paper. As I go on to calculate the size and position of the right side, I estimate where the top and bottom of each side are in relation to the cube. Then I draw horizontal guidelines connecting the two sides at the top and bottom. These guidelines will help me develop the ellipses in the next step, but at this stage, they serve as checkpoints. The top line is about half an inch higher than the uppermost edge of the cube, and the bottom horizontal intersects the right side of the cube about three-quarters of an inch above the bottom right corner.

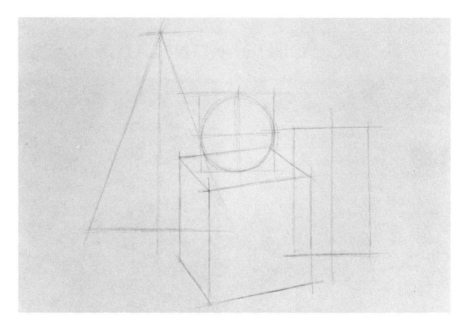

I visualize the vertical axis of the cone, holding my pencil vertically at arm's length, and gauge its approximate distance from the cube; then I construct it on my paper, drawing a vertical guideline about half an inch from the left edge of the cube and taller than the cone actually will be. Next I line up my pencil with the angled side of the cone to visualize its slope and also the place where it intersects the cube; I also hold the pencil horizontally at the tip of the cone to determine its height—it is about one and a half times taller than the main vertical of the cube—and locate this spot with a small mark on my paper. I calculate the left side of the cone by referring to the right side, since the object is symmetrical. I draw a horizontal guideline for its base, just as I did with the cylinder.

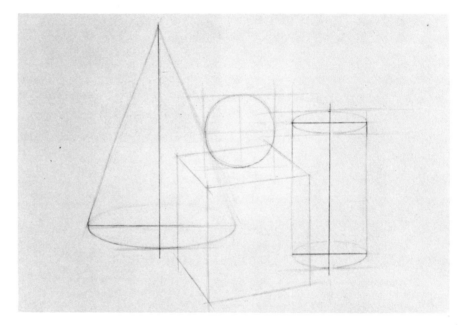

Finally, I locate the position of the sphere by studying its points of contact with the cone and the cube. I rough in a circle on my paper, construct intersecting guidelines to locate its center, and finally construct a box which helps me refine and round the circle. This exact square, with boundary lines that are equidistant from the center, enables me to create a circle within it easily without excessive erasures, which could tear the surface of my paper and make the drawing look overworked.

Step 2. Now I will construct ellipses for the top and bottom of the cylinder and the base of the cone, but before I begin to draw, I use my pencil to measure just how deep to make the ellipses. Beginning with the top ellipse of the cylinder, I line up my

pencil with the curved edge that is closest to me; I estimate its distance from the center guideline I drew in Step 1 and transfer it to my paper, where—because I am drawing on a two-dimensional surface—it appears somewhat lower than the horizontal line. I do the same thing with the back edge, which gives me a horizontal line *above* the center guideline. Now that I have established horizontal boundaries, I construct an ellipse within them, making sure that the proportions above and below the center horizontal guideline are the same, and that the curves on each side of the vertical guideline that passes through the center of the cylinder are also the same. I follow this same procedure for the ellipses that describe the bottom of the cylinder and the base of the cone. Although my drawing is still very rough, the still life is completely and accurately blocked in—and now it gives the illusion of roundness.

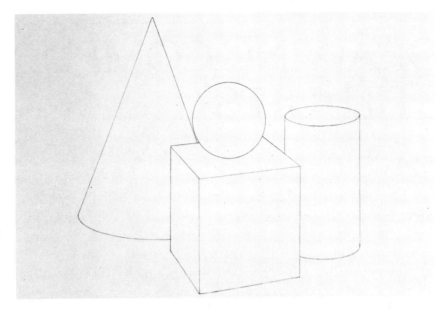

Step 3. In this step I clean up the rough lines of my drawing so that it is a clear, accurate representation of the subject. I indicate the top and bottom rims of the juice can, as well as the rings in its lid, with ellipses—notice that the front curves of these rings are partially hidden by the top rim. I also add "character" lines to the other objects, describing the rough edges of the cube and the cracks near the tip of the cone with delicate pencil lines. I erase all the original guidelines carefully and remove smudges from the white areas of the paper and my kneaded eraser, and then once again I clean the lines of the drawing itself. Finally, I spray the drawing with fixative so that it will not smudge.

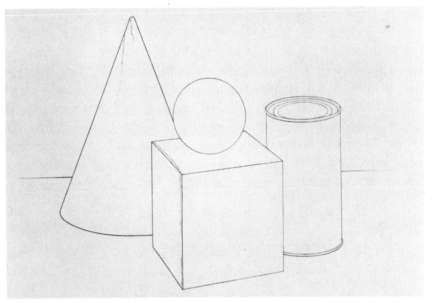

Step 4. When my drawing is completed, I place it alongside the finished drawing from Project 4 and compare the two. Right away I can see that I made some errors in placement and proportion in Project 4. The angle of the cube is drawn incorrectly, there should not be a space between the sphere and the cone, and the proportions of the cylinder are inaccurate. Overall, my new drawing of the same setup has a greater feeling of depth in addition to being a sharper, more accurate rendering of the objects. To do this project accurately, it is advisable to use the photograph in this book, as it might not be possible to duplicate your original setup from Project 4. It also might be difficult for you to establish the same eye level. The essential thing is to be able to compare your drawing with the original setup in order to find and correct your mistakes.

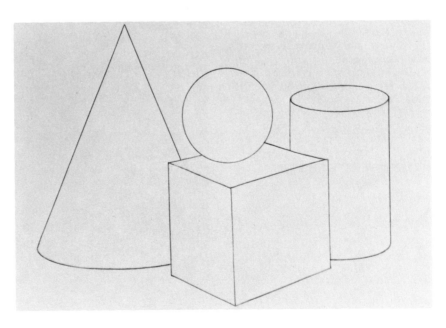

DRAWING COMPLEX STILL LIFES

The preceding chapters have presented a variety of projects and approaches to drawing which should enable you to draw basic shapes accurately. Now, with your newly acquired knowledge, you should be ready to try a thematic still life composed of more intricate objects. The next four projects will involve choosing objects which, when grouped together in a composition, are complex enough to create interest but can be drawn with the same methods you used in the simpler projects.

If you do not have or want to draw the objects I have chosen, you may substitute anything you like, as long as each still life has an overall idea or theme. For example, I have selected antique kitchen utensils to create the theme for Project 17. For Project 18 I have again chosen antique objects, as I have a preference for them and am fortunate enough to have access to antiques. But whether or not you choose antiques, it is essential to find objects that create an interesting picture. Every household has tools, which are recommended for Project 19. Whether you select a screwdriver, a hammer, or a saw, be concerned with creating an interesting grouping, and let these unlikely items engage interest as a unit. The shoes needed for Project 20 should also be easy to collect. Sandals, sneakers, dress shoes, and boots, whether men's or ladies', can be interesting because of their variety and their irregular forms.

As you do these projects, remember the basics. The objects are more complex, but begin each drawing the same way you began the previous exercises, by planning out your drawing and starting with basic shapes. This approach will allow you to progress in a rapid yet systematic manner.

PROJECT 17

ANTIQUE KITCHEN OBJECTS

When choosing my grouping, I select shapes that look good together. My setup for this project is based on the large bucket on the left, and everything else either repeats or complements its basic shape. The only truly complex object is the ice cream scoop, but when it is broken down into its basic shapes, it becomes a combination of rectangles and circles. When you construct your kitchen still life, you may use pots, pans, spoons, and even your favorite coffeepot, as long as your grouping is not haphazardly arranged. Your final picture should show that you have put some thought into the composition.

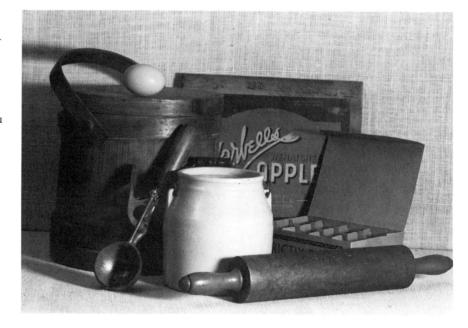

Step 1. I begin my drawing by sketching the center line of the rolling pin with an HB pencil on ledger bond paper. This enables me to achieve the symmetry and balance of that object right away. For each ellipse of the rolling pin, I draw a long axis line which I will use as a guideline, and I connect these axes to the sides of the rolling pin. Having the first object blocked in enables me to place the others by using vertical and horizontal checkpoints. I notice where each object touches other objects, as well as the various angles of negative space that their positioning creates. I establish these on my paper by tilting my pencil with the angle of the object and then transferring this angle to my drawing, as discussed in Chapter 5. When you start a drawing—even a complex one such as this—making a basic shape construction should always be the first thing you do. Think of the cylindrical rolling pin as three rectangles: a large one for the roller section and two small ones for the handles. Break everything down into its most basic shapes.

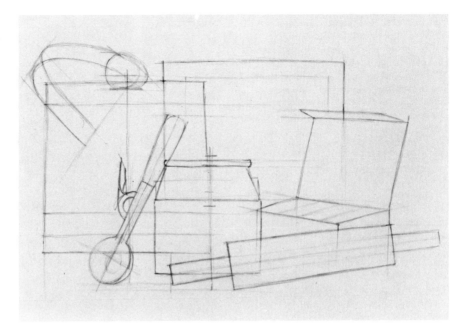

Step 2. Now that all the objects have been blocked in, I go back to the horizontal guidelines I blocked in for the bucket and the crock, and I use them to construct ellipses. I give shape to the handles of the rolling pin and add more details to the ice cream scoop. The objects are actually beginning to look as though they have form. I am still using an HB pencil, often rubbing the lead against my sanding block to maintain a needle-sharp point. Now I sketch the lettering on the sign. I have erased none of my rough guidelines, as I am not concerned about a clean drawing at this stage; rather, I want to concentrate on creating an accurate preliminary block-in.

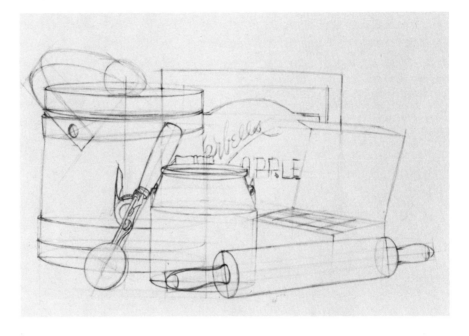

Step 3. After the fun and spontaneity of creating a quick representation of my kitchen still life on paper, I am ready to mold my rough sketch into a precise drawing—and the more detailed work begins. Cleanliness and accuracy are my main objectives now. I begin refining my drawing by erasing it, using a kneaded eraser and leaving faint indications of my block-in visible. After the drawing has been erased, I slap a clean cloth against the paper to remove any grit left by the eraser, so that I will have a clean surface on which to refine my drawing. Using my HB pencil, I begin working from front to back of the setup, refining the center lines with a ruler and constructing precise ellipses so that the irregularly shaped objects take on smooth, even curves. I always use a ruler in conjunction with the tracing paper method because it allows me to position the tracing paper more accurately when aligning the two halves of the object.

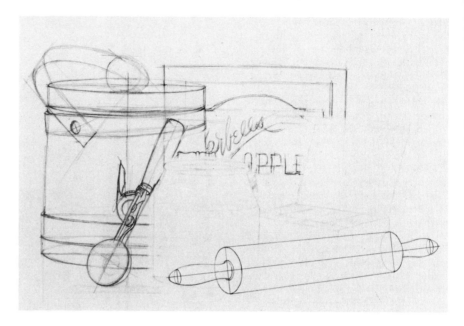

Step 4. The center line of each object has been refined with a ruler, ellipses have been smoothed out, and the lettering blocked in more accurately. Note that when I refine the block-in, I still draw the ellipses all the way through so that the foremost curves of the object can be compared with the ones in back for consistency. At this point my drawing is complete as far as placement is concerned.

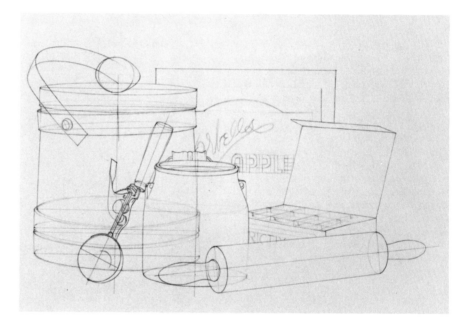

Step 5. To create exact symmetry in the objects, I decide which half of each object looks more like the original object, and then I erase the unnecessary half. I place tracing paper over the remaining half and secure it with masking tapes. With a ruler and a 3B pencil I trace the center line. Then I proceed to trace the rest of the object. I do this for the rolling pin, the container, and the ice cream scoop. This method can be used for every symmetrical object, and it should be used whenever exact symmetry is necessary; however, some objects can also be drawn by eye, without using tracing paper.

Step 6. I flip the tracing paper over, line up the center lines, and retape it to prevent its slipping. I am extremely careful when removing the tape so that I don't tear or lift part of the paper. I often apply the tape to my pants leg first to remove some of the stickiness. Now I redraw the lines, tracing them with a sharp 5H pencil. The pressure transfers the softer graphite from the 3B pencil to the ledger bond, leaving a faint impression which I will finally refine.

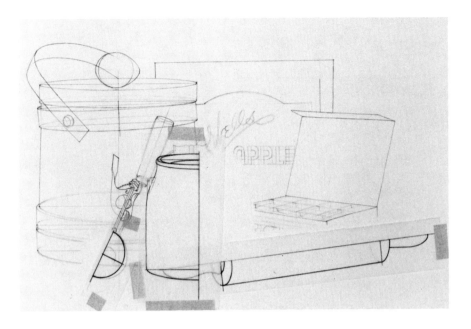

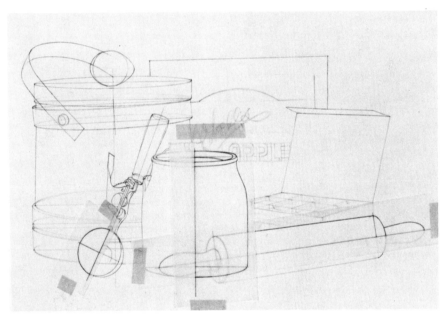

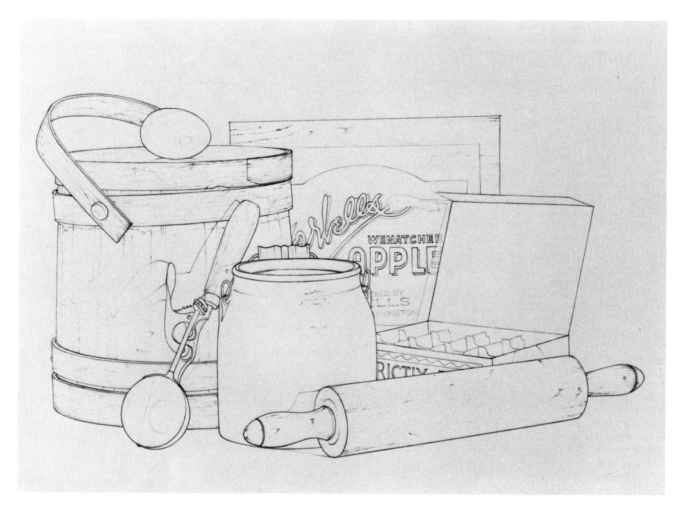

Step 7. I erase all sketch lines and add refinements. I finish the
lettering on the sign, and I indicate the wood grain, shadows, and
reflections. All of this adds to the realistic appearance of the
kitchen objects in this linear still life drawing. The last step is to
spray workable fixative on the completed drawing in order to
keep the lines from smudging.

SIX ANTIQUE OBJECTS

If you do not have any antique objects around your home, it would be to your benefit to borrow or buy just a few for this project and find out for yourself how interesting they are to draw. My own collection is constantly growing, and I enjoy the fact that my wife has placed many of these objects throughout our house. Of course, objects pertaining to another theme will suffice, since this assignment does pose the problem of availability; but try your hardest to gather a good arrangement, as that is part of this project. If you select other items, make sure they have character and good design; try to avoid plastic, streamlined objects which would produce a simple-looking drawing. For my still life I have chosen an ice-cream-making bucket, a top, an automobile horn, a bee smoker, a watering can, and an old egg-weighing scale.

Step 1. I begin the block-in with the watering can, drawing its most basic shape with an HB pencil on ledger bond paper. A horizontal line forms the base of the can, and I draw a center line perpendicular to it. Then I construct identical half circles on both sides of the center line to represent the basic cylindrical shape of the can. I locate the place where the spout connects with the half circle on the left and construct two lines which taper and angle toward the left. I determined this angle by lining up my pencil with it and then duplicating the angle on my paper. Constantly using my pencil to find vertical and horizontal checkpoints, I determine where each object is located in relation to the others, until all the objects are blocked in. At this stage in the drawing, I work from the front of the setup to the rear, constructing each object as if it were transparent. I use rough center lines to determine direction and create symmetry as I construct the most basic shape of each object.

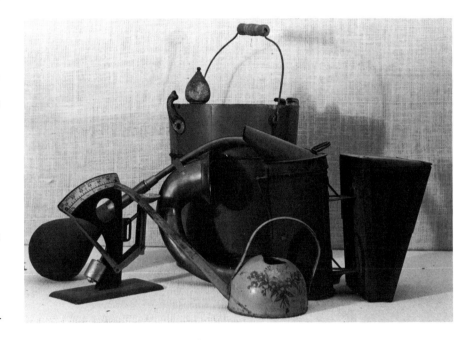

Step 2. With my HB pencil I begin adding ellipses and giving shape to specific sections of each object. While I am creating more realistic-looking objects, I am also concerning myself with their placement. This stage is still considered a block-in, however, so I don't make fine adjustments yet.

Step 3. Now I use my kneaded eraser to erase my still life until it is barely visible. With an HB pencil and a ruler, I redraw the center lines precisely. This helps me create exact symmetry as well as determine the correct direction of objects placed at an angle, as I redraw the setup over the traces of my original sketch with a sharp HB pencil. Now I have created a precise linear drawing of my antiques.

Step 4. In this step I want to refine the symmetrical shapes of the top, the watering can, and the bulb of the horn. These are the most crucial sections where symmetry is needed. Using the tracing paper method, I decide which half of each object is more accurate and erase the other half. With masking tape I secure tracing paper over the remaining halves and then trace over them with a sharp 3B pencil, using a ruler to construct the center lines. Accuracy is most essential if I am to achieve precise symmetry.

Step 5. I flip the traced halves over and secure the tracings with masking tape to prevent movement. I make sure the center lines are lined up exactly with those in the drawing. Even the slightest degree of misalignment will result in a drawing that isn't symmetrical. With a sharp 5H pencil I carefully transfer my tracings to the erased portions of the paper. Finally I remove the tracing paper and refine the forms on the drawing, and the symmetrical objects are completed.

Step 6. To refine my drawing, I remove any remaining lines with my kneaded eraser. I add subtle textures, patterns, and the numbers on the scale so that the various objects will look like the ones in my setup. These fine details help to create a more pleasing still life. Finally, I spray workable fixative on the completed drawing to prevent smudging.

MECHANICAL OBJECTS

This project is more complex than any other linear assignment in this book. Because the objects have many small, detailed parts, the initial block-in is crucial to achieving any degree of accuracy. When you do this project, you may prefer to choose relatively basic tools for your grouping. But remember, your proficiency will only be as great as the challenge you attempt to meet. In other words, if you consistently draw setups with only basic objects, your skill will not be adequate for more complex drawing problems. So, for this project, use a variety of mechanical objects. Be confident, and don't be disappointed if you make errors; you will learn from your mistakes. Before you read any further, look at the setup in the photograph and familiarize yourself with the tools I have chosen. In the center is a tube cutter. To its right is a plane, to its left a staple gun, and behind it, from left to right, are a framing clamp, a porcelain light socket, and a pipe wrench.

Step 1. I begin by blocking in the wrench and framing clamp with an HB pencil on ledger bond paper. This step differs from the first step of previous projects (I usually start with an item in the *front* of my setup), but because the other tools rest against them, these two objects are the foundation of my drawing. The wrench and clamp are made up of a series of geometric shapes (squares and rectangles). It is essential to draw them all the way through, using horizontal and vertical checkpoints, in order to place them correctly. Now I add the stapler, the plane, and the tube cutter by constructing boxes and then breaking down these objects further into their simplest shapes. I establish the light socket's direction by holding up my pencil and tilting it until the socket is cut exactly in half. This main center line is also my guideline for creating symmetry. Once it is established, I construct a short axis line perpendicular to it, and I can sketch in the ellipse at the correct angle. (See Chapter 4 if you need to refresh your memory on ellipses.)

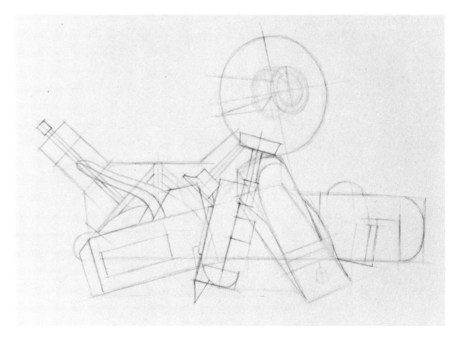

Step 2. At this stage of the block-in, I begin adding the various components which transform the basic shapes into real objects. For every form I add to my initial sketch, I use my vertical and horizontal checkpoints to determine where it lines up with the rest of the drawing. If the first object was constructed correctly, the other objects and their parts should line up easily. I try to keep the drawing light, however, so that the lines will erase cleanly later on, leaving no trace of any problems I might have at this stage.

Step 3. Now that my block-in is complete, I erase the entire drawing, leaving just a slight indication of the objects. Still using my HB pencil, I begin redrawing and refining lines, making slight adjustments in the curves and taking care to keep the straight lines straight. While refining my drawing, I keep a handkerchief under the pad of my hand to prevent my smudging the paper as I draw. When I have refined all the objects except the porcelain light socket, I go on and refine only its directional center line and the two axis lines for the width of the ellipses. It is important to make sure the direction line intersects the axis lines exactly in the center if I am to achieve precise symmetry.

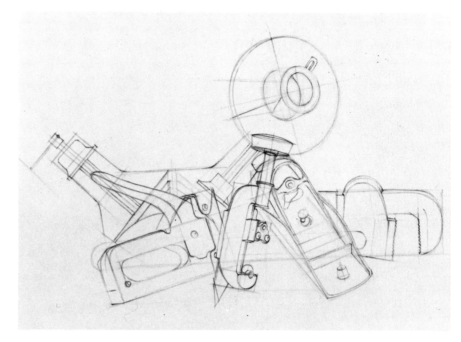

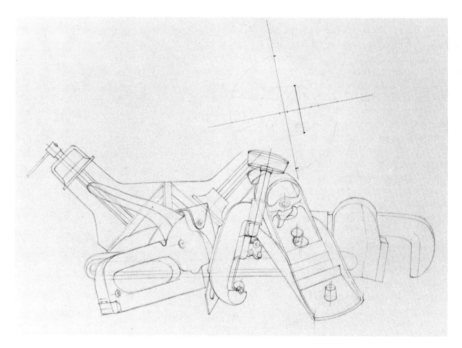

Step 4. I decide to use the dot method to construct the ellipses of the light socket. On a separate piece of paper I mark points A, B, and C. (Refer back to Project 12 if you have forgotten how to use this method of constructing precise ellipses.) Besides eliminating much frustration, the dot method enables you to avoid continuous erasing, which could ruin the texture of your paper and make your drawing look overworked.

Step 5. I begin adding the finishing touches, first to the light socket—I add the rings indicating thickness and draw the outlet for the plug—and then to the other objects. I add threads to the pipe cutter and framing clamp, and I give texture to each object. I also darken the lines of objects which overlap others to enhance the illusion that they are in front. This adds interest to the overall drawing. At last I spray workable fixative over the completed drawing to keep the results of all my hard work from smudging.

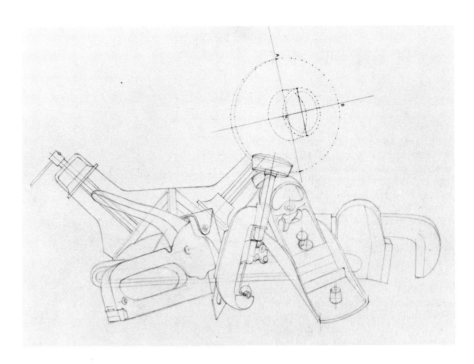

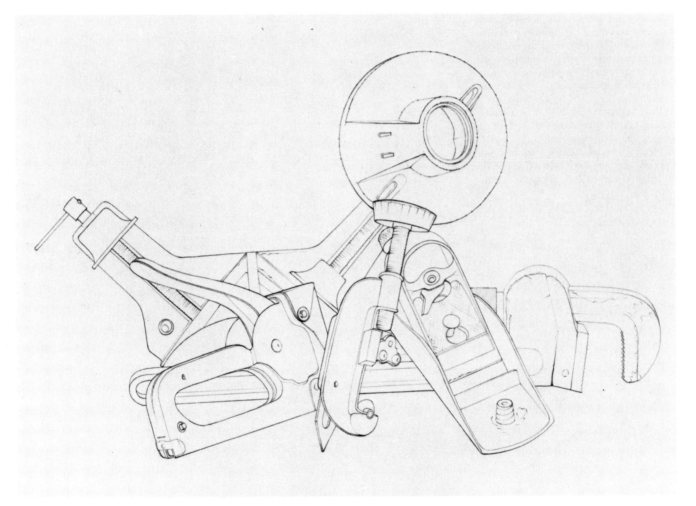

A STILL LIFE OF SHOES

There is a large variety of shoes to choose from when you compose your setup for this project. Boots, sandals, and sneakers, to name just a few, have their own character and contrast nicely in shape and size. For my grouping I've selected a boot, two types of high-heeled shoes, and two sneakers. When setting up your still life, arrange the shoes in a way that shows their form and character. Don't hide or distort any of them, or they will not appear realistic when you draw them. Use a variety of shoes and have fun; these props are exciting to draw.

Step 1. I start my block-in by establishing the placement of the boot in a sketchy fashion, using an HB pencil on ledger bond paper. I don't use center lines in this construction because the shoes are not symmetrical; they are free-form objects with curved and straight lines located in different areas. Holding my pencil in front of me at arm's length, I line it up with the angle of the upper portion of the boot and then rough in this angle on my paper. I go on to sketch in the other shoes, constantly using vertical and horizontal checkpoints to determine their size, proportions, and position relative to the boot. You will notice that I don't bother to erase these lines, because this is only a sketch and I am not yet concerned with making a finished picture. The drawing itself is sketchy, and the straight and curved lines are not precisely accurate.

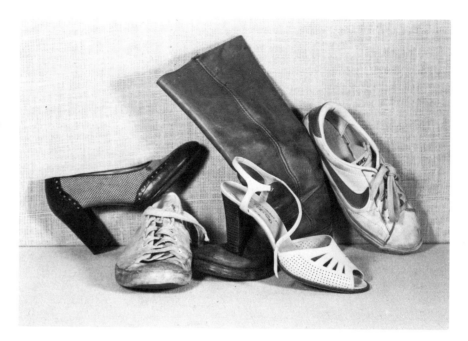

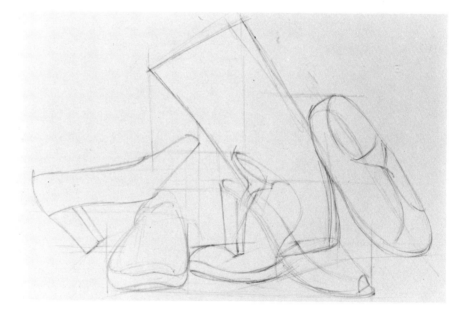

Step 2. After resharpening the point of my HB pencil on a sanding block, I begin adding the body of the objects. I add laces to the sneakers and patterns to the shoes, creating interest and giving each object its own character. Many times the beginning artist starts a drawing by fussing with refinements like these—instead of first drawing the basic shapes of the grouping—and therefore, when the still life is completed, nothing lines up and there are many obvious mistakes. As you draw, take one step at a time and line up small areas carefully, constantly using your pencil as an aid in aligning the various objects and their components.

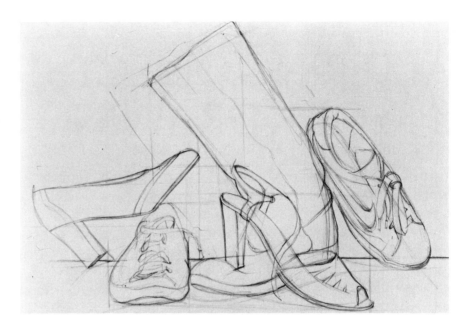

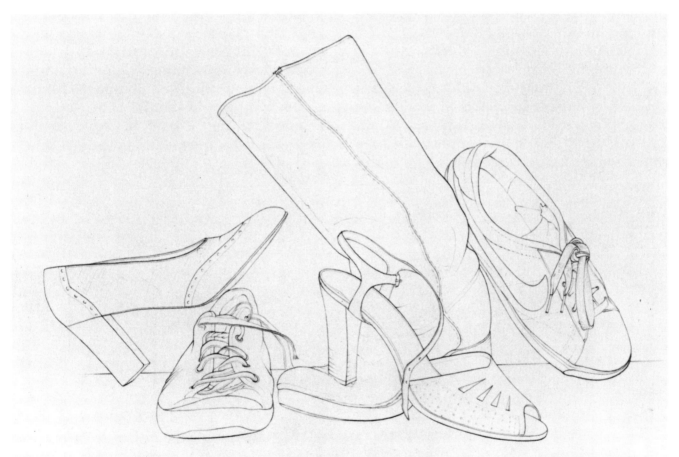

Step 3. Much of the drawing has been established in the first two steps. All I need to do now is refine it. I begin by erasing the entire construction so that only a faint impression is visible on the paper. With a sharp HB pencil I redraw and refine the shoes with one consistent, flowing line which describes the character of each shoe. I add further subtleties such as patterns and stitching to create dimension and greater interest in my still life drawing.

Here again, using a line that varies in thickness, as you can see in the lacing of one of the sneakers, helps to separate the objects from one another and also adds a little flair. A more consistent line also could be used, but this is a matter of individual taste. Finally, I spray workable fixative over the completed still life drawing.

ALTERING OBJECTS IN YOUR DRAWING

Up to this point I have been drawing the objects in the various projects as close to life size as the size of my paper permits. This chapter will show you how to make drastic modifications in size and in the angle from which an object is viewed. You will learn how to reduce large objects and enlarge small ones, as well as change the angle of an object by referring to photographs. (Since the photographs are often taken from catalogs or similar material, my term for these projects in altering perspective is *catalog drawings*.)

It is often necessary to make objects smaller when you draw them because of their sizes relative to the size of your paper. Although you will not often need to enlarge objects on your paper, it's a good idea to learn how to do it—and you will have fun with it. Small objects appear quite strange when enlarged because they have a

monumental feeling. It is quite astonishing to see a book of matches the size of a paperback book. The most difficult aspect of making such enlargements is incorporating enough detail into the object to keep the viewer's interest. When objects are reduced, however, many details may be eliminated without losing interest. Changing the angle of an object is much easier, of course, if you have that item and can simply study it from the required angle. But if you have only a photo from which to work, you should be able to alter the angle of the object as needed. You may never be in a situation where you are required to do this—unless you are an illustrator or commercial artist—but knowing how to do it will be useful in your own drawings, as it will enable you to make changes as freely as you wish.

REDUCING OBJECTS

For this project I use a sheet of ledger bond paper which has been cut to 11 x 14 in. (28 x 36 cm). The objects in my setup range from 9 in. (23 cm)—the child's boot—to 25 in. (64 cm) tall (the shoe form). Because the objects are larger than my paper, it is necessary to reduce them. When you do this project, what you have learned about proportion (Chapter 5) will play an important part in reducing objects correctly.

Step 1. On my paper I begin roughing in all the objects very lightly with an HB pencil. A rough overall sketch is especially important in this project, as it helps me avoid the risk of drawing one object in great detail only to find that I haven't left enough room for the rest of the still life. To create a relatively small drawing of large objects, it is essential that I make sure the first object is blocked in considerably smaller than its actual size. When the others are blocked in relative to it, they too will have scaled-down proportions and it is likely that everything will fit comfortably on the page.

I construct the rocking horse first, breaking it down into a variety of rectangular boxes. I start with this object because it is large and I can relate everything else to it easily. Next I add the basket, using a center line to determine its direction and axis lines for the front and rear ellipses. Then I add the boot inside the basket by constructing a rectangle for the top portion and a triangular shape for the foot area. I indicate the shoe form with a tall, slender rectangular shape topped by a triangle. Finally, I draw the tube as a rectangle sloping downward toward the front of the picture. As the drawing progresses, I use my pencil constantly to determine angles and calculate the placement of each object in relation to the others.

Step 2. Going back over my basic construction, I begin to give shape to the various objects, still using an HB pencil. I develop the curved lines of the head, seat, and rockers of the horse, the foot portion of the boot, and the top of the shoe form. Finally, I add ellipses to the cylinder, enhancing the effect of roundness.

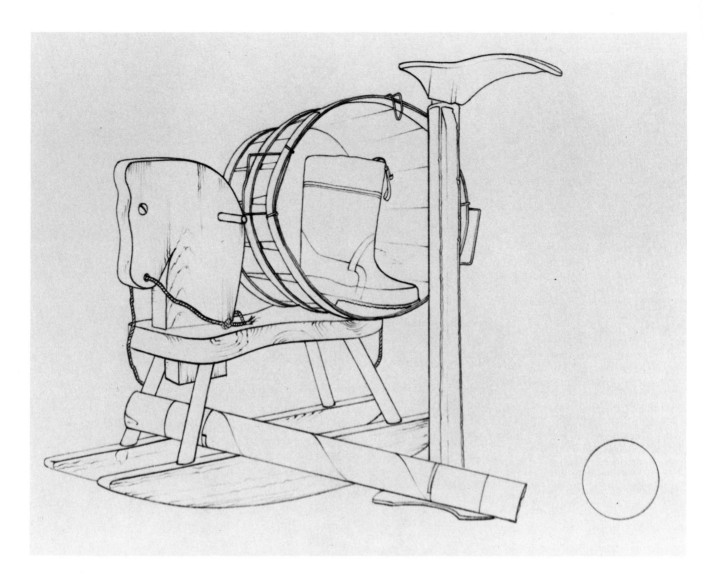

Step 3. I have kept the lines of my sketch light to make sure that they will erase easily and leave no impressions to detract from my finished picture. Now I erase all of the sketched lines, leaving just slight traces of them showing. I switch to a 2B pencil and draw the objects again, trying to create an extremely accurate interpretation of the still life. I describe the staves, thickness, and handles of the basket in detail to add more interest to the drawing. I add a rope to the horse, laces to the boot, and surface texture to all the objects to give them character and create a more interesting drawing. To give you a better understanding of how much I reduced the objects in this drawing, I have drawn a circle on the right which is the size of a quarter. When the drawing is finished, I spray fixative over it.

ENLARGING OBJECTS

This project is quite exciting because it involves taking small objects out of context by enlarging them. The skill you achieve in enlarging small objects is often useful when you are called upon to enlarge one section of a drawing as if it were being viewed through a telephoto lens. It is also fun. When I assign projects like this one to my drawing classes, the response is always favorable.

When you compose your setup, choose objects that are less than 5 in. (13 cm) tall. They should be small by nature—not miniatures or small versions of larger objects. For example, don't use small bottles, which will simply look like ordinary large bottles in your drawing. You can use pins, buttons, matches, and other simple objects, as long as they do not normally exist in large sizes. Select items which, when enlarged, can still be identified and understood for what they are but also contain enough detail to keep your drawing interesting. The objects I will enlarge for this project are a book of matches, a toy figure, a type block with the letter Z, a key, a golf tee, and a safety pin.

Step 1. When enlarging objects, I begin the way I would start any still life composition—by roughing in all the objects right away, constructing them in terms of their basic shapes. I don't get involved with their individual forms yet. A quick sketch is especially important in this project, as I don't want to make the objects so large that they run off the paper. I begin by sketching in the type block with an HB pencil on a 14 x 17 in. (36 x 43 cm) sheet of ledger bond. I construct the type block first because the rest of the objects surround it or rest on it; determining its placement will help me locate the other objects more easily. After the block I add the book of matches, paying special attention to its location in relation to the block. I add the toy figure next, using squares and circles for its basic shapes; later my rough sketch of the toy will give me a better understanding of where the safety pin and key should be placed.

As I block in the toy, I am aware of its location in relation to the block and matchbook. To find the correct location for the key, which is in front of the figure, I hold my pencil in front of me and tilt it until it divides the key in half. In this way I determine the angle, and where the key crosses the figure I draw a line on my paper. Where various parts of the key touch the figure, I use horizontal lines to help me locate them correctly. Now I construct the key with a series of rectangles; already its

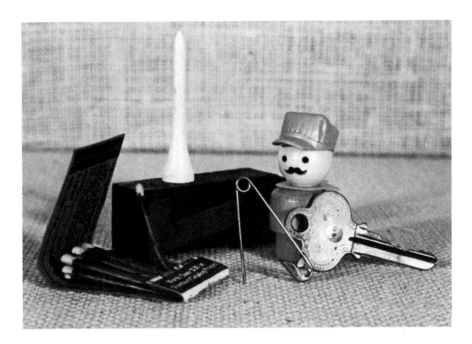

shape is somewhat recognizable. I sketch the safety pin, not worrying about indicating its thickness for now, and study where it passes in front of the key, toy figure, and type block. I add the golf tee last because of its simplicity and location. I hold my pencil vertically at arm's length to locate its center and determine where it is in relation to the block and book of matches. Then I duplicate this vertical center line on my paper so that I can construct the golf tee symmetrically.

Step 2. I don't change the block and book of matches except to add slight curves to the matchbook cover. By constructing ellipses over the horizontal guidelines of the golf tee and the little railroad man, I give these objects a more cylindrical form. I also round the contours of the key. Within the rectangle of my original construction for the safety pin I define the curves of the catch. The wire of the pin also gains thickness at this stage. I haven't erased anything, not even my guidelines, as my drawing is still in the block-in-stage.

Step 3. Now I erase the entire construction, leaving visible just a faint indication of the still life. This enables me to begin refining the objects with a 2B pencil. I sharpen their contours with clean, crisp lines. I find it necessary to correct the symmetry of the golf tee by using the tracing paper method, and so I erase the left half, which I feel is less accurate than the right, and trace the lines of the right half.

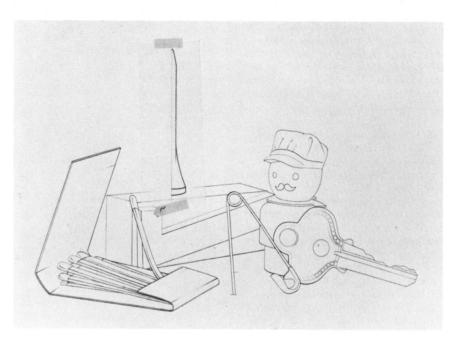

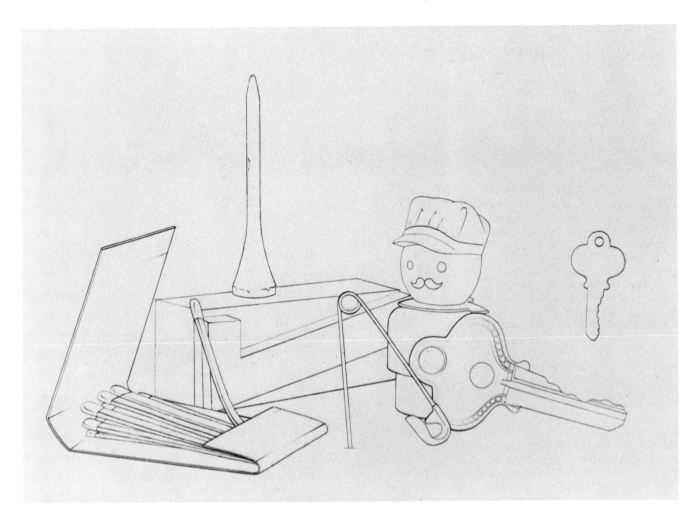

Step 4. I transfer my tracing, remove the tracing paper, and refine the golf tee. My drawing is completed, and I spray fixative on it to prevent smudging. The outline of the key to the right, drawn actual size, demonstrates how much I have enlarged the objects in my drawing.

CHANGING PERSPECTIVE

Most of the time the still lifes you draw
will be setups of actual objects, so when
you want to change the angle from which
an item is viewed, you can simply alter its
position in the setup. There may be times,
however, when your only available refer-
ence is a photograph. For example, in your
travels you may have photographed a
composition which appeared exciting at
the time, but later you wish you'd pictured
it from a different perspective. I recall the
case of a friend of mine who was asked to
illustrate an electric blender for a bro-
chure, using only a photograph for a refer-
ence, and had to alter its position to ac-
commodate the layout of the brochure.
How does an artist handle such a situ-
ation?

If you keep in mind what you have
learned about perspective, foreshortening,
and checkpoints, it is not as difficult to
change the angle of an object as you might
think. When it's not possible to study the
item itself from a specific angle, you can
rely on your knowledge of these visual
principles to guide you.

If you were asked to draw a box from
memory, you would undoubtedly have no
trouble. You could establish various an-
gles and create a box that could be under-
stood. More than likely you could repeat
this procedure with boxes seen from dif-
ferent vantage points, showing more or
less of the sides by merely increasing or
decreasing the angles. To alter a more
complex object you would do the same
thing—but first you would study the object
to determine its basic shapes and forms. In
this project I will alter the perspective of
an electric sanding machine, which has a
relatively simple, boxlike shape.

Step 1. The first step in changing the angle
of a boxlike object is to either increase or
decrease the angle of one of its sides. I
have decided to show more of a profile
view of the sander, so I decrease the angle
on the left side, which exposes more of
that side of the sander. This makes it nec-
essary to increase the angle on the right
side. Once the angles have been estab-
lished, I proceed to break the sander down
into its simplest basic forms. Even though
I am changing the angle, all vertical lines
remain vertical, only the horizontal ones,
which indicate depth, change; this is
where my knowledge of basic perspective
comes in handy. This basic construction is
the most important step because it estab-
lishes the object's general structure.

Step 2. I begin adding curves to the top planes of the sander to create roundness. The addition of the vent areas and the base pad creates a more detailed block-in. Now I can make other refinements with less apprehension.

Step 3. I erase all of Step 2 lightly until the sander can be seen only vaguely. Then I redraw the lines with a 2B pencil, emphasizing some of the lines more than others because variety in the weight and quality of the lines produces a more interesting drawing. Much of what I accomplished in Step 2 remains in the finished picture. I simply remove the sketchy construction lines and add subtle lines within the sander to define its form more specifically. Although it has a boxy shape, the sander has both straight and curved, flowing lines; it's essential to draw them correctly in order to produce an accurate finished drawing. Finally, I spray workable fixative over the drawing to keep it from smudging. This completes the first "catalog" drawing.

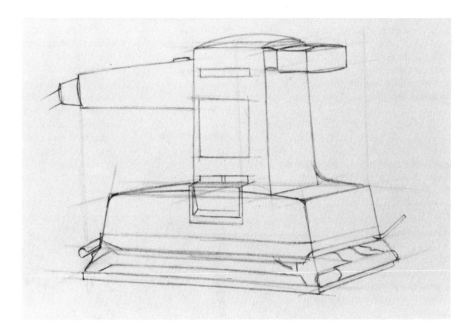

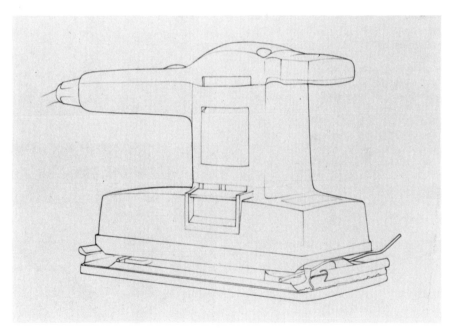

ALTERING MORE COMPLICATED OBJECTS

In Project 23 you learned to alter the perspective of a rectangular object by increasing the visible area of one of its sides and, correspondingly, decreasing the visible area of the other. This principle can be applied to most objects, even very complex ones, if you first break them down into their basic shapes and then apply what you have learned about constructing those shapes in perspective—keeping in mind, of course, the effects of foreshortening. This project is designed to develop your ability to change the perspective of a wide range of objects.

The objects I have photographed and used as references progress from a simple, boxlike item to more complicated forms and finally to the textured, irregular contours of a soft toy. To do this project, select your own photographs—don't repeat the ones I've already drawn here—and start with objects whose general shapes are easy to draw. As you gain confidence, progress to increasingly more difficult objects. If original photographs are not available to you, use pictures from catalogs or magazines. Just make sure that they are clear photographs and that the components of each object are visible. You may alter the angle drastically or only slightly, as you wish—as long as there is a noticeable difference between the position of the object in the picture and its angle in your drawing. Increase or decrease the visible areas of an object, but don't add something which you can't see at all in the photo; avoid the risk of accidentally inventing something which isn't really part of the item. Try to achieve the same exactness in these drawings as you have in previous projects, relying on a ruler if necessary to create precise, straight lines.

Slide Viewer. I started with this object because it is relatively simple, and its straight lines enabled me to practice using a ruler for precision. In the original photo the front of the slide viewer is angled toward the picture plane. In my drawing I shifted it to appear more or less in profile. I achieved this change by varying the angles of the front and side planes, as I did with the sanding machine in Project 23.

Telephone. The telephone in this drawing was changed to the same position as the slide viewer—one that shows more of a side and less of the front. I used a series of rectangular shapes to construct the specific elements which, when properly combined, identify the object as a telephone.

Ski Boot. In this drawing I have done the opposite of what I did with the telephone. The boot, which is seen nearly in profile in the photo, has been altered to a slightly angled position to show more of its front. This object was a little more difficult than the two preceding ones, and I began by drawing a triangular shape, more or less resembling the overall shape of the boot, at a position different from that shown in the photo. I then altered this shape further by adding the various curves and components of the boot.

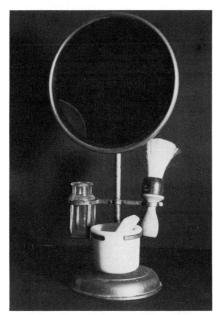

Antique Shaving Mirror. I changed this object more drastically than any other in this project—from a head-on view to a nearly profile view. Since I know that a circle flattens to an ellipse when tilted away from the picture plane, it was not difficult to alter the mirror's position; I simply changed its shape from a circle to an ellipse, adding reflected shapes from my studio to indicate the character of its surface. The brush, bottle, and soap container appear to create greater depth because of their placement. The soap container is now at one side and the brush is in front of the bottle. The base and vertical bar of the mirror remain the same because of their symmetry—they would look the same from any vantage point as long as they were, respectively, parallel and perpendicular to the ground plane as in this setup.

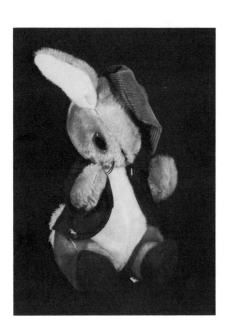

Stuffed Animal. This free-form object, which has no disciplined, geometric lines, was the most fun to draw, and in some ways the most challenging. The rabbit was shifted from an almost head-on view to a more profiled angle. Your most important objective when drawing an object of this type is to make sure its character is not lost. Do not use a strict, unvarying line— the material is fur, and so the line must show this texture without relying on tones. When altering an object, you must remember to also convey its texture and character to the viewer, as you would in any other line drawing.

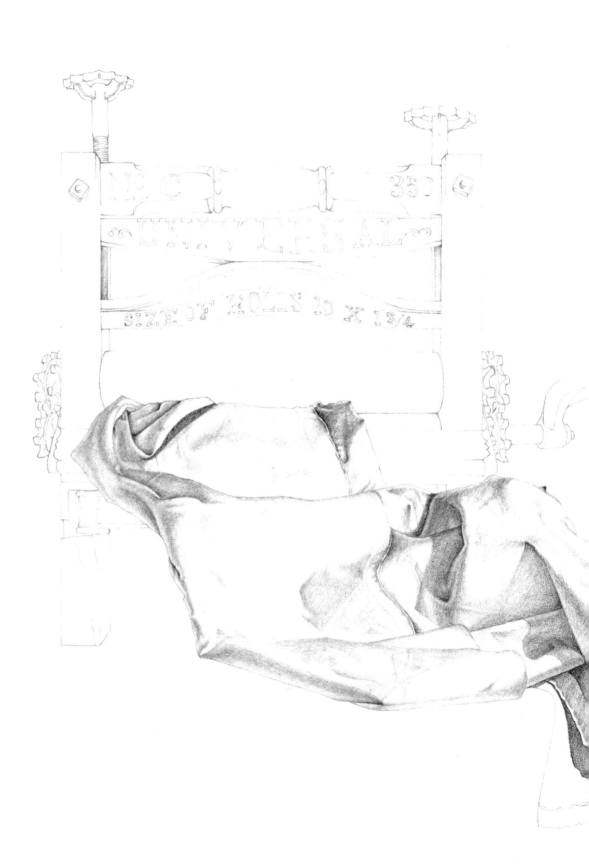

RENDERING WITH TONE

CREATING VALUES WITH TONE

Now that you understand the basic techniques of linear drawing, you are ready to go on to another important aspect of sharp focus drawing: tonal rendering. Tone can be used alone or in combination with line to create the illusion of three-dimensional form. However, it must always be used with an understanding of the correct proportions, placement, and perspective of the objects you are drawing—just as if you were constructing them in line alone. Many people mistakenly begin to draw by applying tone before they even know how to draw correctly in line. They scratch away at the surface of their paper, smudging and overlapping tones haphazardly. The result of such an attempt is usually an unprofessional, almost childish picture.

This chapter opens with a discussion of the pencils you will need for creating different values, or light-and-dark gradations, of tone and how to control them. Next, the range of values from light to dark is broken down numerically into a five-point scale, and you will do two projects in which you draw value charts based on this scale. Project 25 will give you practice in creating tones of different values, and in Project 26 you will learn to blend tones smoothly to achieve a subtle gradation of values from light to dark.

PENCILS

Graphite drawing pencils range in hardness from 6B, the softest, to 9H, the hardest. The leads of the softer pencils are fat in diameter and produce very dark, waxy tones which tend to have a highly polished shine. Despite the boldness of the marks they make, they are extremely delicate; when a soft pencil is dropped, its lead is apt to break inside the wooden shaft and then fall out when sharpened. Care must be taken to avoid the frustration and added expense of breakage. At the other extreme is the 9H pencil. The harder the lead, the thinner it is—and the fainter the line it

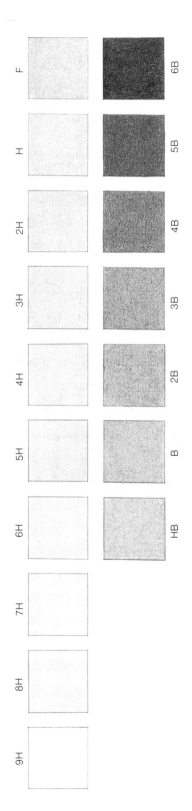

produces. A hard pencil is perfect for creating vague, delicate tones. Hard pencils must be handled carefully too, however. Because of the hardness of the graphite and the sharpness of the point, a hard pencil can tear your drawing paper if you apply too much pressure. Resting the pencil on the paper and letting its weight produce the tone, without forcing it, is a good way to prevent such an accident.

The chart at left shows the tones produced by pencil leads of various degrees of hardness and softness. Only one tone is shown for each pencil, but this doesn't mean that is all a particular pencil can produce. By applying more or less pressure, you can create several different values with each pencil: an HB lead, for instance, can give you a range of values from 3B to 2H. With practice you'll be able to get many tones from each pencil; however, when you first start rendering tones, use as wide a range of pencils as necessary to create them: harder leads for light tones and softer pencils for darker values. You may wish to add a 5H and a 4B pencil to the 2H, HB, and 2B pencils you already have.

PENCIL CONTROL

Applying graphite to your drawing tone is the final step in producing a good rendering; however, it requires not only an understanding of values but the ability to control your drawing tools in order to produce them. The goal of pencil control is to be able to render, with practice, as smooth a tone as possible by building layers of graphite with a variety of pencils. This is made easier if the value scale, which actually has an infinite number of subtle gradations, is broken down into just a few basic values. A value scale of 1 to 100 would be extremely difficult to perceive at this point, and even a scale of 1 to 10 would pose problems—and so I recommend beginning with the simple scale of 1 to 5 shown on page 96.

HOLDING THE PENCIL

It is important to know the proper way to hold a pencil if you want your tones to be smooth and even. If you are covering a large area, hold the pencil at the end opposite the point, grasping it lightly with your thumb, index, and middle fingers. When you move the pencil from side to side with your wrist and arm, you can produce a light tone. To produce tones in a smaller area, you need more control: hold the pencil approximately halfway down. To produce tones in a tight space, hold the pencil all the way down where the bare wood meets the painted part and, resting the pad of your hand on the paper, move the pencil mainly with your fingers. To prevent the oils and perspiration of your hand from staining or smudging the paper, place a handkerchief or tissue under the pad of your hand.

APPLYING TONES

Values or tones can be applied in many ways. Producing smooth, even tones is extremely difficult. I have found applying the graphite first in one direction, then in the opposite, and possibly even on a diagonal to be the most rewarding method. It is essential to maintain a sharp pencil point when you are using textured paper. The point fills in the indentations in the paper and makes a smooth, fine tone. A blunt or rounded point just skims over the surface, creating a spotty, uneven tone. Dark and middle or halftones should be started with an extremely light value and built up slowly in successive applications with various pencils so that you will always be in control and can stop when you feel the tone is dark enough. To darken values, move the pencil in a circular motion. Before you go any farther in this chapter, I strongly suggest practicing on a scrap of paper to get the feel of holding the pencil and finding the amount of pressure needed for applying tones.

1

3

5

1 ← ——————————————————————————— → 5

RENDERING VALUES

In this project you will create the three values shown above, in which a five-value scale has been simplified by leaving out values 2 and 4. Take a small piece of bristol drawing paper, preferably Strathmore 18-2, which is found at most art supply stores, and use a ruler to draw three 2-in. (5-cm) squares in a horizontal row. The first square on the left will be the no. 1 value, which is the white of the paper. The middle square will be the no. 3 value or halftone, and the last square on the right will be the no. 5 value, which is almost black.

After you have drawn the squares, start applying a light tone in the middle and last squares, using a 5H pencil. Leave the first square white. Now concentrate on the last square and continue building up the tone with the 5H pencil until it doesn't appear to get any darker. Now switch to an HB pencil and repeat building up the tone in the last square. If the pencil point becomes rounded after a while, a few swipes on the sanding block will re-

turn it to a nice sharp point. Keep going over the last square until you no longer see it getting darker, and then switch to a 4B, repeating the process until the square is almost black. My reason for choosing to stop when the value is *almost* black is to control the tone so that it does not have the mirrorlike shine that softer pencils often produce. In my own drawings I use black only for accenting one object in relation to another, creating what I feel is a more delicate-looking drawing. After all, anyone can create a black square.

Now go back to the middle square, repeating the same process with the 5H and HB pencils until the value of the tone in the square is between white and almost black. Keep in mind that you need to have a needle point on your pencil so that all the indentations in the surface of the paper get filled. When your chart is finished, protect the surface by spraying it with workable fixative.

BLENDING GRADATED VALUES

On another small piece of bristol drawing paper, use a ruler to construct a rectangle 2 x 10 in. (5 x 25 cm). In this project you will fill in the rectangle with gradations of tone from white to almost black, as shown on the preceding page. This will enable you to test your skill in blending tones smoothly.

Using a 5H pencil, start applying a light tone, working from right to left; leave a small area of white at the far left. As you continue to work on the rectangle, always progress from right to left so that by the time you reach the light area, you'll have total control over both the pencil and the values. If any scratchy lines or mistakes occur, they can be covered later with darker tones and made less noticeable. Continue building up the graphite from right to left by constantly blending in new tones on top of the previous ones, stopping farther from the left edge each time so that

you create a subtle gradation of values from light to dark. Use the 5H pencil until the tone doesn't appear to get any darker. Then switch to an HB pencil and repeat the process. Once you've achieved as dark a tone as you can with the HB, switch to a 4B pencil and continue building up the tone until the right end of the rectangle is almost black. The rectangle should have a smooth gradation of values from white to almost black.

Squinting at your chart will help you determine whether the tones are blended well and will enable you to see any sudden breaks in them. If you notice such a break while squinting, more blending is necessary; simply go back and repeat the process just described. When your chart is complete, spray workable fixative over it to prevent smudging.

THREE-DIMENSIONAL FORM: A NUMERICAL BREAKDOWN OF VALUES

The next four diagrams show how tones, which are broken down numerically into five values, can be used to render basic forms three-dimensionally on a flat surface. If you refer back to the five-value scale you used in Projects 25 and 26, breaking up objects in this manner should help you understand how the tones are created. On the sphere, cylinder, and cone I have used the same numerical breakdown of graded values to stress the illusion of roundness. On the cube, each plane is broken up into separate values, as in reality it is possible to see more than one value on a plane. (Had I presented the cube with just flat tones, you would not have known that you can vary the values if needed.) These illustrations are just informative diagrams to acquaint you with the way values can model form and to show you a simple way to understand the placement of tone.

Sphere. Each shape within the circle in the first diagram is an ellipse constructed around another ellipse. The smallest ellipse, no. 1, is the lightest value, or the highlight. The second ellipse, which is constructed around the highlight, is value no. 2. The third ellipse, which connects with the right side of the circle, is value no. 3, or the halftone; it

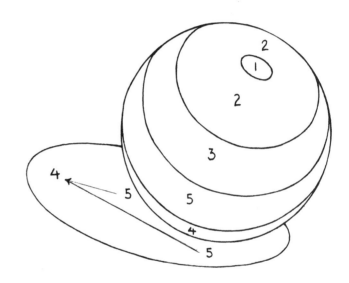

is the middle value on the five-value scale. The next ellipse, which wraps into no. 3 on the right side, is no. 5, the darkest value. The bottom ellipse, no. 4, is the next-to-darkest value and represents reflected light. The cast shadow is an ellipse whose position is determined by the position of value no. 1. You can figure out the placement of the shadow by setting a ball on a table with a light source shining from the same angle as that of the diagram. For the shadow I use value no. 5 nearest the sphere and lighten it to a no. 4 value as the shadow moves away.

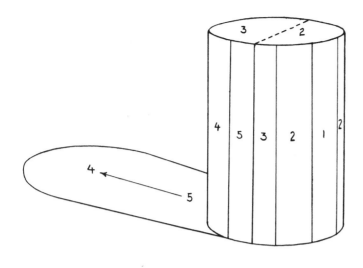

Cylinder. I have broken down the cylinder in the second diagram into six rectangular shapes, each of a different width. The one on the extreme right has a no. 2 value. From right to left, the next value is no. 1—the lightest light, or highlight. Next is no. 2, then 3, then 5, and finally the reflected light, which is the no. 4 value. The progression of values leads the eye around the object, helping to create a three-dimensional illusion. The flat top plane is broken down in a manner similar to the top plane of the cube, with value no. 2 on the right fading into no. 3 on the left. Again, the correct placement of the shadow was determined by setting up a can with a light source. As with the cube, the shadow is drawn by gradating the values nearest the object to no. 4, since the shadow becomes lighter the farther it is from the object.

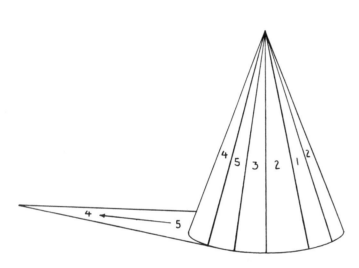

Cone. Instead of using rectangles, as for the cylinder, I now use elongated triangles to break down the cone in the third diagram; the numerical breakdowns remain the same. Shadow construction is also done in the same manner as for the cylinder, by setting up an actual cone, shining a light on it, and drawing the shadows with values 5 and 4, respectively.

Cube. At first the breakdown of values in the fourth diagram appears to be different because the object is not round, but the numerical breakdown actually remains the same. The top plane gets indirect or diffused light, and so the right side of the top has the no. 2 value, which fades into no. 3 on the left. The plane on the right side of the main vertical receives light from the top right corner, and so this has the no. 1 value, which fades into value no. 2. The plane to the left of the main vertical doesn't receive any light, and so this plane consists of values 5 and 4 broken into two triangles. The shadow is constructed in the same manner as for the other objects, by shining a light on a box and drawing it in values 5 to 4 at the correct angle.

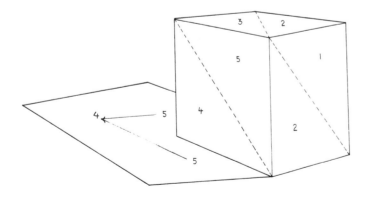

CREATING FORM WITH TONE

Now that you have learned the fundamentals of pencil control, completed the tonal charts in Chapter 8, and studied the numerical breakdown of values used in creating form, you should be ready to put this information to use in modeling form with tone. The projects in this chapter will show you how to apply tone to the basic forms you constructed in line at the beginning of the book: the sphere, cylinder, cube, and cone. What you learn from rendering these basic forms can be applied to more complex objects. There is no need to be confused by intricate objects; simply take a good, long look at them and, in your mind, break them down into the four basic shapes. Learning to recognize the simplicity of objects is fundamental to drawing. And being able to render form by applying tone, confidently and with patience, will play an important role in determining the quality of your finished pictures.

As you render these forms, remember to keep a sharp point on your pencil in order to fill the indentations of your paper and create a smooth tone. (When applying graphite to create tones, I often rub my pencil lead on a sanding block to maintain a needle-sharp point.) Applying graphite in this manner becomes easier with practice, but it is not easy at first to control the values—and so squinting at your drawing is an important aid in achieving the correct values.

In the next five projects you will be dealing with mass. Shapes will be given more substance and form. You will apply the tones in the same manner as you did on the value charts, building up the graphite slowly so that you will have total control over the different values. Each of these exercises is designed to better acquaint you with form and creating the illusion of three dimensions. Even though an actual still life would differ from these forms, an understanding of how, why, and what to look for when drawing them will make your interpretation more accurate. At the end of each completed rendering I have shown a photograph of the actual object illuminated by a light source. This will help you to see how the actual object may differ from the one you drew in the exercise. Note that each object has at least three distinct values: light, dark, and halftone or reflected light. Remember—shapes and values of objects may differ, but the principle of applying tones to create form remains the same.

SPHERE

The obvious way to begin constructing a sphere is to draw a circle. By applying tones to this circle, you can give it the illusion of three-dimensional form which appears to project from the surface of the paper.

When you are applying tones to a shape, the main concern is to use at least three distinct values: a light, a dark, and a reflected light. This automatically creates a sense of three dimensions. The reflected light, which is light being reflected back onto the shadow side of the object, gives it a slight glow. This glow should not compete with the light side of the object, however; if it is as light as the light side, it will flatten out the form instead of making it appear three-dimensional. When drawing a sphere, make sure you apply the tones in a series of more or less elliptical shapes—but without any obvious guidelines. Remember that when you apply graphite over previously drawn lines, they darken and show up as distinct separations in the finished shape.

Step 1. I start by tracing around the base of a soup can (you can use any round object) on bristol paper with a 5H pencil. I use a hard pencil because it creates a very light line which will not show when I blend my tones up to its edge. Don't use a compass to draw your circle because it will leave a hole in the center which will eventually show as a black dot in the middle of your finished rendering.

For the shadow of the sphere I draw an ellipse which angles away from it. I have determined the angle of the shadow by setting up an actual ball and shining a light on it at the same angle shown in the diagrams of the numerical breakdown on page 97. This enables me to interpret the shadow correctly.

Step 2. Holding the 5H pencil at the end opposite the point, I begin moving it back and forth, using only the pressure created by the weight of the pencil to apply a light tone. I build up this tone continuously until I have created a tone of no. 2 value and the difference between it and the white of the paper is visible. I blend the edge where the two values meet, since distinct separations would give the sphere the harsh appearance of being chiseled out of stone. I build up a no. 2 value in the shadow as well; this unifies the picture.

Step 3. Now I start constructing a new elliptical shape by "wrapping" a new tone around the no. 2 value, building up the graphite with the 5H pencil. To make the difference in tones more noticeable, I switch to a softer lead, a 3H. I continue to blend the new tone, a no. 3 value, with the previous one to create a smooth transition between them. I also work this no. 3 value, or halftone, into the shadow to keep the form unified.

Step 4. After changing to an HB pencil, I start building up more tone until I have established the no. 4 value. By blending this value into the no. 3 value, I start to create the illusion of roundness. Again, I work my new tone into the shadow.

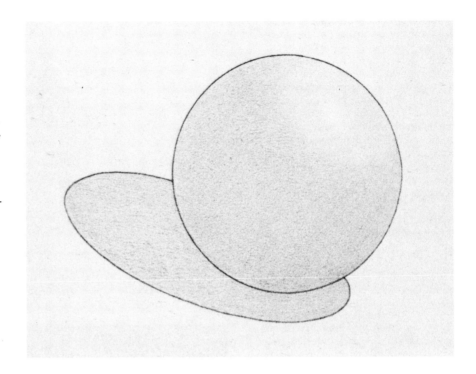

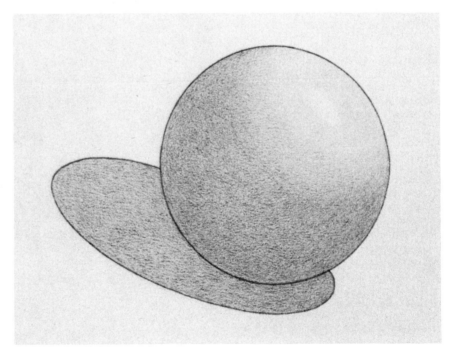

Step 5. To finish the sphere, I use an F pencil and then a 2B. I move the pencil in a circular motion with my fingers closer to the pencil point so that I have greater control, and I begin constructing the last elliptical shape toward the bottom of the sphere. This value is the darkest, or no. 5, value. I do not allow it to connect with the lower left edge of the sphere; instead, it splits the no. 4 value, creating a reflected light. I blend the no. 5 value into no. 4 on each side. I also work the no. 5 value into the shadow closest to the form, which creates the illusion that the sphere is resting on a surface. As the shadow goes away from the sphere, I allow it to fade to a no. 4 value. My sphere is now complete. I erase any smudge marks and then spray workable fixative on the drawing to prevent further smudging—and finally admire my representation of a three-dimensional sphere.

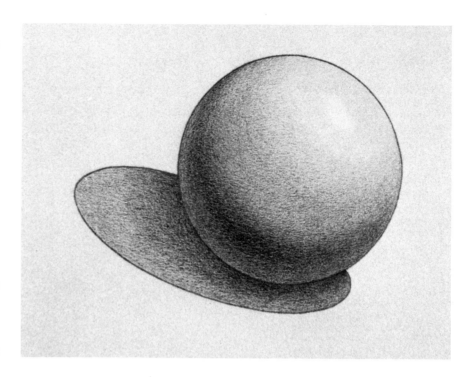

Photo of a Sphere. Having completed the modeling of the sphere, I compare it with a photograph of an actual sphere to show how the form would look in a still life setup. The sphere was illuminated from the right by a 60-watt incandescent bulb; notice how it breaks down into at least three distinct values: light, dark, and reflected light. Of course, there are many subtle gradations of value within them, and it is possible to create a more realistic rendering by using at least five values. Notice that the dark value goes all the way to the edge on the left side, and the lighter glow is at the bottom, indicating that the surface on which the sphere rests has a slight shine. The shadow is darkest closer to the sphere, becoming lighter and softer as the shadow extends out from it. To acquaint yourself better with the tonal modeling of a sphere, set up a ball and light it from various angles. Then study where the new values are located as the angle of the light changes. The shape and size of the shadow may change according to the position and distance of your light source.

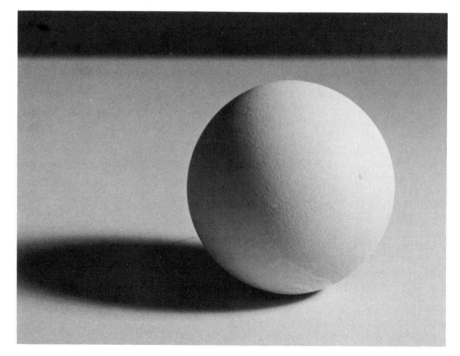

CYLINDER

Like the sphere, the cylinder is also an easily recognized shape which you find within many still life objects that you will be drawing. Cylinders, of course, come in many sizes; but whether they are tall and thin, like a piece of straw, or short and wide, like a roll of tape, all are drawn in the same way. By adding tones, you can give cylindrical forms a three-dimensional quality. Many people think that because a form is round, graphite should be applied in the same direction as the turn of the object. I feel that as long as you combine the right shapes and values, your objects will appear to turn no matter how you have applied your tone.

Step 1. Using bristol paper and a 5H pencil, I construct a cylinder by lightly drawing a vertical rectangle. The top and bottom horizontals of the rectangle form the long axis lines around which I construct ellipses to represent the top and bottom of the cylinder. The bottom ellipse, of course, is slightly deeper to create the illusion that I am looking downward at the cylinder. For the shadow, I draw two straight lines going away from the cylinder with an arc connecting them to represent the curve of the top. Shining a light on a soda can gave me the model for this particular shadow. Now I erase my construction lines so that later they won't appear as streaks in the finished cylinder.

Step 2. Holding my 5H pencil lightly at the end opposite the point, I begin applying tone to the right side of the cylinder. When I have achieved a no. 2 value, I apply the same tone to the left side, leaving a strip of white paper showing between the two tones. I block in the tone in the rectangular areas shown in the numerical breakdown on page 98, but I blend the edges between values so that the gradation will look smooth and rounded. I also apply a no. 2 tone to the top and shadow. To keep the cylinder from becoming jumbled and confusing at this stage, I have broken its form into just two values, no. 1 (the white of the paper) and no. 2.

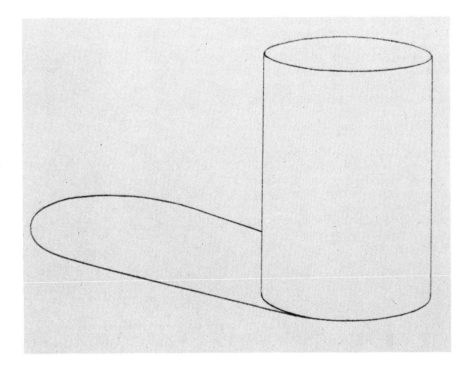

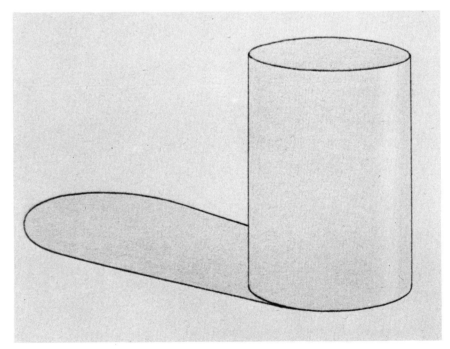

Step 3. Still using a 5H pencil, I create my third value in the fourth rectangular shape from the right, building up tone with the graphite until a softer pencil is needed to produce a darker value. I switch to a 3H pencil to finish my no. 3 value, which is now noticeably darker than no. 2. This value extends all the way to the left edge of the cylinder and on into the shadow. Notice that the top of the cylinder has a no. 3 value on the left, which blends into a no. 2 value on the right. Now the cylinder has been broken down into three values.

Step 4. I change to an HB pencil to produce yet a darker value, and I start building up the tone on the left side until I have achieved a no. 4 value. This value constitutes the fifth rectangle on the left, but I take care to blend the edge softly to create a smooth transition. I also continue this tone into the shadow.

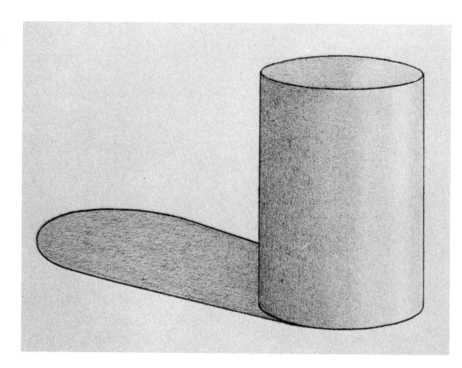

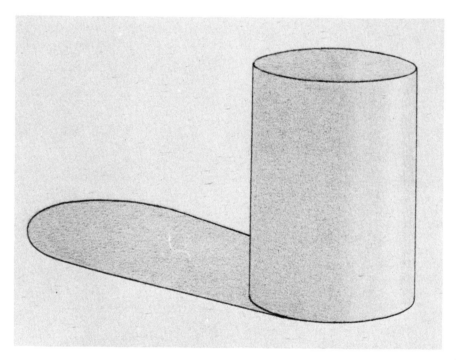

Step 5. I now finish the cylinder using an F pencil and then a 2B to produce my fifth and final value. I build up this tone in the center of the no. 4 value, blending it to the reflected light on the left and also into the no. 4 value on the right. I also build up the tone in the shadow next to the cylinder until it is a no. 5 value, blending it into value no. 4 as it extends farther away from the cylinder on the left. Now I erase any smudging which has occurred and spray the completed cylinder with workable fixative.

Photo of a Cylinder. Notice the three important values which make the cylinder appear three-dimensional: light, dark, and reflected light. Other values are present also, but they are more subtle, creating smooth blends from value to value. To understand better where the various values are on a cylinder, set up a cylinder (such as a soda can painted white, which I have used here) and study the value changes that take place as you light it from various angles.

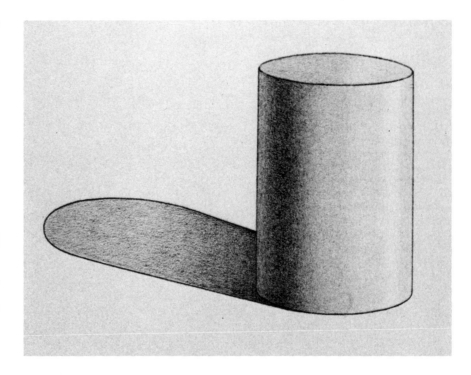

CUBE

A line drawing of a cube can illustrate it three-dimensionally without the use of tones; however, the addition of tones increases this illusion of three-dimensionality and helps the viewer understand the direction from which the light is coming. In this project I will divide each plane of a cube into two values to create a more accurate representation of light and shade. It is also possible for each plane to have just a simple value, depending on the angle of the light source and the other objects around the cube.

I find mastering the drawing of a cube important, since so many subjects have this basic shape. When posed with a drawing problem such as rendering a barn, refer back to the cube and it will be considerably easier to understand what to do.

Step 1. To construct a cube, I begin by drawing a vertical line approximately 2 in. (5 cm) high with a 5H pencil. From the base of this vertical I draw a line approximately 1 in. (2.5 cm) long, which is angled so that it is slightly higher on the right than at the base of the vertical. To the left of the vertical line I draw another angled line—this one 2 in. (5 cm) long—slightly higher on the left and at a sharper angle than the line on the right. From the top of the vertical I extend lines on each side which are parallel to the two bottom lines. I connect each pair of parallel lines with a vertical line to the right or left of the main vertical, and now the cube has sides. I define the top plane by drawing two more lines, each parallel to one of the parallels I have previously drawn, and the basic structure of the cube is finished. The shadow could be drawn with another series of parallel lines, but setting up a light source on a box, as I have done, would help you to create a more realistic-looking shadow. When setting up a light, try to use the numerical breakdown of the cube as an aid so that the values of the object and its shadow correspond.

Step 2. With my 5H pencil I start applying a light tone to the right plane, working from the lower left and allowing the tone to fade into the white of the paper near the middle, creating a smooth transition. The white of the paper, of course, is my no. 1 value. I build up the tone until I have established a no. 2 value that is noticeably different from the no. 1 value. I also build up a no. 2 value within each of the other planes and the shadow.

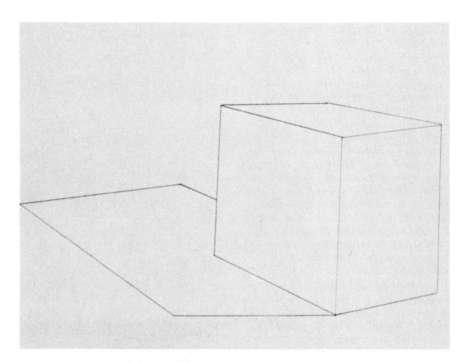

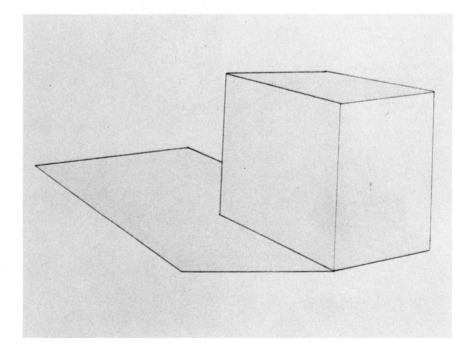

Step 3. I switch to a 3H pencil now so that I can produce a no. 3 value, which is distinctly darker than value no. 2. At the left corner of the top plane I apply a tone and blend it into the no. 2 value toward the right. I build up the no. 3 value until I have established a noticeable difference between the two values. By squinting I make sure that the values are blended and that there are no sudden breaks in tone. In creating a transition from one value to another, the division between them does not have to be centered; the essential thing is that the difference be noticeable. I go on to build up the no. 3 value on the other planes and in the shadow. To create a smooth tone, I apply the graphite first in a vertical direction, then horizontally, and finally diagonally. This permits the graphite to fill the indentations of the paper. If I were drawing an actual cube, rather than a theoretical cube such as this one, the division of values might differ in size, depending upon the light source. Many times the shadow side of a cube is divided into a dark tone and reflected light, while the top and other visible side remain flat values with no such divisions.

Step 4. Having used a 3H pencil to produce the no. 3 value, I need to change to an HB to produce a darker tone, which will become the no. 4 value. Applying the graphite with more movement of my wrist than of my arm, I build up tone slowly within the left side plane, going over and over it to produce a value darker than no. 3. I also work this new value into the shadow.

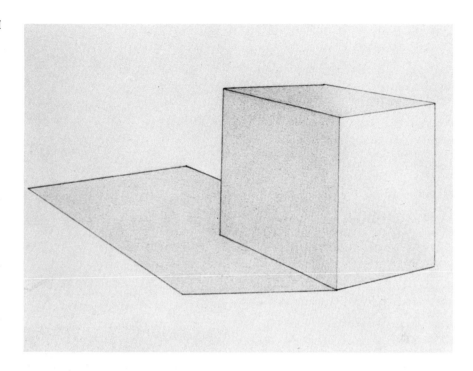

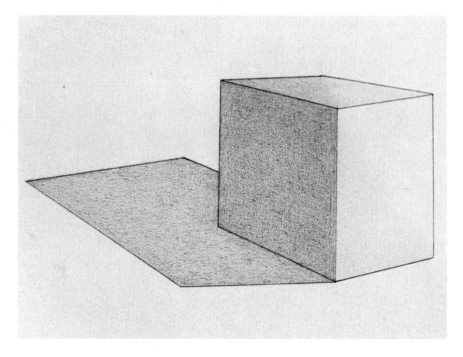

Step 5. To finish the cube and establish my darkest value, I change to a 2B pencil. Starting at the top right corner of the left plane, I build up the graphite, blending this new tone into the no. 4 value, which represents reflected light. This plane now has no light at its top, but light reflected from the surface on which the cube rests is now visible nearest the base. With my 2B pencil I build up the shadow around the base of the cube, blending it so that value no. 5 gradually fades into the no. 4 value on the left. The cube now gives the illusion that light is being cast on it. I erase any smudges from my paper and spray the completed cube with workable fixative.

Photo of a Cube. As I mentioned when modeling the cube, each plane may have its own value. The top and right planes of this cube appear to have their own distinct values, whereas the shadow side has two values (the darkest value and some reflected light in the lower right corner). The proportions of these values on the shadow side of the cube depend on the distance between the object and a surface or object that could reflect light back onto it. Using a 60-watt bulb, place a light-colored cube or rectangle in various lighting situations. Light the cube from various distances and angles; put it next to a plane which casts light back into its shadow and lights up its shadow side. Experiments such as this will show how various lighting situations can change the appearance of a shape while retaining the values with which you are familiar.

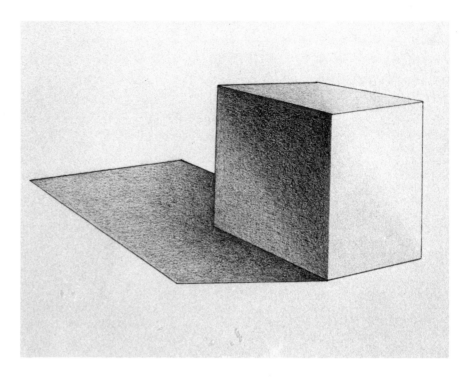

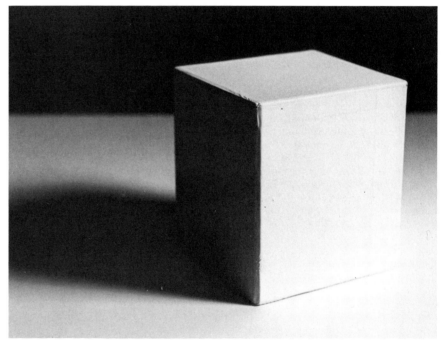

CONE

A cone and a triangle look similar, but there are distinct differences due to the fact that a cone is three-dimensional and a triangle is a flat, two-dimensional shape. The base of a triangle is straight, horizontal line, whereas a cone has an elliptical base. Many objects that you draw, while not actually cones, have many of their characteristics, and so learning to model a cone becomes important for drawing accurate still lifes. As with other forms, you need to use at least three values to make a cone appear rounded, but using all five values creates an even more realistic, three-dimensional appearance. The same numerical breakdown used for the sphere and cylinder applies here, but tonal areas take the shape of elongated triangles rather than ellipses or rectangles.

Step 1. Using my 5H pencil on bristol drawing paper, I lightly draw a triangle with a vertical center line which divides the base in half. Using this divided horizontal baseline as a long axis and creating a short axis along the center line, I construct an ellipse, which finishes my block-in of the cone. I create the shadow by drawing a line which extends to the left from the center front of the ellipse and connecting it with another line from the center back of the ellipse. I used light and an actual cone to determine the appropriate angle for the shadow.

Step 2. Next I apply a light tone with the 5H pencil along the extreme right side of the cone from the point to the base, creating an area shaped like an elongated triangle. Leaving a slender, triangular area of white paper next to this tone, I apply a light tone to the rest of the cone as well as the shadow. This tone is my no. 1 value. I then build up more graphite on the left half of the cone until there is a noticeable difference between this new tone, a no. 2 value, and the no. 1 value. Where the two values meet, I blend the tones slightly to create a rounded effect.

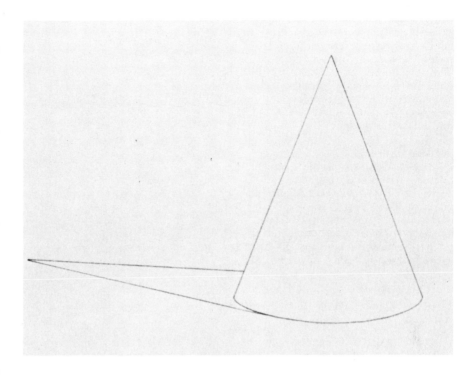

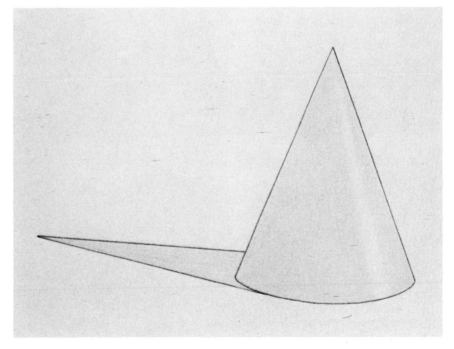

Step 3. Now I begin to construct a fifth triangular shape to the left of value no. 2, changing to a softer pencil, a 3H, and again building up tone without applying much pressure. I rest the pencil on the paper and use only the pressure created by the weight of the pencil. The darker tone created in this way becomes my no. 3 value. After the new value is well established and I have blended it into the previous tone, I continue working this no. 3 value all the way to the left side of the cone and into the shadow.

Step 4. To create a no. 4 value, I switch to an HB pencil, which enables me to produce many darker values up to a no. 4. Over the left half of value no. 3, I begin creating another triangular shape with my new no. 4 tone. By the time I have blended this new tone into the previous one and continued it into the shadow, the cone has taken on a three-dimensional appearance.

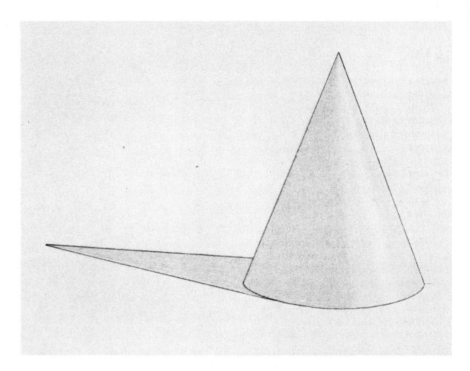

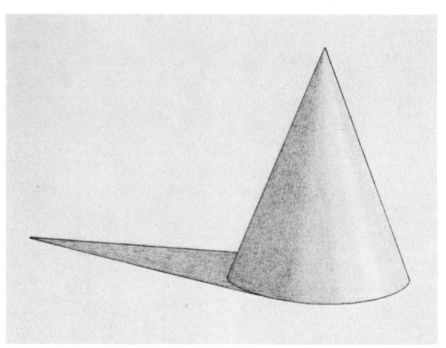

Step 5. To finish the cone I switch to a 2B pencil, holding it nearer the point and moving it in a circular motion. With it I build up a no. 5 value in an elongated triangle which splits the no. 4 value in half, blending on the right and creating a reflected light on the left. The cone itself is now completed and I turn to the shadow.

The shadow nearest the base of the cone becomes a no. 5 value, making the cone appear to be resting on a surface rather than suspended in air. I blend the no. 5 value softly into value no. 4 as the shadow moves toward the left, softening the shadow and giving it a transparent appearance. I erase any smudges and spray the drawing with workable fixative.

Photo of a Cone. The same values appear in a cone as in a cylinder or any other form. It has the three essential values of light, dark, and reflected light, as well as the more subtle gradations of values which contribute further to the illusion of three-dimensional form. The only difference is in the shapes of the tonal areas, which are elongated triangles rather than the elongated rectangles you would use in rendering a cylinder. The cone in this photo was constructed from white paper, so that the values would show up more distinctly. Construct a cone, place a light source in various positions, and determine for yourself where the values are.

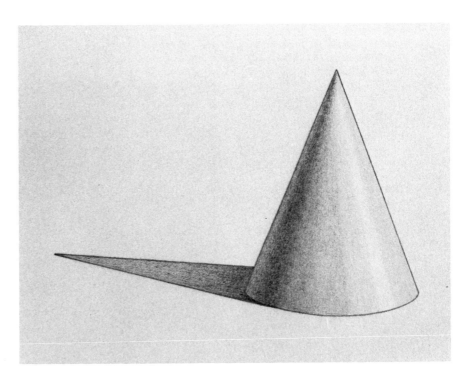

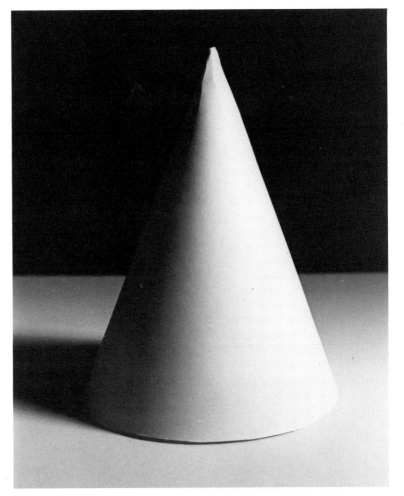

MODELING A BASIC STILL LIFE

Now that you understand how to render the four basic forms with tone, apply these principles to drawing a basic still life. My setup for this project is composed of a painted soda can, a jewelry box, a child's rubber ball, and a cone constructed from a piece of white paper. My light source is a clip-on lamp with a 60-watt bulb, which makes the different values easy to see. The location and proportions of certain values may differ from those in the previous projects, but the same drawing theory still applies: you need at least three values— light, dark, and reflected light. Remember, anyone can create a value, but much patience is required to draw it with smoothness and accuracy.

Step 1. Using an HB pencil on bristol drawing paper, I construct a line drawing of my still life, blocking in each object in the grouping—including its shadow—in the manner demonstrated in the four previous projects.

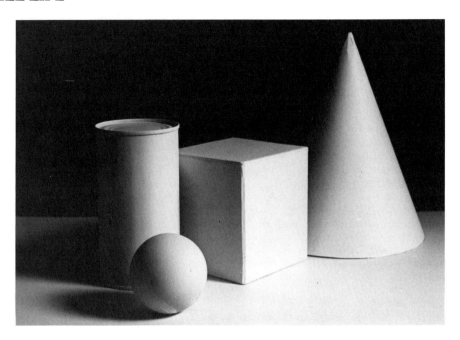

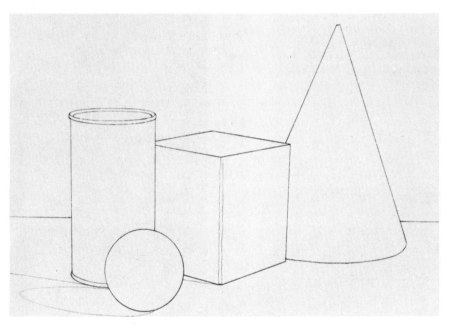

Step 2. After studying my still life to determine where the different values are located, I begin applying the first tone to each object with a 5H pencil. I leave the white of the paper for the no. 1 value and apply the no. 2 value by building up the graphite until a slight difference between the values is noticeable. Now I have established a delicate value pattern of light and shade.

Step 3. Having determined where the highlights and the first tones are located, I build up the darks by continuously going over the no. 2 value on the left-hand portion of each object with a 3H pencil. Each object and its shadow should be modeled as a unit to keep the values consistent. The tones are still relatively light at this stage, and in order to keep them light, I hold the pencil at the end opposite the point and manipulate it mainly with my wrist; this creates only a small amount of pressure on the pencil. If I were to apply too much pressure, dark, spotty tones would appear in my drawing. As I add the no. 3 value, the symmetrical objects start to appear round. I complete the top plane of the cube by blending the no. 3 value from the left into value no. 2 near the back, showing the angle from which the light is shining.

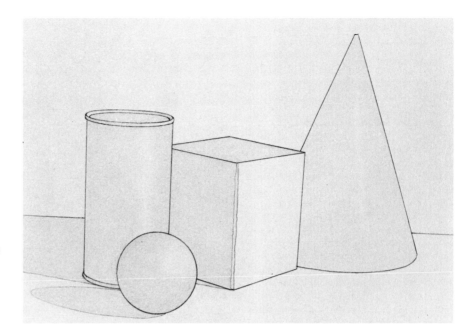

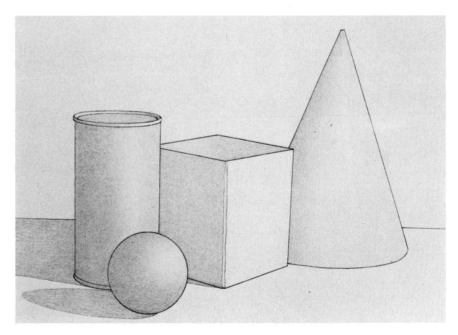

Step 4. Now I build up the left sides of the objects with an HB pencil, blending the new no. 4 value into the no. 3 value. The cube's entire left plane is now value no. 4. Squinting at my setup, I make sure the values I have applied have no definite hard edges and do not contrast too sharply.

Step 5. Changing to an F pencil, I continue building up the darks on each object, dividing the no. 4 with the new no. 5. I soften this darkest tone into value no. 4, allowing a glow to develop on the shadow side and eliminating any flattening that would give an object a cutout appearance. The cube's left plane is darkest near the cylinder and toward its front edge, creating a glow of reflected light from the cylinder. The contrast of the light cylinder and the dark cube makes the cylinder appear to come forward. The shadows are darkest close to the objects and lighter farther away, which creates the illusion of softness and transparency. After all the tones are complete, I go back to each object, smoothing and softening tones with a 5H pencil to add slight variations that give the still life more character. I erase the smudges from my completed rendering and spray it with workable fixative.

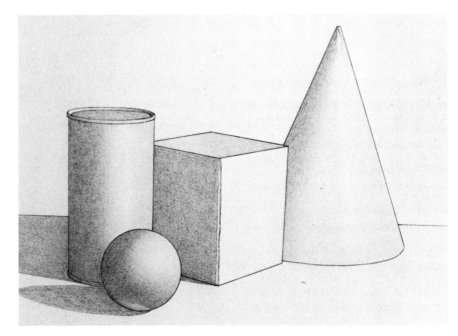

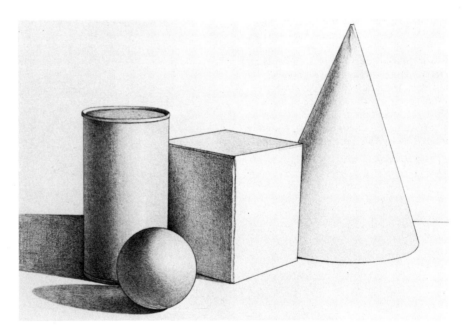

RENDERING TEXTURES WITH TONE

In this chapter I will challenge your drawing skills by giving you projects which incorporate a wide variety of textures and surface problems. It is obviously very important to be able to render a variety of textures in order to create convincing drawings of objects. For this reason I have chosen seven different pairs of surface textures to draw in the next fourteen projects, each of which presents a different rendering problem. Each material is presented in two entirely different ways: wood will be drawn in one project as rough and in another as smooth; paper, both stiff and soft; clear and colored glass; reflective as opposed to satin-finish metal; rust, both flush and in relief;

both soft and stiff cloth; and rough and smooth stone. By drawing such a variety of textures, you should develop a better understanding of why textures and surfaces look the way they do and how you can duplicate their appearance.

The practice you receive from drawing these projects will enable you to create even more realistic still lifes in the future. You should be concerned mainly with how well you can capture a variety of textures, and not by how many you can draw or how fast you can execute them. Take your time, and continue drawing each project until you feel satisfied with your results before going on to the next one.

PROJECT 32

ROUGH WOOD

To demonstrate how to render rough wood, I have selected a still life consisting of an aged birdhouse and a chicken egg. When choosing some rough wood to draw for this project, it is essential to find either an object constructed from rough wood or a piece of old wood that is interesting by itself. Cracks, nail holes, and rust spots are good examples of subtle details that add interest. Beware of selecting an object such as a split log or an overly rotted piece of wood, which could become unrecognizable when your rendering is finished. Many artists fail to consider the fact that often when color is reproduced in terms of black and white, a drawing has a scattered value pattern which may make objects difficult to identify.

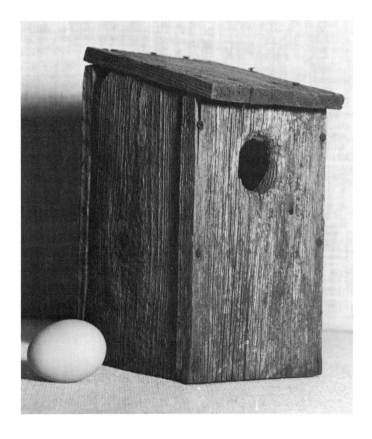

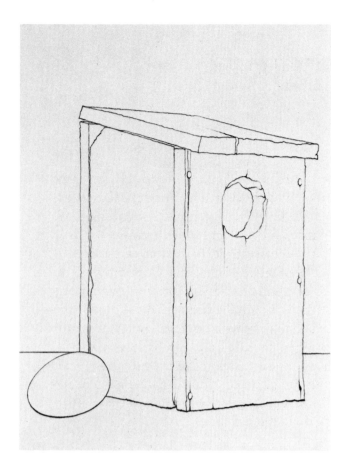

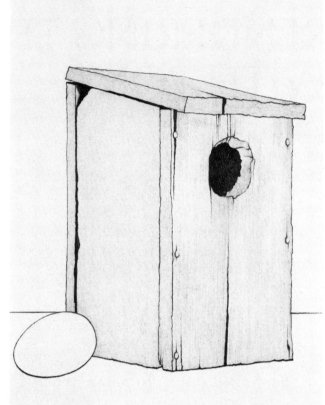

Step 1. First I sketch the birdhouse and egg lightly with an HB pencil on bristol paper. The birdhouse is a simple vertical box with an inclined roof. I suggest major cracks, nails, and the texture of the wood with a rough, wavy line rather than a smooth one, to suggest texture in a linear manner. Finally, I refine the sketch until I have a finished line drawing.

Step 2. Leaving the drawing of the egg just as it is, I apply a semismooth tone to the entire birdhouse with a 5H pencil. I have left vertical streaks, which I will utilize for the grain of the wood in the steps to follow. With an HB pencil I apply the darkest value to the birdhouse, concentrating it in the opening and in several deep cracks. This dark value will help me to gauge the values I'll need for the different planes and to achieve the proper degree of contrast more easily.

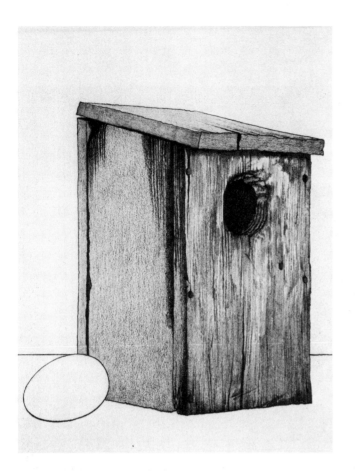

Step 3. Now I gradually build upon the graphite applied in the previous step. With an HB pencil I begin accenting the rough lines and streaks of tone by placing darker values next to the lights and halftones. Already this helps to create the appearance of a rough wood grain in relief, which is needed if I am to interpret correctly the rough texture of the old birdhouse. I do this step slowly to capture the pattern of the wood grain exactly, as you can see in the partially rendered section on the left side of the birdhouse.

Step 4. Having utilized the vertical pencil strokes for the pattern in the grain, I begin applying a subtle horizontal texture in the same manner, creating more varied tones with a 2B pencil. To achieve more interest, I go back and begin applying a darker value over the grain—still using a 2B pencil, which produces the variety of tones needed—to create a rough, weathered appearance. To complete the drawing, I add the end-grain patterns and nails, which convey my interpretation of rough wood more realistically. Spray fixative is applied to prevent smudging, and this first textural rendering is complete.

SMOOTH WOOD

For this project I have chosen the back of a picture frame juxtaposed with a water pitcher to create a picture within a framed area. Pine, plywood, or any other type of smooth wood will suffice. Smooth wood normally has subtle stainlike tonal patterns; these can be rendered with the same subtlety of contrast by using little or no black in your drawing. Because smooth wood lacks textural interest, it would be better to select an object constructed from it rather than just a nondescript piece of wood, which would be difficult for the viewer to identify.

Step 1. Using an HB pencil on bristol paper, I construct the picture frame as a rectangle with several smaller rectangles placed within it. Sketching a center line allows me to achieve symmetry in the pitcher more easily. Then I rough out the pitcher in a basic fashion, sketching it through the frame as though the wood were transparent and working on both sides of the center line.

Step 2. Lightly I erase the rough preliminary sketch with my kneaded eraser, and then I redraw and refine the still life with a sharp HB pencil. Using a ruler, I refine the picture frame, making sure the divisions within the outer rectangle have the right proportions. To the pitcher I add the curved top section, a more involved handle, and the floral pattern. Since I intend to leave the pitcher as a line rendering, I use a varied thick and thin lines to make it more interesting.

Step 3. To help establish the values, I apply a light tone to the smooth wood with a 5H pencil. I apply this tone as smoothly as possible in order to capture the smooth surface I am interpreting.

Step 4. Now I am ready to draw the wood grain of the picture frame. I begin working on only one section, using a 3H pencil, and slowly build up the graphite to create the pattern of the grain. I use smoothly applied tone, making sure this value is in key with the first tone I applied. Again using a ruler, I darken the straight lines with a sharp HB pencil to create the impression of depth and space between sections of the frame.

Step 5. I continue to render the wood grain of the picture frame, carefully duplicating the pattern of subtly contrasting light and dark tones. I build up the shadows on the frame with an HB pencil until I have achieved enough contrast between them and the lighter areas of the wood. Finally, I add the character marks—the cracks, holes, and stains—still using the HB pencil. Again, as always, I spray fixative on my completed drawing.

CLEAR GLASS

For this project I thought that the contrast of old and new bottles would make an interesting composition. To simplify matters, I have placed white paper under and behind my grouping; this enables me to recognize the values easily. It also gives the bottles a smooth, clean appearance. If a pattern or texture were placed behind the objects, not only would the glass surfaces be more difficult to interpret, but also the texture behind the objects would have to be drawn. Although the bottles in my setup are of both clear and colored glass, I will concentrate only on rendering the clear glass in this project. The other bottles will remain drawn in line only. The objects for your grouping can range from a drinking glass to a glass sculpture, as long as they have a smooth surface rather than cut, textured, or patterned; the idea is to capture that certain elegance of smooth glass.

Step 1. First I draw the entire composition in line, using an HB pencil on bristol paper. I break each bottle down into its basic shape, utilizing checkpoints and negative space to guide me in positioning it. From my block-in I create a finished line drawing, still using the HB pencil. I have decided that all but one of the bottles will remain drawn in line only, and so I complete every detail, including their reflections. For now, I draw just the outlines of the bottle on the far right.

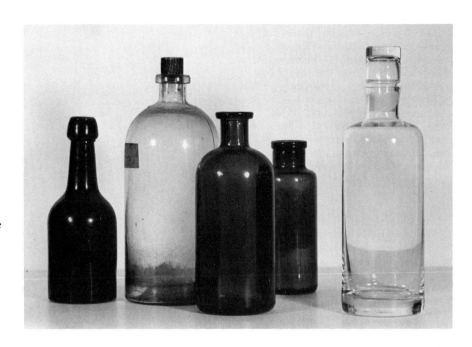

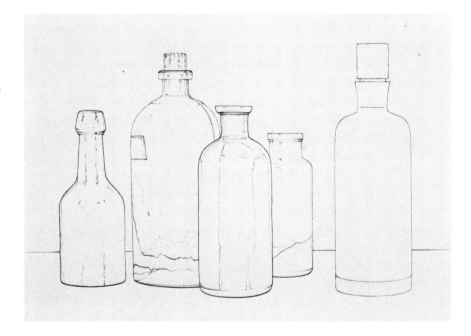

Step 2. Now I am ready to start rendering the clear bottle on the extreme right. I apply a very pale overall tone, using a 5H pencil. I must apply this tone as flawlessly as possible if I am to create a realistic illusion of clear glass; since the surface I am rendering is smooth, my application of tone must also be smooth. This step builds on Project 26, which was intended to give you practice in applying tone smoothly.

To render clear glass in tone, I will need to use values of a higher "key"—that is, a range of values limited to lighter tones. (A lower key would consist of darker values.) The key is determined both by the color of the glass and by the value of the background or objects behind the bottle.

Step 3. After changing to a 2H pencil to create a tone noticeably darker than that of the 5H pencil, I begin making the various separations of the bottle more pronounced, working from the top down. I add even darker values, first with an H and then with an HB pencil. To capture the full illusion of glass, I must always be concerned with putting the right values and shapes in their proper places, and so I constantly refer to my setup.

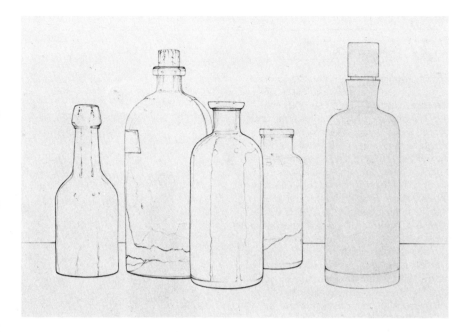

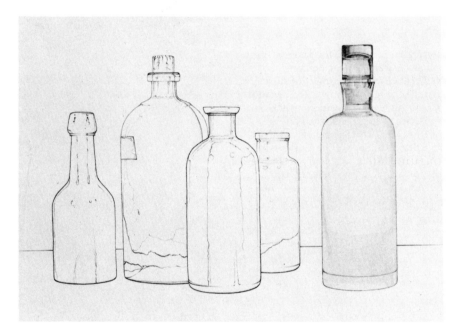

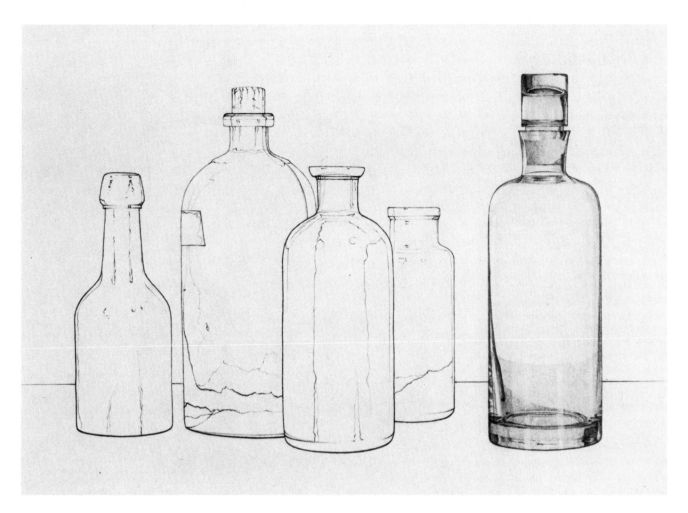

Step 4. Having worked tones into the bottle from top to bottom once, I begin switching from the 2H to the H and back to the HB pencil, consistently reworking areas which appeared to have been completed in Step 3. Then I smooth the graphite over the entire bottle by reworking the drawing gently with an extremely hard pencil, an 8H. This blends all the granules of graphite very, very smoothly. The edges of the glass need special attention, and so I clean and soften them, using a 5H pencil to add subtleties I previously overlooked. I form a point with my kneaded eraser and begin eliminating some of the graphite to create highlights. Now the glass has a shiny, reflective appearance. As always, I spray my finished drawing with fixative.

COLORED GLASS

For this project I have selected two ordinary glass bottles with very simple basic shapes and a wire bottle rack. By placing one bottle in the metal rack and the other in front of it, I have created a challenging drawing problem which incorporates rendering the surfaces of both clear and colored glass, the use of perspective, and the overlapping of objects—including drawing the metal rack through the bottle set in front of it. Choose similar household objects for your setup, and arrange them in a similar manner.

This project will help you to learn to see objects in more detail. You will have to look closely to see not only lights and darks but also many subtle halftones, which often appear as reflections and transparent distortions. Imagine that you are working a puzzle: by putting down the shapes as you see them, you will create the illusion of a reflective object. Remember to keep your tones close in value; this will make the surface of your object subtle and create the texture of glass. Since a glass surface is smooth, you must also apply the graphite to your paper smoothly.

Step 1. I start with a rough sketch, using an HB pencil on bristol paper, and put down what I see as loosely and freely as possible. At this stage I am just concerned with putting down on paper the basic shapes and their relationships to one another.

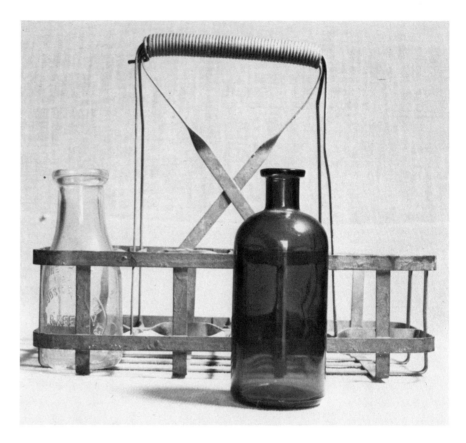

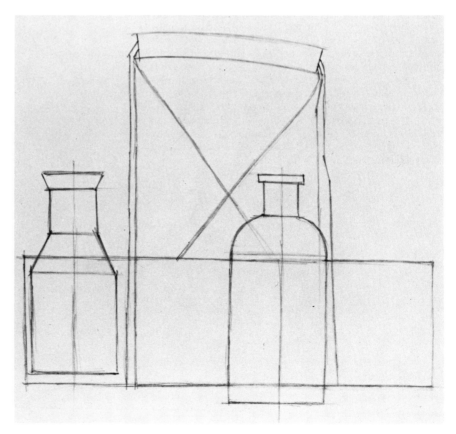

Step 2. Now I start to rework my rough sketch. I add the horizontal and vertical bars to the milk case, giving depth to the drawing. I also add ellipses to the bottles to add to the illusion of roundness.

Step 3. I now start to refine the objects. Using a delicate line, I draw the wires in the milk case, adding details to the metal strips and handle. By putting down the basic shapes I see in the glass bottles, I begin to establish the reflections and distortions.

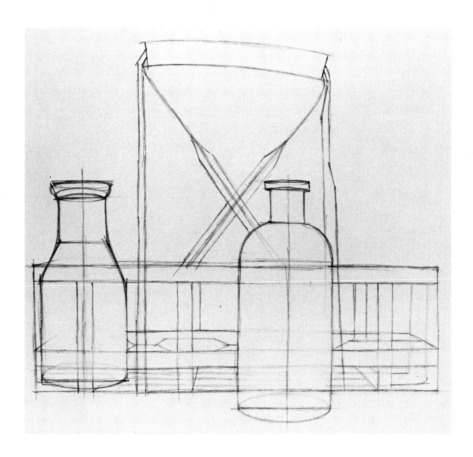

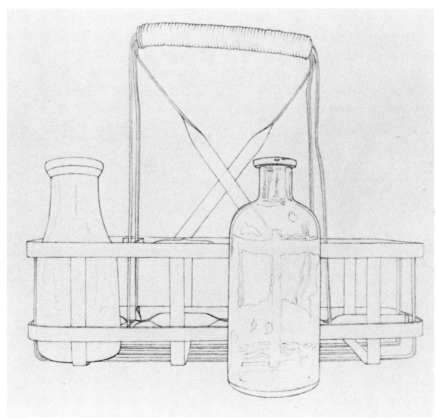

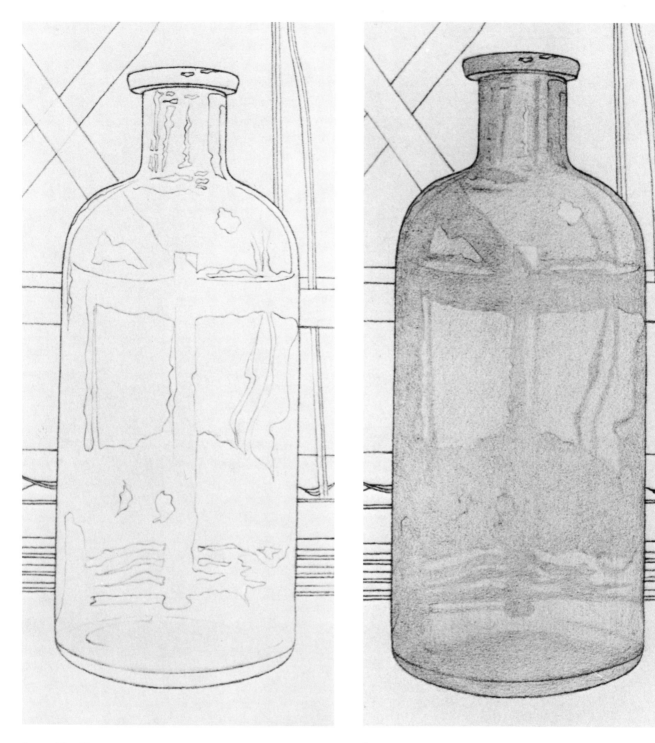

Step 3 (detail). This close-up of the front bottle shows how I add the distortions by duplicating the shapes I see reflected in the glass. When I put these shapes down, I am concerned first with just the large areas. Then I work the smaller shapes into the larger ones. I erase all of my earlier sketch lines, and then I redraw and refine all of the objects.

Step 4. Now I apply tones to the front bottle, softening and blending the edges. As I render the distorted shapes of the wire rack behind the bottle, I continually study my setup to re-create the exact appearance of the bottle.

Step 5. To create the darker, finished tones of the front bottle, I continue to build up graphite. Because this bottle is made of colored glass, I apply an overall tone to indicate that it has color and then work deeper reflections and highlights into this tone. Notice that the values in the front bottle are close and the contrasts are subtle, as in the bottle rendered in Project 34. This colored bottle is rendered in a low key, however, whereas the clear glass in Project 34 called for high-key values. The contrast between linear drawing and tonal rendering in this still life emphasizes the contrasts between the clear and colored glass bottles. It also pulls the toned bottle forward, creating the illusion of depth. When my picture is complete, I spray it with workable fixative.

REFLECTIVE METAL

For this project I have chosen a setup consisting of two clear glass objects and a highly polished metal cocktail shaker. The glass objects will be drawn in line and the reflective metal container rendered in tone. Notice that the patterns reflected in the mirrorlike container are neither too simple nor overdone. Strive for a similar effect in your own setup; remember that your working area also may be reflected in the polished surface. You should have no difficulty with this project if you handle it in the same manner as the colored glass in Project 35. Just put down the various shapes and tones as if you were assembling a puzzle. Again, one of your main concerns should be to apply tones smoothly in order to create the polished appearance of the shaker.

Step 1. To construct my still life, I break the objects down into their basic shapes—squares, triangles, rectangles, and circles—using an HB pencil on bristol drawing paper. Since each object is symmetrical, I have also sketched a center directional line and short axis line for each ellipse. Note that I've sketched each object entirely "through" the other objects—even the metal shaker, which is not transparent. This assures me of a consistent, flowing line that smoothly connects one area of an object with another.

Step 2. Next I lightly erase my rough construction until only faint traces of it are visible. I sharpen my HB pencil to a needlelike point and redraw the rough sketch with smooth, flowing lines. I refine these further to represent the still life accurately. Since the glass objects will remain as line drawings, I add their reflections and distortions to make them more interesting. The metal container will be rendered in tone, but I also break it down into reflective shapes in line; this allows me to note where I'll need to apply specific tones.

Step 3. I change to a 5H pencil and begin applying a light tone to the entire shaker except for the highlights, where I leave the white of the paper showing. I add tone to the lid, which leans against the shaker, so that the two objects will be consistent in appearance. I go back over the initial tone as many times as necessary to achieve the correct value. I want to create a distinct separation between my tone, which is value no. 2, and the highlights.

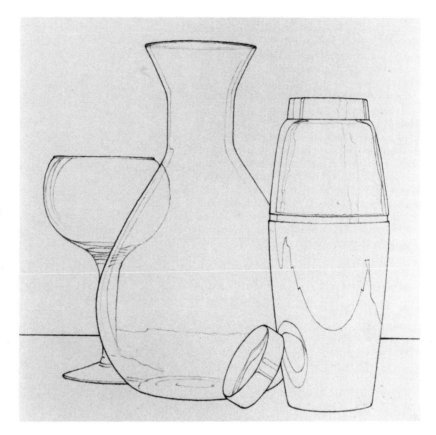

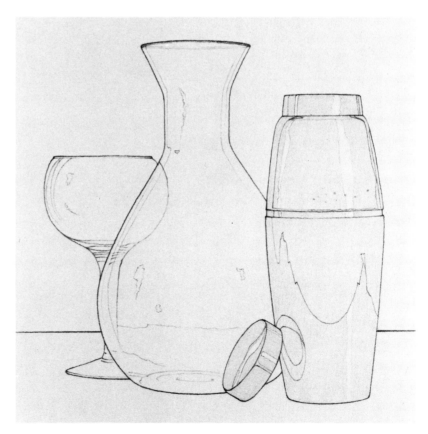

Step 4. Still using a 5H pencil, I begin darkening certain areas of the container until a third value is identifiable. I substitute a softer pencil, a 2H, when the 5H pencil no longer appears to be creating a new value. This is the final step in which most of the shaker is toned and it is rendered as a total unit. I continue to work on both the container and its lid as if they were a single object, in order to keep them consistent.

Step 5. In this step the point of the pencil should always be kept sharp so that the graphite will find the indentations in the paper. This will create a smoother tone and represent a smooth surface more accurately. Starting at the top of the shaker, I begin building up the darkest tones with an HB pencil. This makes the contrast between the lights and halftones more evident. Gradually I add tone to the entire object, capturing as many subtle variations in values and reflections as possible. Finally, I spray workable fixative on the completed drawing.

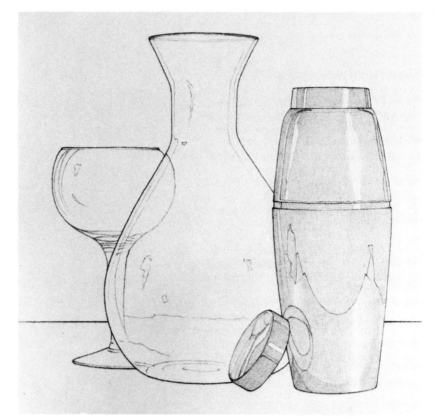

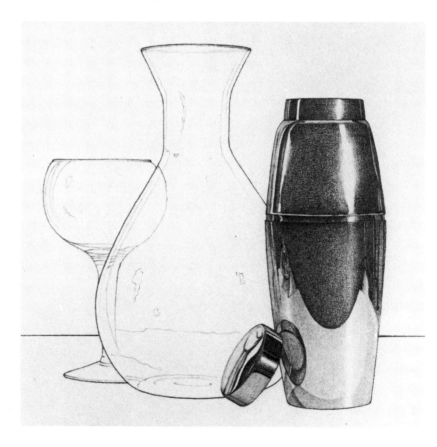

SATIN-FINISH METAL

I have chosen to draw a setup consisting of two books, a beer mug, and three different types of paint brushes for this project. Since the purpose of the project is to acquaint you with the techniques for rendering metal with a satiny, nonreflective surface, it's a good idea to select an object with a simple shape, as I've done here. That way you will be free to concentrate on drawing the surface characteristics rather than getting involved in making a complicated drawing. However, the various principles of drawing which were covered in previous projects—perspective, checkpoints, and negative space—should still be utilized to create a correct interpretation of the still life. The difference between a reflective metal surface and one with a brushed or satin finish is in the appearance of the reflections. Reflections on a highly polished surface have definite shapes, whereas shapes reflected on a satin finish are blended together and slightly blurred, creating a softer appearance. In this as in all of the projects, you must maintain a good, sharp point on your pencil in order to achieve an accurate rendering.

Step 1. Using an HB pencil on bristol drawing paper, I begin constructing the foundation for my drawing. The books, which are the base of the still life, are constructed as low rectangular boxes. As I draw them, I keep in mind the principles of two-point perspective. I sketch the other objects in terms of their basic shapes, using checkpoints and negative space as guides for positioning them.

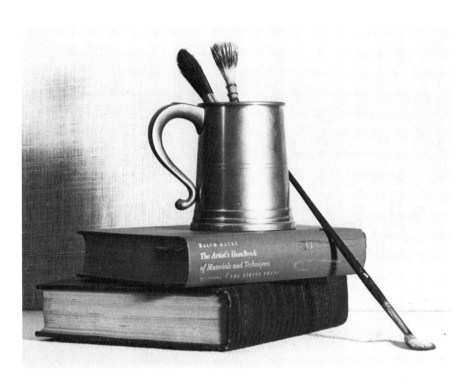

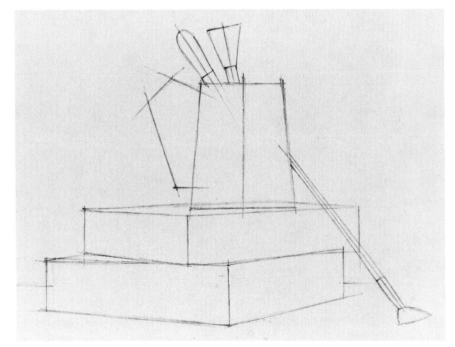

Step 2. Still using my HB pencil, I give basic shapes more specific contours, and they take on a new look. By making the rectangles look more like books, establishing the handle on the mug, and rounding the mug by constructing ellipses at top and bottom, I create a concrete construction from which to develop a finished drawing.

Step 3. Lightly I erase my rough sketch from Step 2. Now the objects can be redrawn and refined with an HB pencil. I complete the books by adding details, such as the thickness of the bindings, and articulate the bristles of the brushes; their texture makes the drawing look more realistic and adds interest to the overall composition. I refine the mug, using a ruler for the straight lines and patiently constructing clean, smooth, flowing ellipses.

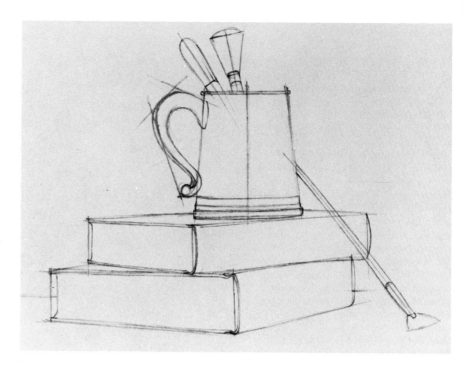

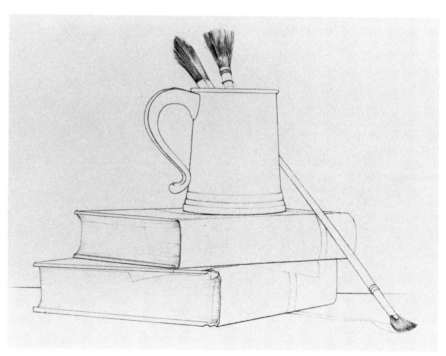

Step 4. Now that my linear drawing is complete, I am ready to start adding tone. Once again I will leave all the objects but one—the metal mug—rendered in line only. Using a sharp 5H pencil, I begin applying a tone to the mug, leaving the white of the paper showing to represent the lights. As I apply this tone, I use little or no pressure; instead I allow the weight of the pencil to create the pressure. I continue to apply tone until I can perceive a definite difference between the tone and the white paper. Since the texture of the object is smooth, the graphite should be applied smoothly.

Step 5. Still working with my 5H pencil, I apply a new tone, allowing it to blend into my first tone to create the illusion of roundness. I take care to preserve the highlights, which are more pronounced now. When I see that the new tone that I need cannot be achieved with a 5H pencil, I change to a slightly softer pencil—a 2H—and build up the tone. I still apply tone smoothly in order to capture the texture of the mug.

Step 6. I change to an HB pencil and begin applying even darker values, leaving areas of lighter tones to represent shine and reflections. Where an extreme dark is needed, I press a little harder on the pencil to get a black line; then I blend this into the tone next to it. It's necessary to pay special attention to the shapes of the values I am applying at the base of the mug if I am to maintain the elliptical construction. After completing my rendering, I smooth the graphite with a 9H pencil. The extremely hard lead tends to blend and move the softer graphite around and into the indentations in the paper's surface, creating a smoother gradation of tones. I spray workable fixative on the finished drawing to prevent smudging.

Step 6 (detail). This close-up of my rendering shows the smoothness with which the graphite was applied to create the subtle, muted reflections on the satiny surface of the mug. Compare the metallic sheen of this mug with the brilliant reflections on the cocktail shaker in Project 36.

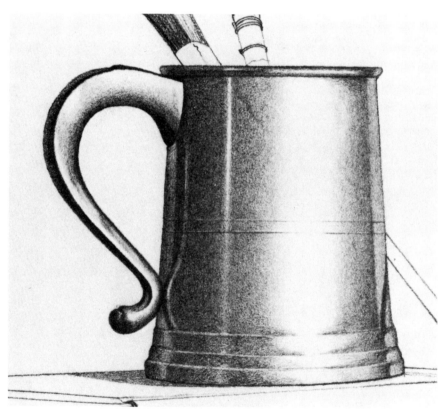

FLUSH RUST

I came across this deteriorated metal elbow, which was used for joining two pieces of stovepipe, while hunting for props in my father's basement. I wanted to find an example of rusty metal, but I felt that tin cans would be too ordinary to be interesting to draw, and a car muffler would be too large. This metal elbow is just the right shape for my composition and has exactly the texture I need—somewhat gritty and rough, but not so heavily encrusted that the rust stands out in relief from the basic form of the elbow. I have placed the rusted object on a simple wooden box so that the complementary rough and smooth textures will create an interesting picture. When you choose objects for your grouping, look for a suitable texture; don't worry if you cannot find anything more exotic to draw than tin cans—after all, the key element is the surface texture.

Step 1. Using an HB pencil on bristol drawing paper, I construct the box on which the rusty elbow rests. Since the front plane of the box is parallel to the picture plane, I use my knowledge of one-point perspective to construct it. Then I rough in the pipe by drawing a rectangle for its base and another at the right and connecting them with two diagonal lines. These diagonals joining the rectangles are my guides for constructing the elliptical curves of the pipe.

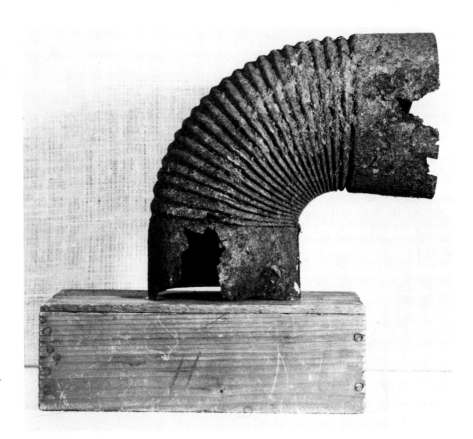

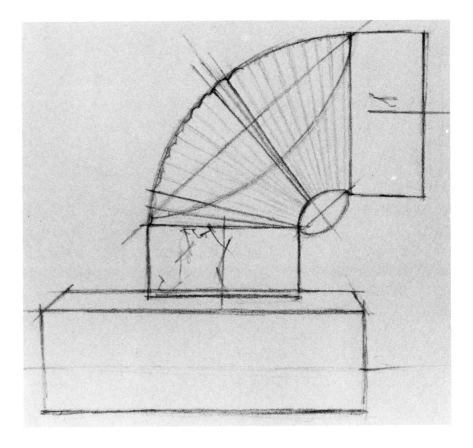

Step 2. Still using my HB pencil, I add ellipses to the rectangles, creating the illusion of roundness. Then I add the accordionlike folds, using many shallow ellipses to round the central section of the pipe. To draw this section realistically, I pay special attention to how many rolls or folds there actually are. At this point in the block-in I also sketch the rotted areas of the pipe.

Step 3. Now I must lightly erase my rough preliminary sketch to achieve clean, accurate lines. With a sharp 2H pencil I refine the box and stovepipe, capturing the character of each object as well as creating accurate contours within which to apply the tones. The box, which is not the primary object in this project, will remain drawn in line, and so interpreting the texture and grain of the wood in line is essential to keeping this object interesting.

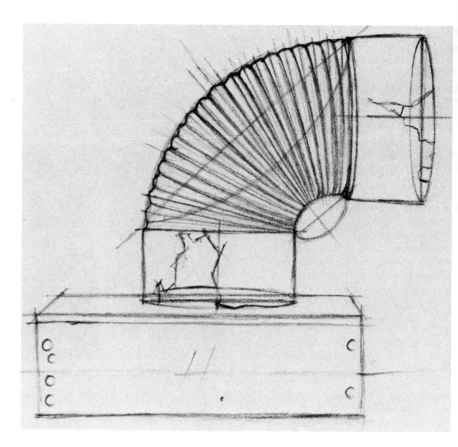

Step 4. To determine the range of values I need for creating the illusion of a rusty object, I establish my darkest darks—the cracks and holes at each end of the stovepipe—with a sharp 2B pencil. This allows me to gauge how dark the pipe should be overall to retain the correct value scale. Then I switch to an HB pencil and begin applying tones to the pipe, creating a pattern of light and dark to represent the basic forms of the folds.

Step 5. Now, with a 5H pencil, I begin building a tone over the entire object to create a darker value. Since the stovepipe is a dull object, not a shiny one, I use this darker value, rather than the white of the paper, for the few lights necessary to show its form and texture.

Step 6. Working from the base of the pipe toward the center, I begin rendering the texture, paying special attention to the value changes in each raised section. I utilize a variety of pencils for each section, using little or no pressure; instead, I allow the weight of the pencil and the softness of the lead to create each tone. Once I have rendered the elbow halfway, I begin working from the right end to the middle, gradually building up the tones until I feel I have achieved enough contrast.

Step 7. Having connected the toned areas, I complete the object by going over the earlier tones, producing darker and smoother areas to make the texture as interesting as possible. An object with this much detail and texture takes a long time to render; however, if you are patient, the outcome will be rewarding. When my rendering is complete, I spray workable fixative on it to prevent smudging.

RELIEF RUST

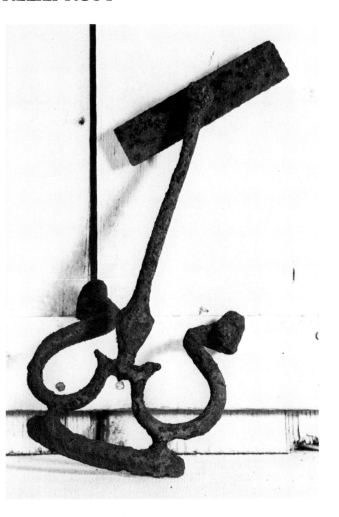

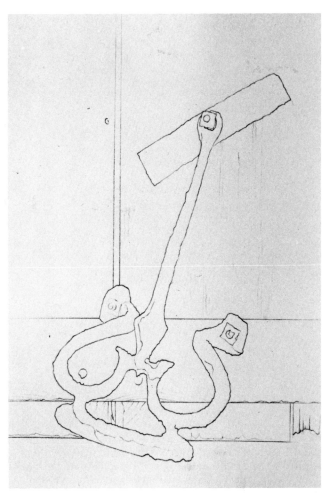

Finding an object with a heavily rusted surface may be as difficult for you as it was for me. By inquiring among friends and fellow artists, I was finally able to locate an old-fashioned boot scraper which was and still is used for scraping mud from the soles of shoes. I have placed the rusted boot scraper against a wall of white wood so that the textured object will be the obvious center of interest. Its heavily encrusted surface presents a problem different from that of the previous project; the raised texture of relief rust on a heavier metal, such as cast or wrought iron, is much rougher and more pronounced than flush rust on a thin metal strip such as tin. Any rusted object will suffice for this project as long as it has a raised texture.

Step 1. Having completed a rough preliminary sketch on bristol drawing paper with an HB pencil (utilizing checkpoints and negative space to determine placement and proportions), I refine my drawing. Still using my HB pencil, I refine the straight lines of the wood with a ruler; in contrast, I employ a wavy line to suggest the curves and texture of the boot scraper.

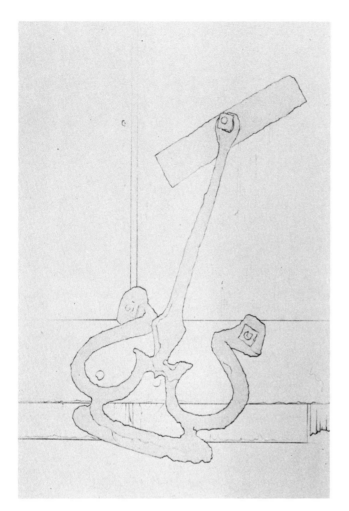

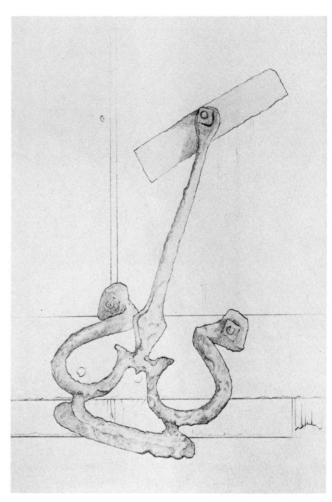

Step 2. I change to a sharp 5H pencil and begin applying a light tone to the boot scraper, building up the graphite until the tone of the object is noticeably different from that of the background. Since the boot scraper has a rough texture, the graphite can be applied quickly. The scratch lines of this first tone can be utilized later on to interpret the raised, rusted surface.

Step 3. Over my first tone I begin applying a darker value with a 2H pencil to suggest the shadows created by the many areas that are in relief. In a simplified manner I am already interpreting the texture of the object with these shadows. As I apply this new tone, it's important to work in each specific area long enough to understand and build up the form and texture correctly.

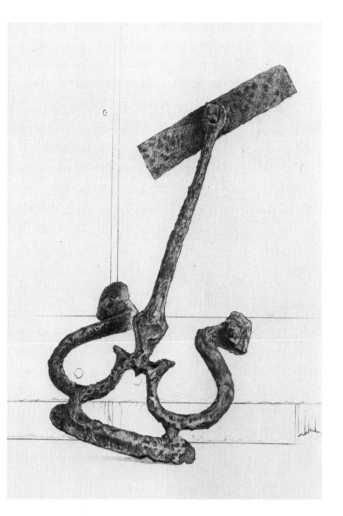

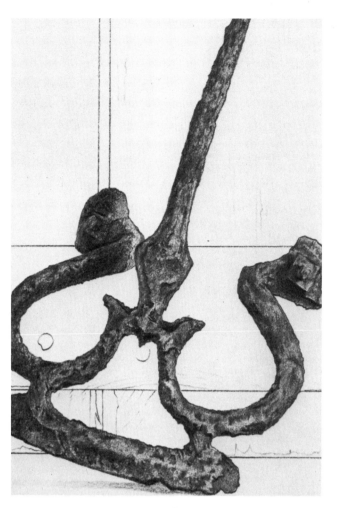

Step 4. Alternating between sharp HB and 2B pencils, I begin applying the darkest values to the object. Working from top to bottom allows me to be systematic so that I can interpret the texture correctly without getting confused. Constantly I switch from one pencil to the other, either smoothing the graphite with a hard pencil or applying a darker tone quickly with a softer one. The raised surfaces have a lighter value than the shadows, which have darker values and recede. I do not concern myself with making an exact copy of every nuance of the texture; I only want to create a realistic impression of the texture in my finished drawing. Finally, I protect the completed drawing with workable fixative.

Step 4 (detail). This close-up of the boot scraper shows the various shapes of the tones and the rough way in which the graphite was applied.

SOFT PAPER

When selecting an item for this project, it is important to choose soft paper that will not be confused with cloth. For this reason I have chosen a roll of toilet tissue, unraveling part of it to create a flowing composition. The soft tissue is self-explanatory because of its shape alone, and you do not have to rely on the tones to make it identifiable.

Step 1. With an HB pencil on bristol drawing paper, I begin constructing the roll as a cylinder, utilizing a center line to establish its direction and axis lines for the width and depth of its ellipses. Next I sketch the unrolled tissue, using checkpoints and negative space to position it properly.

Step 2. To create a finished line drawing, I erase the rough sketch with a kneaded eraser and refine it with a sharp HB pencil. I refine the sides of the cylinder with a ruler, and I carefully create smooth, flowing lines to describe the ellipses of the cylinder and capture the softness of the unrolled tissue. Now I change to a 5H pencil and draw light boundary lines to suggest the correct location of various tones.

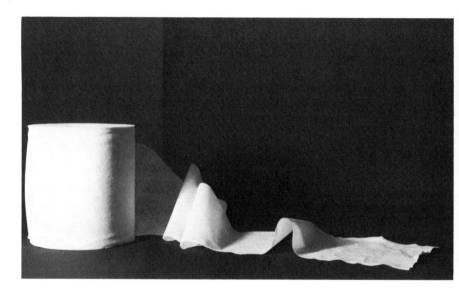

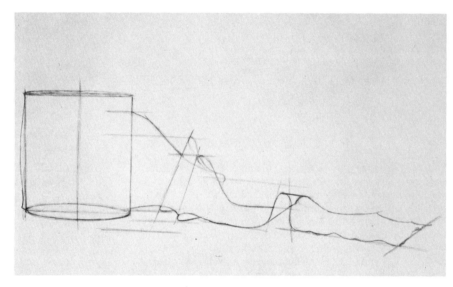

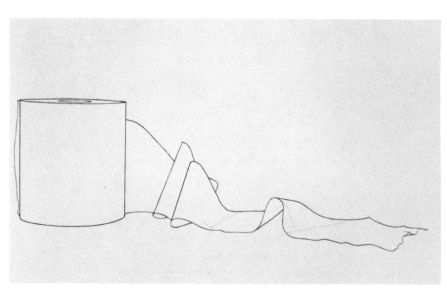

Step 3. With my 5H pencil I apply graphite smoothly to the entire object, leaving only a few areas of the paper untoned to represent the lightest tone. The first tone is applied as smoothly as possible to describe the texture of the tissue correctly.

Step 4. With a sharp H pencil I start to apply a new tone—again, as smoothly as possible—to create a more three-dimensional illusion of form and depth. Gradually I blend this new tone into the tone I applied previously, to ceate a smooth, even gradation from one value to the next.

Step 5. To complete my rendering of the toilet tissue, I alternate between HB and 2B pencils to darken the values and create stronger contrasts between light and dark. This strong pattern, with its wide range of values, adds more interest to my overall drawing as well as makes my interpretation of the roll of tissue more true to life. To make the unrolled tissue appear to be resting on a surface, I also add shadows. As always, I spray the finished rendering with fixative.

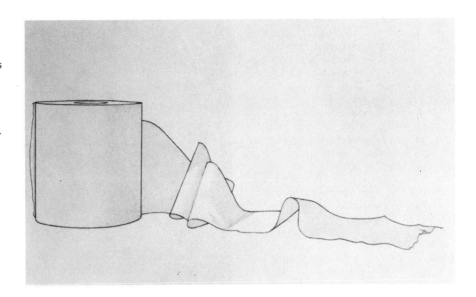

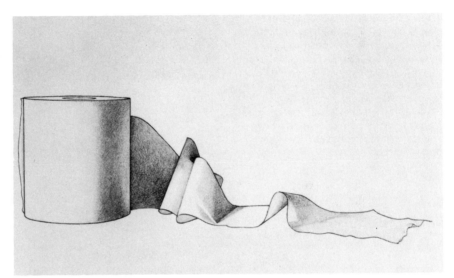

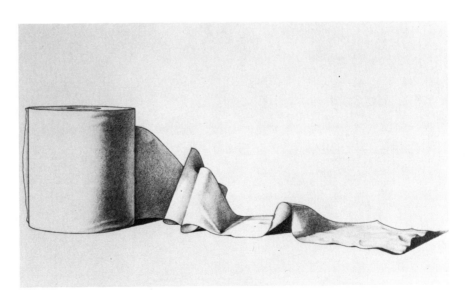

STIFF PAPER

I suggest for this project, as for the preceding one, that you select an object that has a self-explanatory shape so that you can concentrate on rendering surface texture instead of being concerned with making the object identifiable. I have chosen to render a crumpled sheet of notebook paper (the paper bag will remain as a line drawing), but I recommend that you start with a less complicated object such as a stiff paper bag or even a paper airplane. Stiff paper has well-defined planes, but many artists get so involved in rendering every single facet of crumpled paper that they overwork their drawings and the object loses its recognizability. You can avoid this danger by making sure that your line drawing reproduces the actual object as closely as possible—including the placement of toned areas—before you begin to apply tone.

Step 1. Using an HB pencil on bristol drawing paper, I do a rough layout of the objects, from which I reconstruct a clean line drawing. Since the paper bag will be left in line, I accent it by using varied lines. The darker lines will pull forward, and the light ones will recede, creating depth. I also do a finished line drawing of the sheet of paper to be toned, lightly adding lines to indicate where the various divisions of tones will occur.

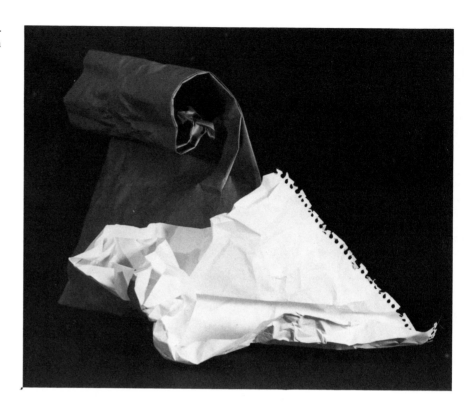

Step 2. I change to a 5H pencil and begin applying a tone to various facets of the paper, establishing my value pattern early. Leaving white paper showing for the lightest value, I cover all the other areas with the first tone. Some of these values will be darkened and therefore differentiated in the last step.

Step 3. After switching to an HB pencil, I gradually begin building up the darker values, frequently squinting at my drawing to make sure the contrast between the lights and darks is the same as on the actual object. When the major folds have been established, I continue to rework the entire drawing, adding subtleties and smoothing the softer graphite tones with an 8H pencil.

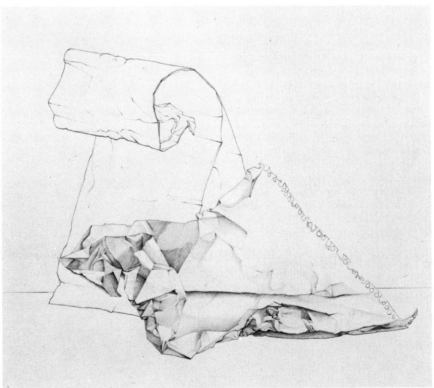

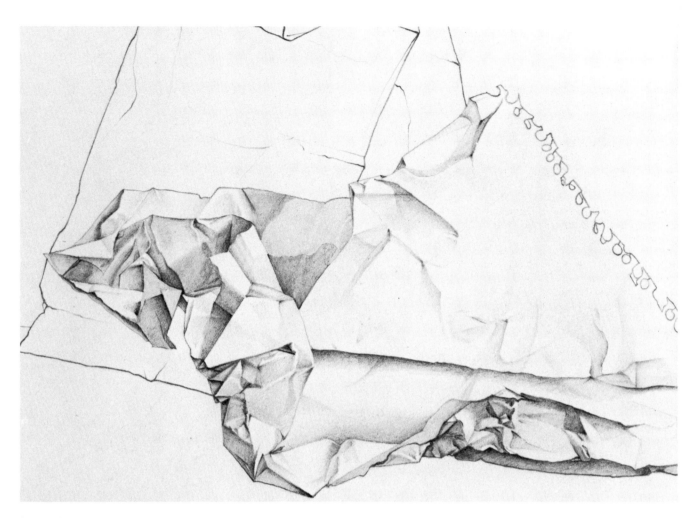

Step 3 (detail). This close-up of my rendering shows the distinct value changes in the crumpled paper as well as the various abstract shapes that characterize stiff paper. Note the limited use of extreme darks—they are used only to create depth in specific areas. This sharp contrast, within a value range that is relatively high in key, makes the lights pull forward and pushes the darker areas back. Notice that value changes are more abrupt in stiff paper than in soft paper, which tends to fall into soft folds requiring smoother gradations of tone.

SOFT CLOTH

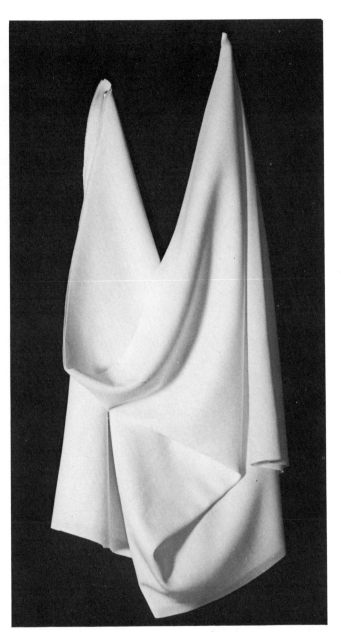

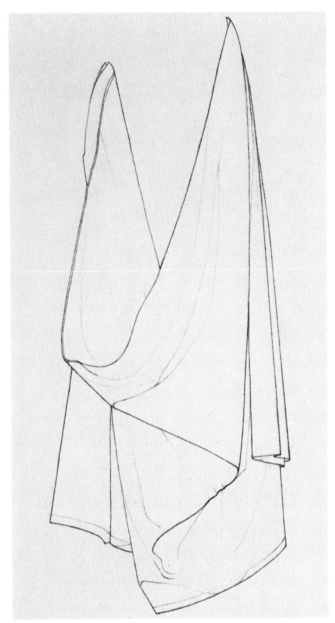

When I first considered drawing the texture of cloth, a handkerchief was the first item that came to mind, but I had difficulty deciding whether to classify it as a soft fabric or a stiff one. It was necessary to make a trip to a local fabric shop to purchase the best examples for this project and the next one. For rendering soft material I chose a piece of white polyester which has a soft, flowing character. When hung, it drapes softly, creating an appropriate example for this project. You may use any soft material that has the same characteristics. Use a solid-colored fabric rather than one with a distracting pattern or texture. To set up your material, either tape or pin it to a vertical surface and drape it so that it creates an interesting set of folds.

Step 1. With an HB pencil on bristol drawing paper, I construct a finished drawing from my initial rough layout. To capture the character of the soft material, it is necessary to use smooth, flowing lines. Very lightly, I indicate where the divisions of the various tones will be located, outlining the correct shape, size, and location of each area.

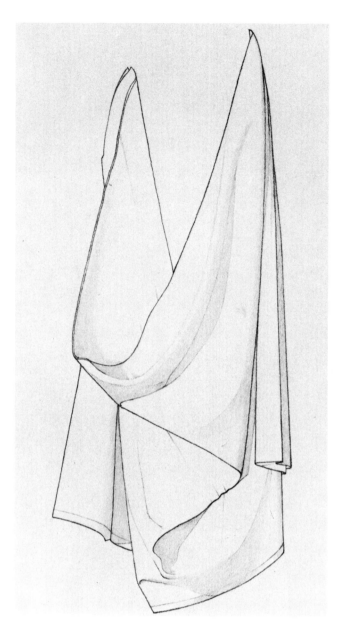

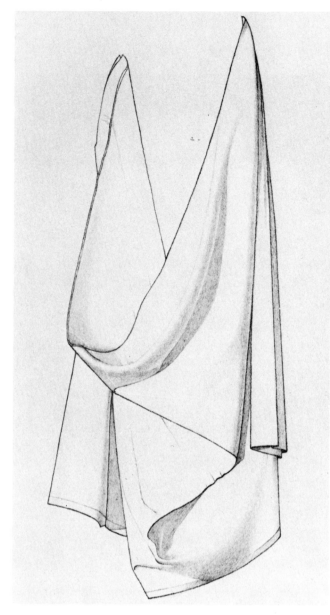

Step 2. Utilizing the divisions I have just outlined for the areas to be toned, I begin applying a light value to establish the value pattern. (I will build upon this pattern in the next few steps.) I apply this preliminary tone smoothly, gradually building it up with a 5H pencil until I feel I've created enough of a value change from the white of the paper. Remember, the texture of soft cloth is smooth, and so the application of the graphite should also be smooth.

Step 3. Using a sharp 2H pencil, I begin creating a second value, darker than the previous one, to give form to the material. I build up this new value slowly so that I have total control over how dark or light the tone will be. I do not use an eraser, for it could destroy the surface of the paper and detract from the character of the object.

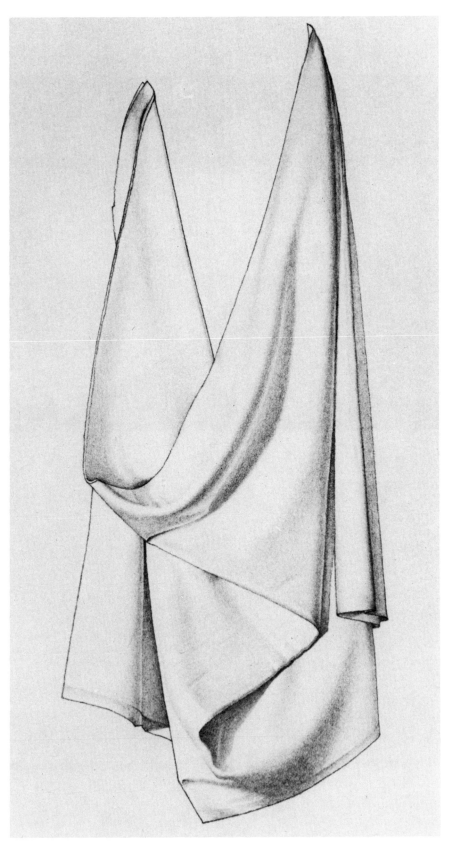

Step 4. This is the final step. Using an HB pencil, I begin applying the darkest value, creating a stronger appearance of depth. This new value also creates a stronger contrast of light and dark values, which makes for a more interesting interpretation of soft material. Notice, however, that I use these darks selectively, and that the overall values of the cloth are light. Working back into the drawing with an 8H pencil, I add many subtle tones in the lighter areas to convey a more realistic impression of the material. Smooth, subtle gradations of tone contribute to the appearance of softness. Finally, I apply workable fixative to the completed drawing.

STIFF CLOTH

For this project I have chosen a heavy, can-vaslike material called cotton duck. It pro-duces sharper, more angular folds than soft material. By tacking the fabric onto a vertical support, I have designed a pleas-ing arrangement of folds which best de-scribes the stiff character of the cloth. There are also some flowing lines, as in the soft cloth, but the creases that appear elsewhere ultimately describe the fabric as being stiff.

Step 1. As usual, I do a rough layout of my composition with an HB pencil on bristol drawing paper, and then I refine my sketch until I have a finished line drawing. Since the material has a free form, compared to many of the objects in previous projects, I draw it in a less restricted fashion. Next I change to a 5H pencil and delineate the areas where the tones will be. When I am ready to render the stiff material in tone, these guidelines will help me achieve exactness.

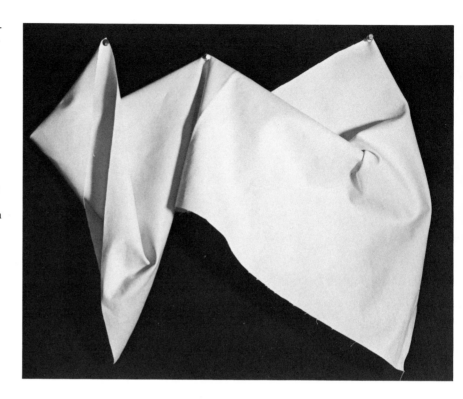

Step 2. With the 5H pencil I gently tone the shadow areas and creases, creating a basic value pattern from which to work. Since the cloth is light in value, I restrict this tone to just these few areas at this stage; in the next few steps I will build upon it to create an exact interpretation.

Step 3. To differentiate the areas of the material which recede, I apply a darker tone with a 2H pencil. I still keep the pattern of tones simple, however, so that they will not become confusing.

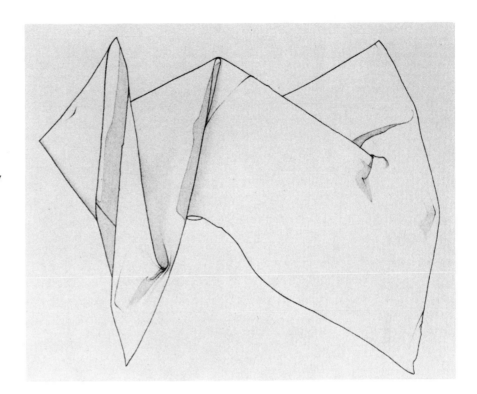

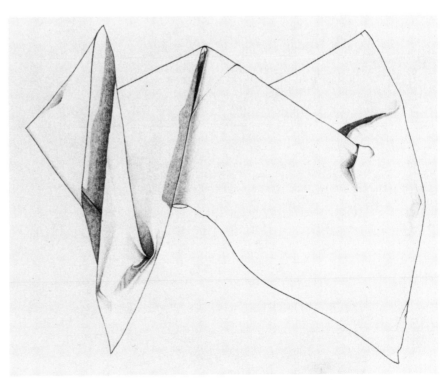

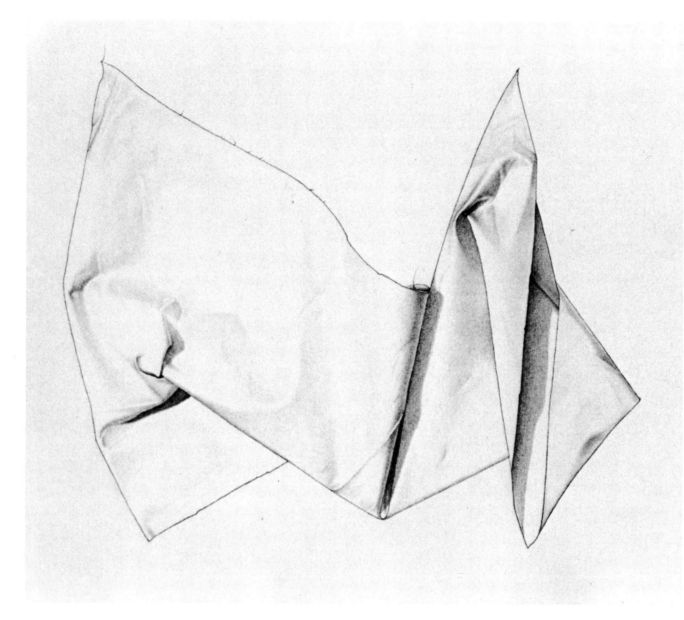

Step 4. Using an HB pencil, I apply many subtle tones within tones that I have already established, creating rolls and crisp folds. Then I take an 8H pencil and create delicate tones in the lighter areas, making even finer distinctions which help to describe the stiff material. I spray workable fixative on the finished drawing to preserve it and prevent smudging.

ROUGH STONE

The subject matter for this project is a rough stone. Manufactured substitutes such as bricks or cinder blocks do not qualify as stone, for they have their own characteristics. Try to find an irregular, textured chunk of rock such as fieldstone; if it is a broken piece, that is all the more desirable, for it will expose more planes that you can utilize in your drawing. To create a more interesting picture, put a few other elements in the composition along with the main object.

Step 1. I complete a rough block-in of my composition on bristol drawing paper with an HB pencil, and then I refine it to create a finished line drawing. I complete the bricks which surround the main object entirely in line, including all the cracks and chips. Within the fieldstone I also indicate light boundary lines which define the correct tonal areas. Because I have drawn the objects with a rough, textured line, it is possible to visualize their texture at this stage, even without having applied any tones to them.

Step 2. With a 5H pencil I tone the entire object with two separate values. These two values differentiate the lights from the shadows and give me a better understanding of where to place other values later on. I don't need to apply the graphite smoothly because the general texture of the stone is rough.

Step 3. Now I break the stone down into another value, using a 3H pencil. This tone establishes where the darker values are going to be placed, and it introduces reflected light to the top and side planes. The rock now has stronger value contrasts and begins to take on the appearance of an object with light falling on it. Still, I keep the shapes simple.

154

Step 4. I change to a 2H pencil and build up a darker value in the areas which receive the least amount of light. This darker value is located at the closest edge and blends into a slightly lighter value which adds yet another area of reflected light. Still I keep the shadowed planes simple in shape.

Step 5. Working on one small area at a time, I begin referring to my actual subject very closely. Using a variety of different pencils—ranging from an 8H to a 2B—I begin creating the many textures on the surface of the stone. Once a particular area is complete, I move down and across the paper in window-shade fashion until my object is completed. To capture the full effect of a rough stone, do not neglect the many subtleties you see. If a tone is too dark, do not hesitate to try tapping it lightly with a kneaded eraser. This technique also may create an interesting texture.

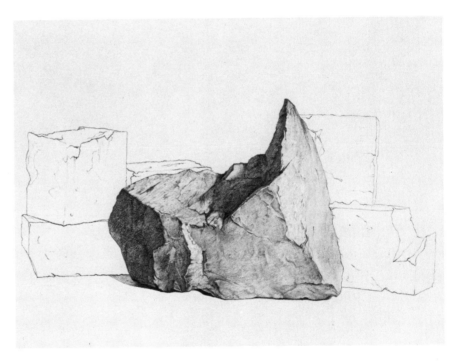

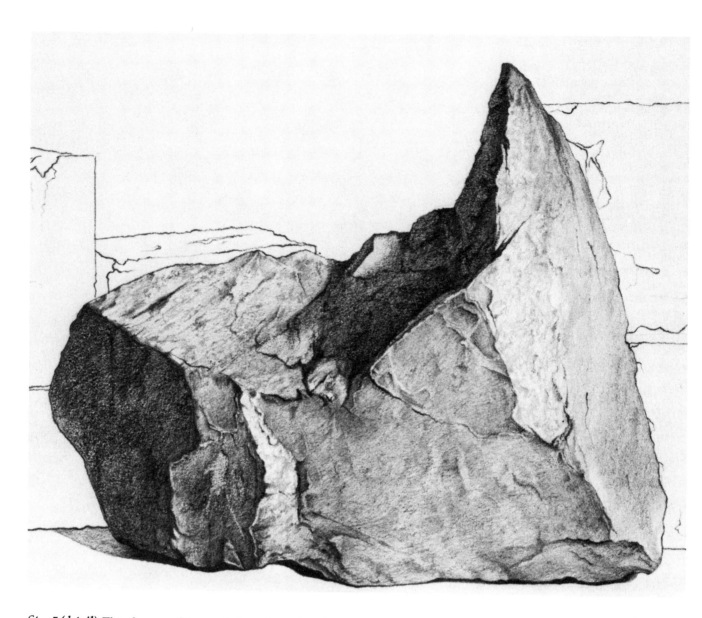

Step 5 (detail). This close-up of the rough stone shows the subtleties of tone and texture that describe its character to the fullest. It is not an obsolutely literal rendering of my subject, however. I feel that improvising an area is fine if it helps the general appearance of the texture. After all, we are artists, not cameras.

SMOOTH STONE

A smooth, rounded stone like the ones in this setup resembles a petrified potato. It has no planes—just the many small indentations that look like the "dimples" in a potato. For your setup, a stone like this one or even a polished stone will suffice as long as the stone is intact and has no distinct planes. As in the previous projects, other objects—in this case, similar stones—have been placed in the composition to add more interest to the overall rendering. When setting up your grouping, remember that your center of interest, which will be rendered in tone, should be seen in its entirety; create your composition accordingly, and do not obscure your center of interest with other objects. This will prevent your creating a drawing that would look unfinished.

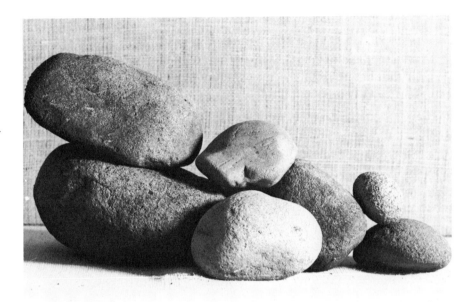

Step 1. First I block in the elements of my composition with an HB pencil on bristol paper, and then I refine my sketch until I have a finished line drawing. In line I create the surface textures of the rocks that will be left as line drawings. I try to give them character marks with a 5H pencil, keeping them light so that they will not detract from the completed rendering.

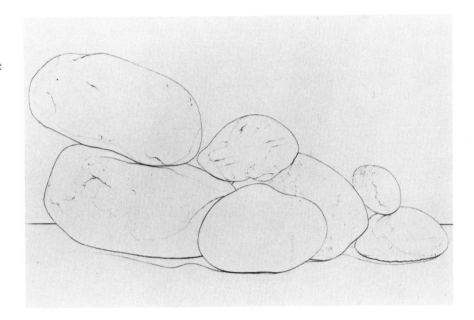

Step 2. With my 5H pencil I begin applying tone to the shadow areas of the center stone, creating a value pattern from which to work. I establish both the shadow side of the center stone and the cast shadow with the same tone so that from the beginning they are consistent in value. Naturally, I apply the graphite smoothly in order to render the smoothness of the stone's surface.

Step 3. Now I change to a sharp 2H pencil and darken both the shadow side of the stone and the cast shadow. Within the stone, however, I don't bring this darker tone all the way to the edge; instead, I leave a little of the tone from Step 2 showing to indicate reflected light along the bottom and left side. The darker tone and reflected light are blended smoothly into each other, and the stone begins to take on three-dimensional form.

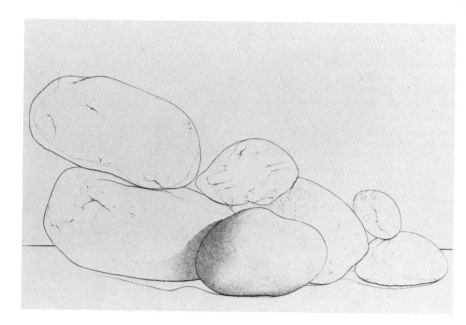

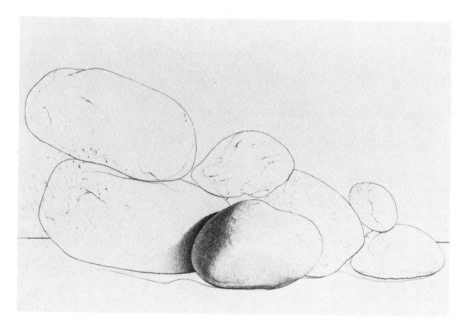

Step 4. Using an HB pencil, I begin emphasizing the slight irregularities in the surface texture. I utilize the tones I produced in earlier steps and I darken them here and there in small areas to create creases and indentations. I do this at random, simulating the texture of the stone rather than producing an exact copy. I spray workable fixative on the finished rendering to pevent smudging.

Step 4 (detail). This close-up of the smooth yet pitted stone shows the technique I used to create the texture. For the larger holes I referred to the object itself, but for the smaller holes I found that a zigzag scribble produced an adequate interpretation of the texture. Remember, experiment to create various textures. You will find your own distinct way of interpreting objects in a realistic manner.

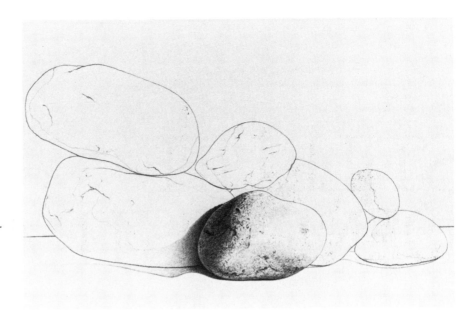

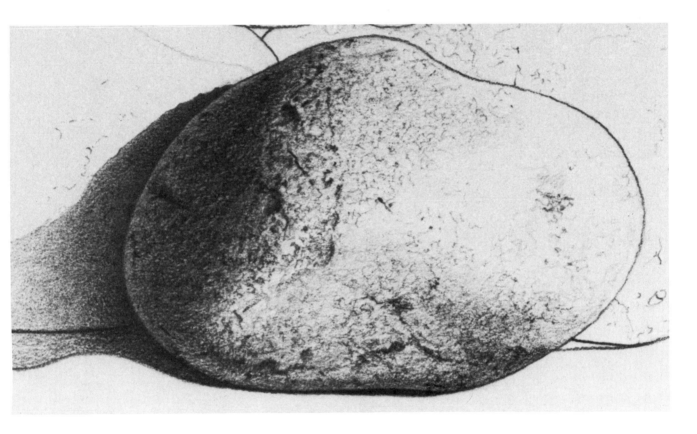

STILL LIFE
DEMONSTRATIONS

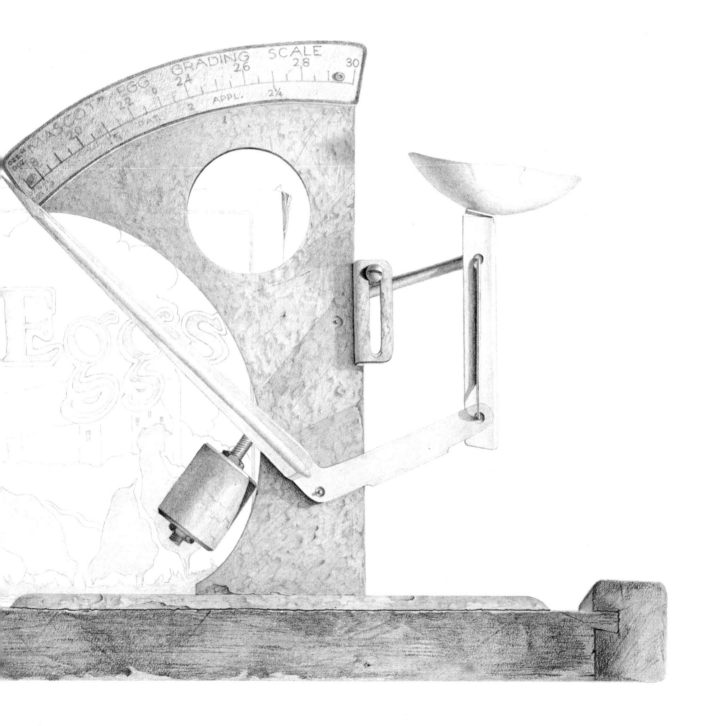

In the following demonstrations I will present several different approaches to drawing inanimate objects: a "product" rendering, in which I do an extremely realistic drawing of a single object against the plain white background of the paper; a pleasing still life composition of natural objects and textures; a drawing in which the objects are partially "cropped" out of the picture area; and a trompe l'oeil, or "fool the eye," drawing in which the objects look photographically real. By introducing you to these approaches, I hope to show you new ways of looking at familiar objects as well as unusual objects that you may never have considered drawing before. In each demonstration I will briefly give you some insights into my approach, and then I will show you, step by step, how I create the finished picture in line and tone.

Although these demonstrations build upon everything I have discussed earlier in this book, there is a difference—for they are *not* projects, but rather demonstrations of my own drawing processes. Up to this point I have tried to present a wide range of techniques which will enable you to achieve many different effects in your own still life drawing. But once you have mastered these drawing methods, it is up to you to determine what you will do with them, for that is the role of each individual artist. The demonstrations which follow present *my* artistic choices, and I think a few words about composition are in order here, for composition plays a strong role in my drawings.

In composing the elements of a drawing, the artist must decide what the center of interest will be and how he or she wants the viewer's eye to move around in the picture. This movement can follow the direction of a particular shape, whether it is an abstract one or the shape of a number or letter—such as an O, for example. How many times have you looked at pictures which led your eye around in a circular motion? This is only one of the many ways of creating an interesting compositional arrangement.

Whenever composition is a topic of conversation among artists, the question of "rules" arises—what can and cannot be done in a good picture. It's often considered taboo to place a dominant object in the exact center of a picture or to lead the viewer's eye diagonally from corner to corner, but as far as I'm concerned, if you can make these devices work, fine. Composition is one of the most important factors, along with the quality of the line drawing, in determining the strength of a finished picture. The tones which the artist adds are just the frosting on the cake, giving flair to the finished product.

You may be wondering why I am making such a big fuss about composition. But many aspects of art are involved in creating a successful finished picture, as I am about to demonstrate, and the artist must take all of them into account. Thus, the composition, the finished line drawing, and the way the objects are interpreted in tone all play important roles in this section of the book.

THE PRODUCT RENDERING

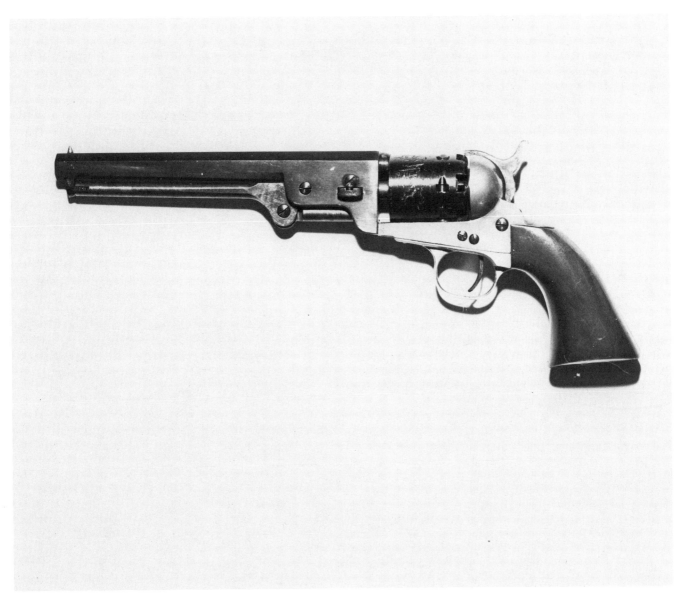

Many times an object can be interesting all by it-self, and to produce a rendering of it which por-trays its interesting character can be both chal-lenging and fun. *Product rendering* means just what the term suggests: the rendering of a single prod-uct or item by itself. Of course, this type of draw-ing has only one center of interest and therefore doesn't pose the compositional problems you might encounter with a grouping of objects. Any

object can be used for a product rendering as long as it has character and its shape would look inter-esting against the white background of the paper.

The object I have chosen for this drawing is an antique revolver. For a long time I had been inter-ested in rendering a revolver of some sort, and when a student and good friend showed me this particular one, I knew it was the one to draw.

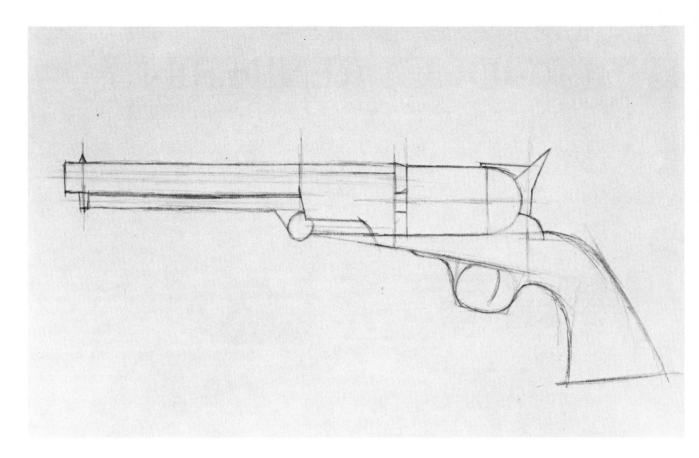

Step 1. To construct a rough sketch of the revolver, I begin draw-
ing the basic shapes with an HB pencil on bristol drawing paper.
By utilizing these rectangles, circles, triangles, and squares, I eas-
ily create a basic foundation from which to render the revolver.

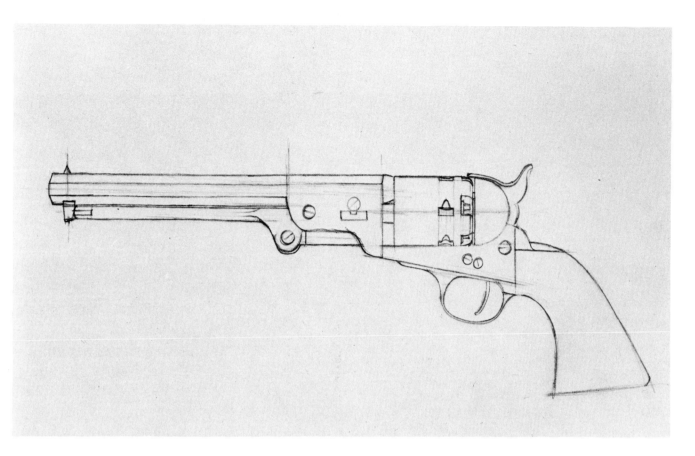

Step 2. Still working with the HB pencil, I begin to add more specific elements to the object. By the time I have refined the shapes of the hammer and handle and have introduced many of the smaller details of its construction, the revolver has begun to take on a more realistic appearance.

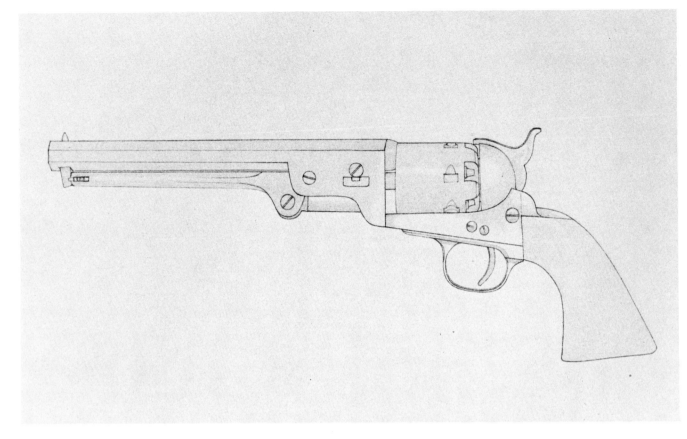

Step 3. With an HB pencil sharpened to a needle point, I begin
refining my drawing. I use a ruler for all straight lines but draw
everything else freehand, using no french curves, templates, or
other aids. When the pistol has been refined to a finished line
drawing, I change to a 5H pencil and begin applying a light tone
to those areas which receive little or no light. This tone estab-
lishes the shadow areas within which I can locate the darker tones
more readily. I have left the white paper showing wherever I want
highlights. I apply the various tones to the revolver in a smooth
fashion so that I can achieve an exact interpretation of its original
texture.

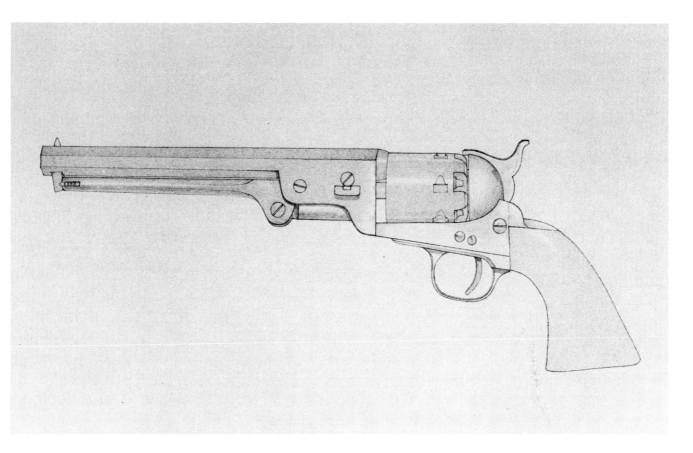

Step 4. Still using my 5H pencil and building up the graphite, I create a darker value, which begins to suggest the three-dimensional forms of the barrel and cylindrical chamber of the revolver. This newly applied tone enables the extremely light areas to be recognized more easily, and the greater contrast creates a more elaborate value pattern from which I will develop more refined tones.

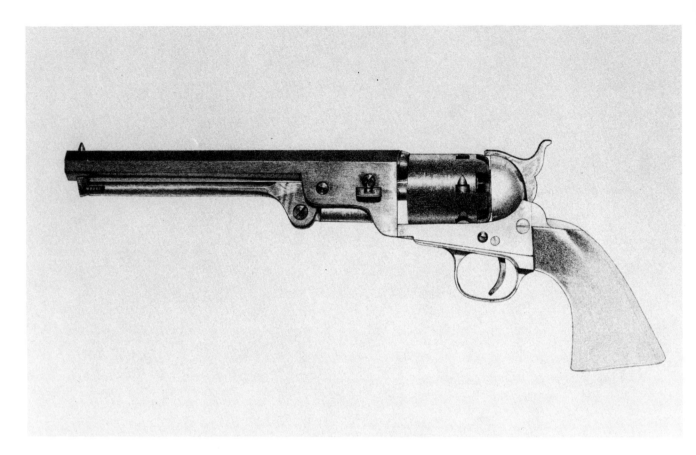

Step 5. To begin refining the revolver, I use several pencils ranging from 5H to 2B, continuously switching pencils to produce the many values in the darker range. I establish the darkest value on the barrel by building up the graphite gradually; I relate the many other values to this one. The handle, which is not yet complete, is the last section of the revolver to be toned; I render it from left to right, window-shade fashion, to keep the tones smooth and even.

Step 6. To complete my product rendering of the revoler, I darken many of the values I applied in Step 5, creating a more dramatic effect. With an 8H pencil I go over the entire rendering to smooth the graphite and fill in all the indentations in the paper. Then I apply spray fixative to the completed rendering.

NAVY CAP AND BALL *4 x 10 in. (10 x 25 cm)*

STILL LIFE

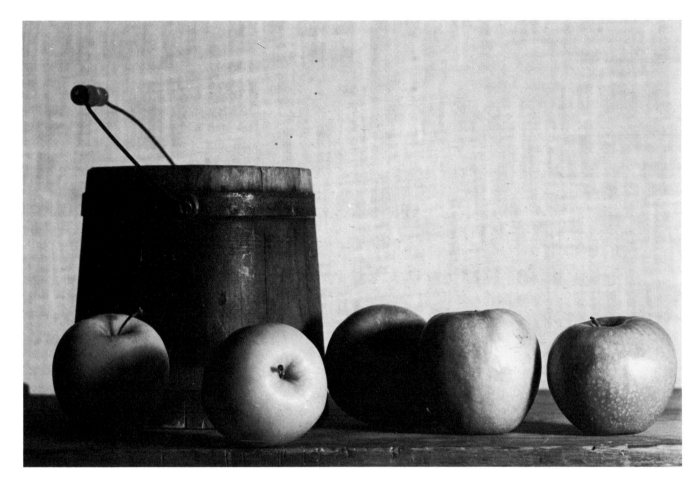

Selecting and arranging props in a pleasing composition is an important aspect of many of the projects in this book. Creating a complete, fully rendered layout of objects results in a picture with a more finished quality. Capturing the various textures and the value patterns created by a light source will understandably take much more time. But the amount of time spent on a particular piece does not matter as long as the outcome is successful.

For this still life I have chosen a small wooden bucket surrounded by five apples. It is not a con-fusing picture, but rather an elegant arrangement of the elements in a simple and easy-to-view still life. Leaving the area behind the objects plain makes it possible for the objects to be read easily without background distractions. My composition includes the shelf or tabletop on which the objects rest so that they won't appear to be suspended in the air. Any number of objects can be placed together to form a still life, and they don't have to relate to one another so long as the grouping is pleasing to look at and the technique used in rendering them is appropriate to the subject.

Step 1. Using vertical and horizontal checkpoints to guide me, I begin roughly sketching my still life on bristol drawing paper with a sharp HB pencil. The objects are sketched only as basic shapes with very little detail. I achieve symmetry in the bucket by using a center line which determines its main direction. This enables me to make one half of the bucket closely resemble the other half.

Step 2. To refine my original sketch, I erase it lightly with a kneaded eraser, and then, using a sharp HB pencil, I carefully begin to redraw my grouping over the traces of the rough sketch. I try to reproduce the character of each and every object as accurately as possible. I suggest the texture of the wood in line and the contours of the other objects with a 5H pencil. I also indicate the areas where I will apply the tones in the next step. I use a ruler for the lines of the bucket and the rear of the shelf, where straightness is essential.

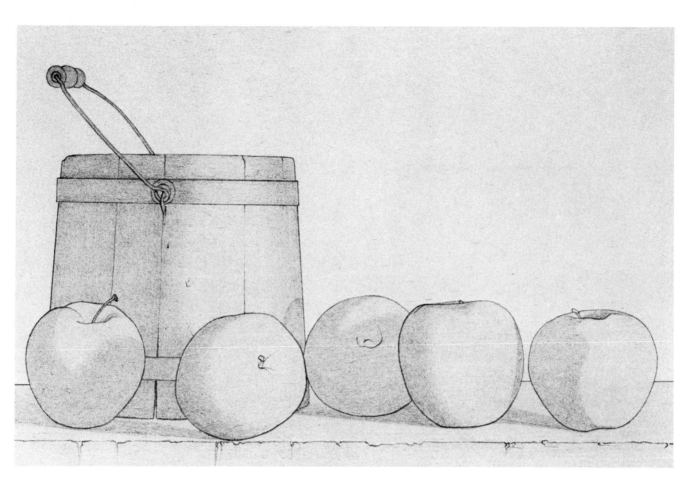

Step 3. This step involves two separate tones. First I separate the shadow from the lights with a 5H pencil. Smoothness is essential in applying tone to the bucket and the apples in order to capture the slick appearance of smooth wood and the polished surface of the apples. Then I apply a second tone, creating a stronger value pattern of lights and darks. This second tone is also applied smoothly, again with a 5H pencil. When a darker tone becomes necessary, I will switch to the softer 2H pencil.

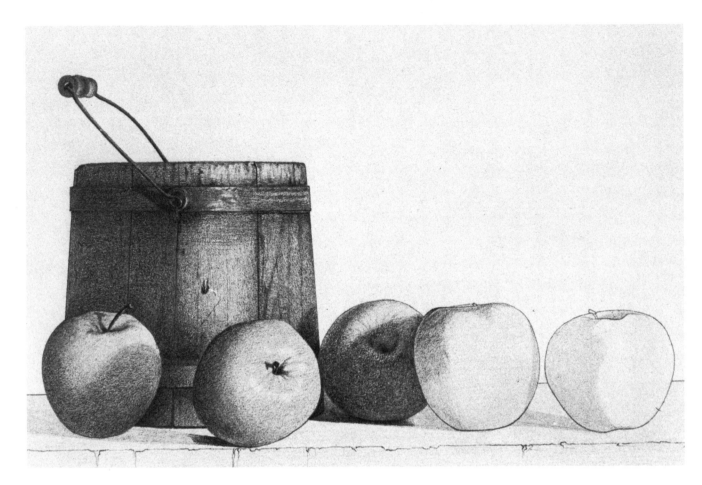

Step 4. In this step the most drastic changes appear. Paying special attention to each object, I begin by refining the wooden bucket. It is important to achieve a value pattern, in this case some of my strongest darks, to which I can relate the values of the apples. I continuously build up the graphite using a variety of pencils, ranging from a 2H to a 2B. Next I refine the apples. A variety of values is also necessary here to show a contrast between one object and another.

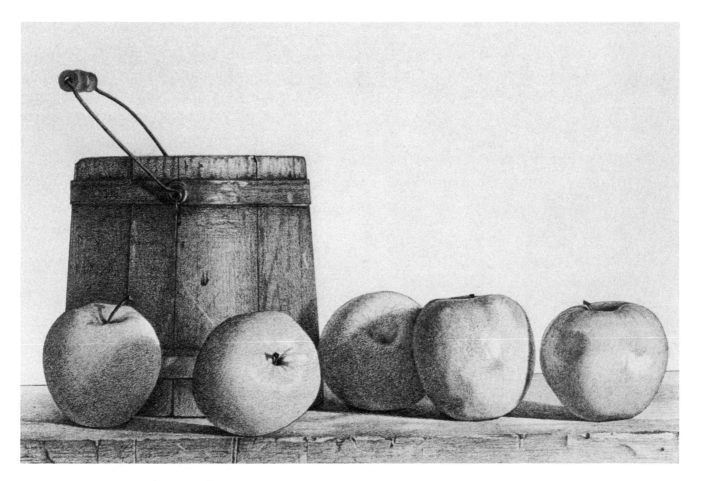

Step 5. There is only a small progression of changes from Step 4 to this one. Here I complete the textures of the apples and the shelf, adding more variety. The apples on the right have more texture than the others, and the bruises are clearly visible, but the shelf helps subdue the apples so that the light areas can be seen more easily. By continuously reworking areas and darkening the values, I strengthen the value pattern. I add slight variations to the bucket and a wood-grain pattern to the shelf. Finally, I spray workable fixative on the completed still life, to prevent its smudging.

JUST PICKED *6 x 10 in. (15 x 25 cm)*

CROPPED OBJECTS

I wanted to create a picture consisting of bottles, but they are so ordinary. How could I compose it in a way that would be different? I began arranging and rearranging a group of bottles, but everything seemed too traditional, and so I pulled out my croppers. "Croppers" are two L-shaped pieces of cardboard; with them I can form a square or rectangular frame through which to view a section of my total setup to create a composition. I took my bottles and lined them up as if they were toy soldiers, and then I viewed them through the oblong rectangle I created with the croppers. "That's it," I decided. "I'll do a drawing of just the bottle necks, playing their various shapes against a white background to create a contemporary drawing." I don't believe in giving up hope on a good initial idea. When I use croppers, I am usually successful in finding new ways to present objects.

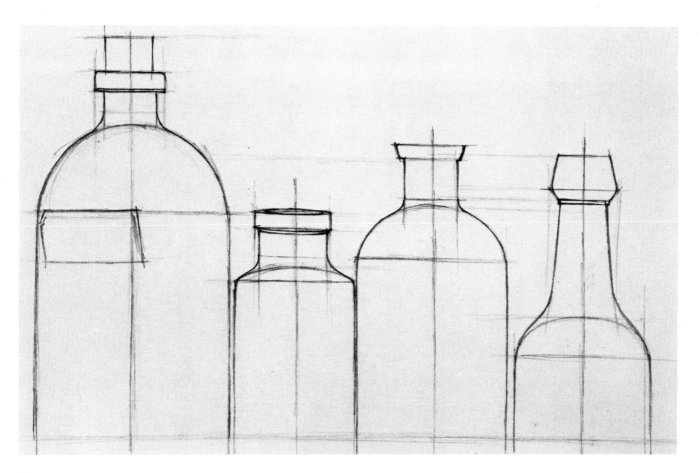

Step 1. On a sheet of bristol drawing paper, using a needle-sharp HB pencil, I begin roughing in the objects. I relate to the bottles only as shapes, not as bottles. Each shape is symmetrical, and so using a center line is essential. I draw the bottle on the extreme left first, since it's the tallest, in order to relate the other bottles to it. Horizontal and vertical checkpoints guide me in placing the objects correctly and achieving symmetry, which must be established with some degree of precision in this initial step.

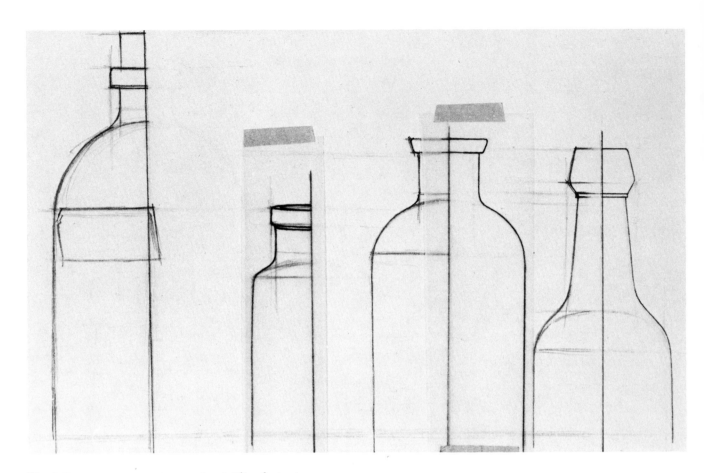

Step 2. To create more exact symmetry, I utilize the tracing paper method to construct each bottle. I trace the better half with a soft, sharp 3B pencil and then flip the tracing paper over; I match the center lines and then trace the remaining half with a sharp 3H pencil. Now I am able to create the exactness I need for the total effect of this picture.

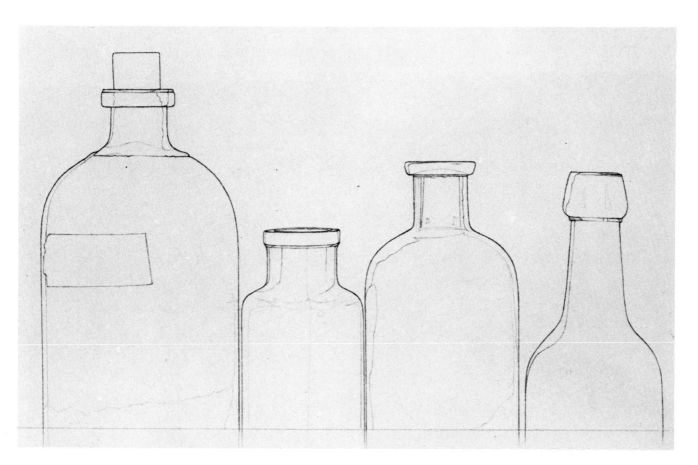

Step 3. I lightly erase the drawing with a kneaded eraser until only a slight indication of the bottles is visible. From this vague impression I am able to create a cleaner, truer interpretation of my cropped objects, using a sharp HB pencil. I delineate various reflective areas, outlining where tones will be applied. The lines of these reflections are kept very light so that they will not conflict with any light tones which I may use.

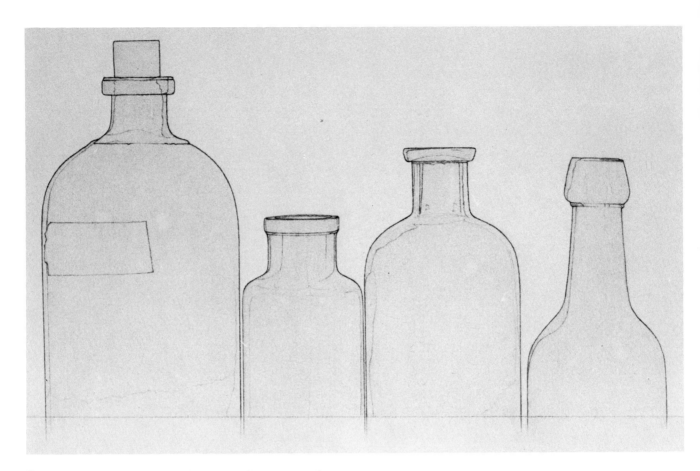

Step 4. Using a sharp 5H pencil, I begin to apply a tone over the entire grouping, leaving only the highlights untoned. This first tone is only as dark as the lightest tone on the bottles themselves. I darken it just enough to create a contrast between it and the highlights so that the bright spots will stand out.

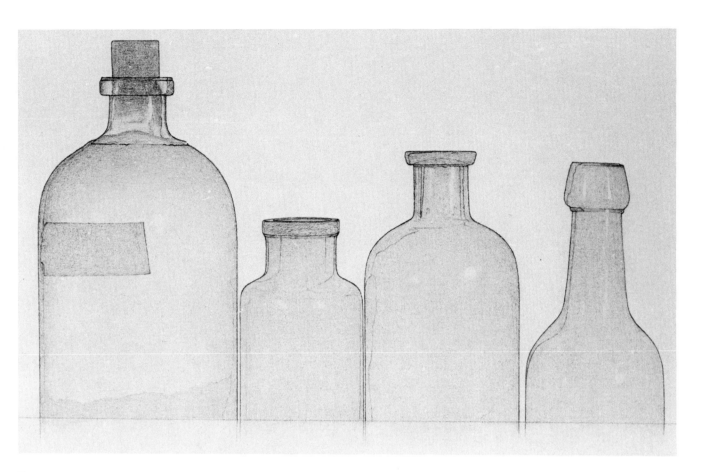

Step 5. Still using the 5H pencil, I build up the graphite in certain
areas to produce yet a darker value. With this new value the
bottle on the left begins to take on three-dimensional form and
the illusion of transparency. The other bottles still look flat. Re-
member, their surfaces are smooth, and so the application of the
graphite must be smooth in order to create the appearance of
glass. Notice how the highlights begin to show more clearly
against this newly established value.

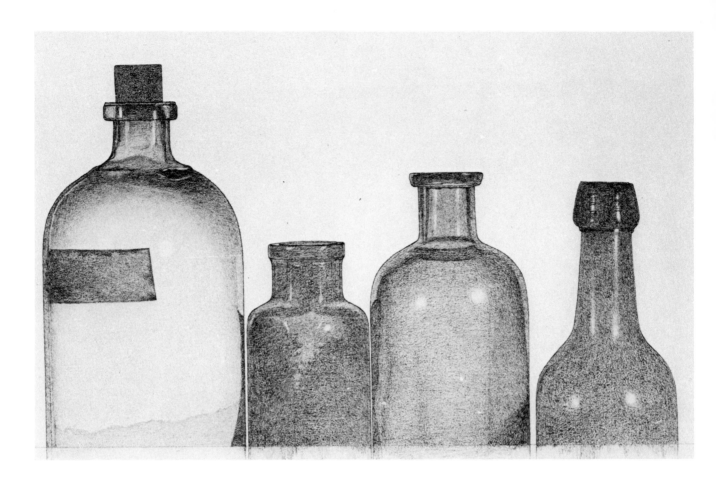

Step 6. Now I bring each bottle closer to its respective value to create a transparent effect. I switch from hard to soft pencils (ranging from 5H to 2B) and back again as many times as needed to capture the tones for each bottle.

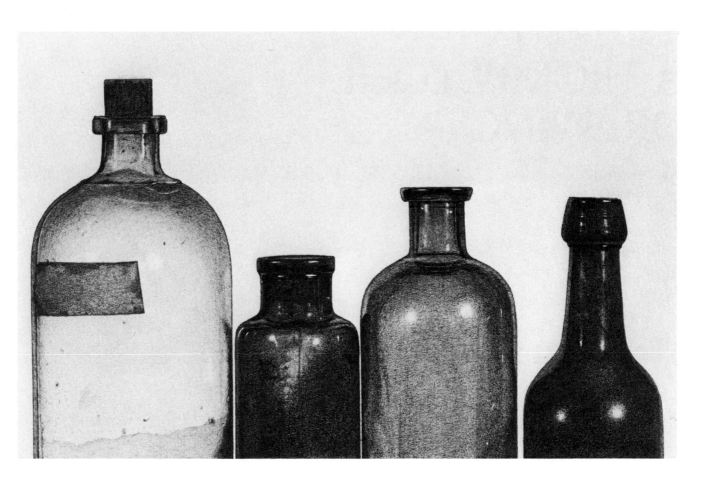

Step 7. To complete the drawing I continue building up the graphite to provide the deep tones necessary to bring the objects into sharp focus. I use sharp HB and 2B pencils to provide a rich, almost black tone, which cannot be produced with harder pencil leads, to provide a greater contrast of values. By moving these sharp pencils gently in small circles, I am able to fill in the indentations of the paper to create a smoother effect. Going over the entire drawing with a hard 8H pencil many times serves to smudge and blend the darkest tones and also creates the smooth appearance of glass. When my grouping is completed, I spray it with workable fixative.

TRANSPARENT FORMATION *6 x 9 in. (15 x 23 cm)*

A TROMPE L'OEIL DRAWING

I cannot conclude a book on sharp focus drawing without demonstrating a "trompe l'oeil." The term, meaning "to fool the eye" in French, refers to a picture rendered so realistically that the viewer is convinced the objects are real and can be touched. A true trompe l'oeil is most convincing when done in a paint medium such as oil, since the artist can work in full color rather than black and white; however, it is also possible to achieve astonishingly realistic results in a black-and-white drawing.

All "trompe" arrangements have in common a distinct background to which are attached various elements that create the illusion of a depth of only about two or three inches. A typical example might be a bulletin board with many messages and notes fastened to it with pins, tape, and possibly even a pen or pencil dangling from a string. Other elements such as darts or even a wad of bubble gum might be stuck to the board.

The manner in which a trompe is arranged and

executed broadens one's creativity. I often tell my drawing students at the Paier School that their trompe l'oeil should be the tightest, most accurate drawing they will ever produce. When I put it this way, the students become aware that many hours of work will be necessary for this project in order to capture all the minute details and textures as exactly as possible.

For my trompe l'oeil drawing I have chosen a textured section of a white wooden door, to which I have attached a string. I use thumbtacks to establish and secure the string pattern, and a nail pulls the string away from the background so that the origami bird appears to be flying. Since the center of interest is the paper bird, I feel the empty area to its left needs another element besides the string, and so I adjust the light source to create an interesting shadow. Now I am ready to draw—and prepared for the fact that my sharp focus trompe l'oeil rendering will take a lot of time and patience.

Step 1. I block in the entire composition with a 2H pencil on bristol paper, keeping my block-in loose at first so that I can construct an accurate foundation on which to build a finished drawing. In a free-flowing manner I shift the lines here and there until I have established the correct placement. Lightly I erase my block-in. Then I change to an HB pencil and, moving from left to right, make refinements that create a truer interpretation of the setup. I use a ruler to straighten the lines of the background planks as well as the string.

Step 2. I complete the line drawing with an HB pencil, still using a
ruler for the straight lines. I add knots to the wood, refine the
string pattern I have established. and indicate the shadow areas to
which I'll eventually add tones. Now I add a light tone to the en-
tire picture with a 6H pencil.

Step 3. To establish an accurate value pattern, I "spot" the spaces between the boards with a 2B pencil. This dark value helps me develop the values of the entire picture, and I can achieve the correct amount of contrast more easily.

Step 4. Using a variety of pencils to achieve the values I need, I begin rendering the tones of a small section of the wood. Proceeding slowly in this manner helps me to understand how to achieve the texture of this wood, and I begin to move across the drawing, rendering it, window-shade fashion, in total confidence. It stands to reason that the last section I complete will be much better than the first because of the experience I've gained as I have progressed. If necessary, I'll go back over the first area I completed and bring it up to the quality of the last section.

Step 5. To complete the setup, I slowly add various subtleties to the wood texture, going over it again and again. I make dark values slightly darker, as this stronger value pattern will contribute to the total effect of the rendering. Certain areas, such as the highlights, need to be brought up to value, but I don't rub them with my eraser. Instead, I tap the kneaded eraser gently on the unwanted graphite to prevent the paper from tearing and wasting all the valuable time I've spent on my drawing. At last I spray it with workable fixative to keep the graphite from smudging.

FLYING 9¼ x 8¼ in. (23.5 x 21 cm)

INDEX